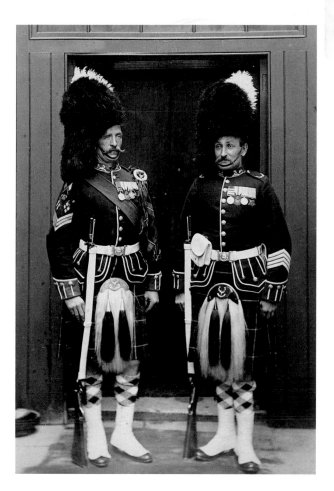

THE SCOTS

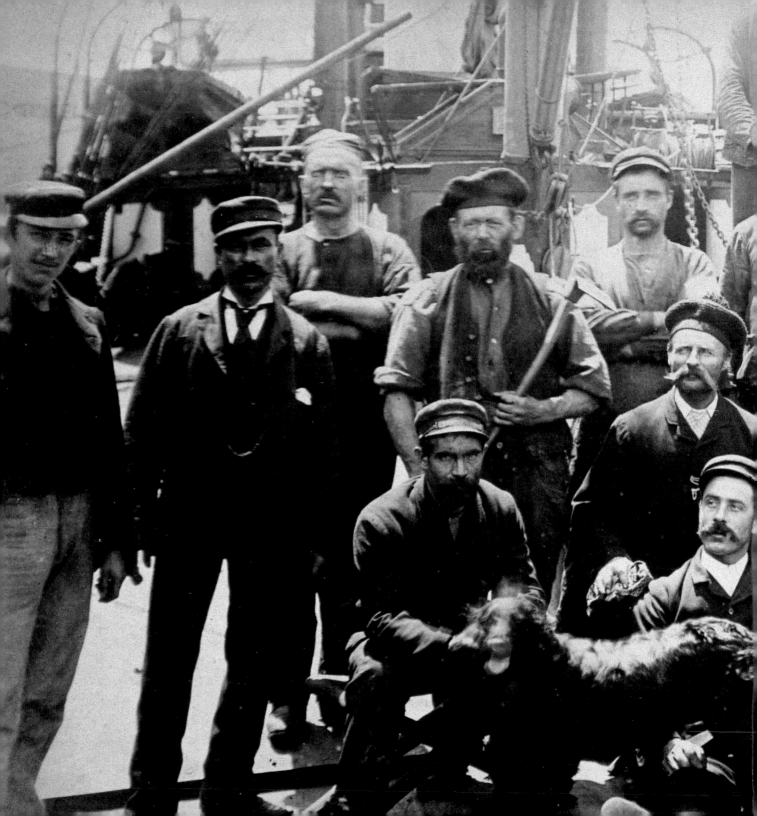

THE SCOTS

A PHOTOHISTORY

MURRAY MACKINNON

RICHARD ORAM

contents

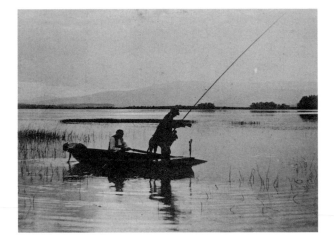

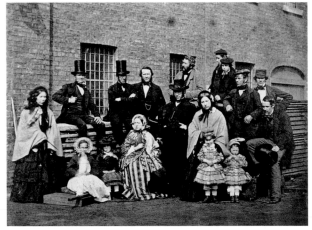

8 introduction

chapter 1
32 people

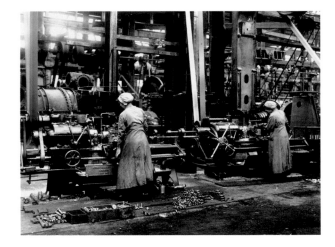

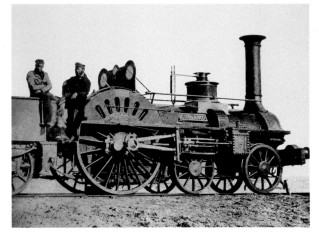

chapter 4
134 work and industry

chapter 5
172 transport

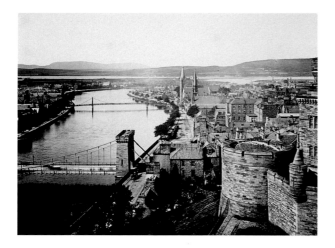

chapter 2
64 places

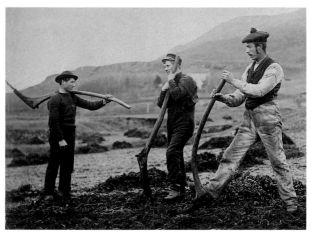

chapter 3
100 coastal and rural life

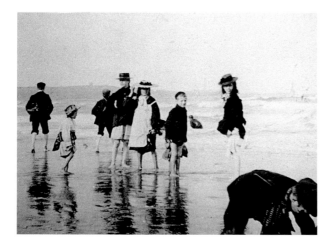

chapter 6
194 sport and leisure

223 further reading

223 acknowledgments

224 index

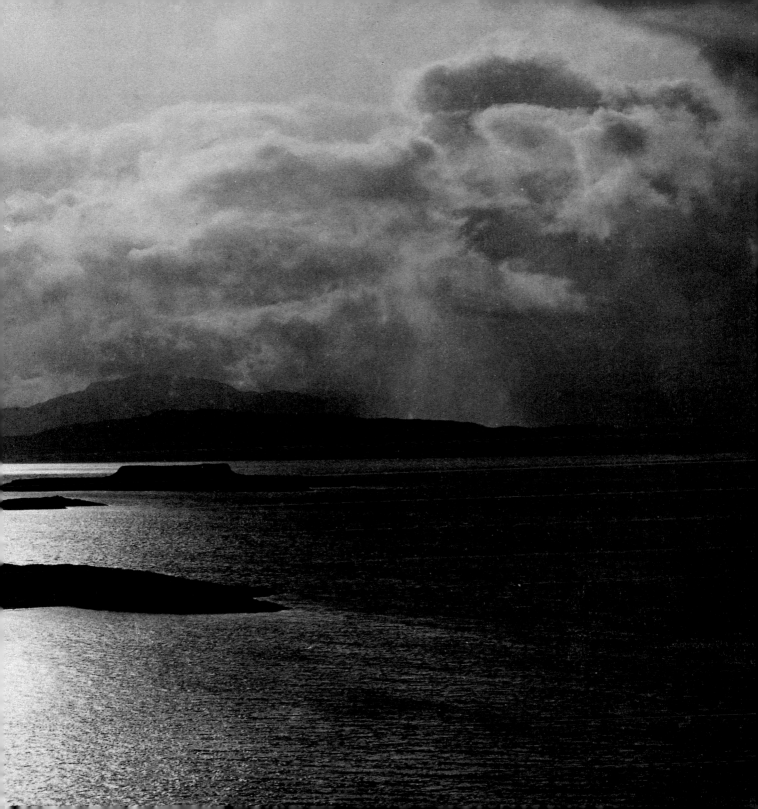

Introduction

'Tell your own children and
grandchildren that you are
Scots, and never to forget it'.
William Lascelles (d. 1785) to
his daughter Helen. *Christian
Watt Papers*, ed. David Fraser,
Edinburgh, 1983, p. 179

Opposite: John Brown (1826–83)
was for many Victorians the
archetypal dour, plain-speaking Scot.
He entered royal service *c.* 1849 and,
as Queen Victoria's personal servant,
attracted admiration and suspicion
in equal measure for his influence
over her.

By the time that Queen Victoria ascended the British throne in
1837, Scotland and England had been joined in a parliamentary
union for 130 years. The Union of 1707 had been a contentious
issue, which saw a majority of the Scottish political elite vote its own
parliament out of existence and enter into a voluntary union with
the English parliament to form a new, British legislature. While
traditional tales of the political chicanery and bribery employed to
secure the passage of the Union Bill have been greatly exaggerated
over the centuries, there is no denying that to many Scots the set-
tlement of 1707 was at best unsatisfactory and at worst a betrayal
of the national interest. As a consequence, opposition to the Union
remained a significant factor in Scottish politics in the early 1700s
and became a vehicle for other agendas, most notably Jacobitism,
which aimed to restore the exiled Stuarts to their British thrones.
Even before the defeat of Jacobitism in 1746, however, the eco-
nomic benefits of Union, and in particular access to the trade and
patronage network of the expanding British colonial empire, had
eroded much of the opposition. Military garrisoning of centres of
former Jacobite support, coupled with punitive legislation, reduced
resistance to the British establishment to an insignificant rump. By
the early 1800s, anti-Unionism was a stance held by a few politi-
cal mavericks and eccentrics and the next four decades seemed to
confirm that Scotland's future lay in integration and empire. While
most educated Scots still identified with their Scottish cultural
heritage and history, for them the Union – and their over-riding
Britishness – was an accepted fact. Before 1900, however, Home
Rule for Scotland, albeit within the framework of the British state,
was once again on the political agenda.

At the beginning of the Victorian Age, however, Home
Rule was not a pressing issue. The Scotland of 1839, when Louis-
Jacques Mandé Daguerre first revealed his pioneering photographic
process to the world, was a nation that had come to terms with its
changed circumstances. Unlike the comparatively recent Irish Act
of Union (1801), which forced the incorporation of the Dublin

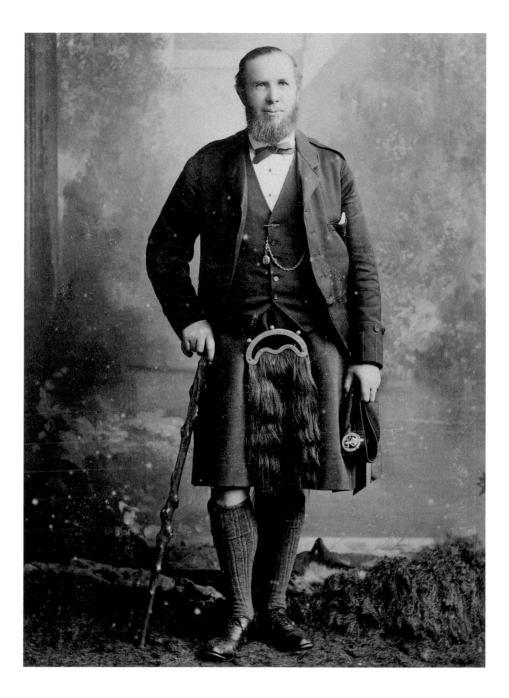

parliament into its Westminster counterpart, the Anglo-Scottish Union had not seen the subjection of the majority of Scots to the authority of a regime that was alien in terms of language, culture and religion. Instead, by the 1800s, the Scots had convinced themselves that their historical destiny had been fulfilled by Union, with the centuries of struggle with England presented as a vital preparation for joining with England as an equal, not as a subjugated enemy. Although an independent political identity was lost in 1707, the Treaty of Union had guaranteed the Scots the unaltered continuance of three key institutions – the Church, the Scottish legal system and Scots Law, and the Scottish Universities – through which a distinctive Scottish character within the British state continued. The Scottish Establishment that had been confirmed by the 1707 settlement was oligarchic, largely aristocratic, and overwhelmingly Protestant in composition, producing a character that was already largely in tune with that of England.

The partial assimilation of the Scots with the English was facilitated by two common factors: a shared crown and a shared language. Although Scots was a distinct language in its own right, it had a common root and was mutually intelligible with the English spoken in southern Britain. By the 1500s, the two branches had diverged but the continued linguistic cleavage had been halted effectively in 1603 when the Scottish king, James VI, ascended the English throne and moved with his court to London, where they were rapidly anglicized. By 1707, English had become the language of government and administration and, by the nineteenth century, was considered a social requirement and an essential passport to success for aspiring social climbers. As this trend progressed, Scots became increasingly marginalized within Scotland, relegated to dialect status and considered vulgar and uncouth, the tongue of the uneducated. It was only in the 1920s, with the 'Scottish Literary Renaissance', that Scots was partly rehabilitated as a language

of the expressive arts, but even then it could not entirely overcome the stigma of uncouthness and has struggled since to gain broad public recognition and acceptance of its linguistic credentials.

The Gàidhealtachd: Repression, Clearance and Revival

Although the Union sealed the fate of the Scots tongue, it had also confirmed Scotland's status as a predominantly Anglophone society. Gaelic, the main language spoken in much of Scotland down to the fourteenth century, had long been eclipsed by the tongue of the court and the townsmen and, by the late 1600s had withdrawn into the Highlands and Western Isles. Long viewed with suspicion by Lowlands-based governments, the anglicizing policies of the government had brought a progressive decline in the status of Gaelic as a spoken or written language. Highland chieftains, although often bilingual, were educated in the south and used English as their main language of business and communication, which created a widening gulf between them and their tenants and clansmen. The decline of Gaelic culture had been accelerated by its identification in the eyes of the government with Jacobitism, despite the loyalty of many Highlanders. Penal legislation after 1746 brought a ferocious onslaught on all aspects of Gaelic culture and by 1800 English had made substantial inroads into the Highlands.

Gaelic culture achieved partial rehabilitation in the early 1800s through a most unlikely mechanism, the literary outpourings of an English-speaking, lowland Scottish, Unionist Tory lawyer. Sir Walter Scott not only helped to establish the 'historical novel' as a literary device but also unleashed the exotic Scottish past onto the reading public. The publication of *Waverley* in 1814 caused a sensation and triggered a vogue for all things 'Celtic'. Such was Scott's popularity that in 1822 George IV, an enthusiast for the new fashion,

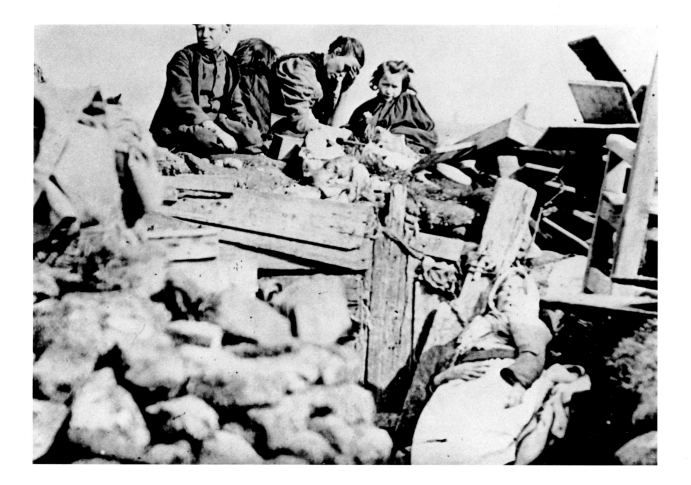

After the initial phases of Clearance in the early 1800s, evictions in Scotland saw little of the violence and brutality experienced in Ireland. As the despair in the faces of this family evicted from their home at Lochmaddy, North Uist *c.* 1895 reveals, however, the Scottish experience produced its own legacy of victims, bitterness and entrenched hatreds.

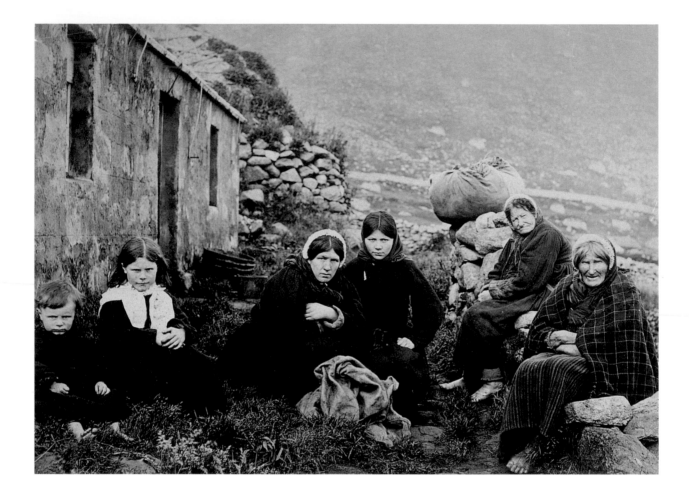

Scottish Highland life attracted the curious and the observant in the same way that the native cultures of more exotic parts of the Empire drew explorers. Canny Highlanders, however, like this St Kildan family *c.* 1880, capitalized on this interest and charged visitors for the photographs for which they posed.

presented himself, resplendent in tartan kilt and pink tights, to his suitably awed Scottish subjects in the first royal visit to Scotland since 1682. Reinforced by this rather dubious seal of approval, the image of the Scotsman as the noble, tartan-clad warrior emerged, leading in time to the re-packaging of Scots culture in general in Highland trappings. Yet, for all its tartan and Celtic-ness, the 'new' Scottish culture remained resolutely Anglophone and the decline of Gaelic continued unabated.

It is an irony of this cultural revival that it occurred against the backdrop of the Highland Clearances. Views of the Clearances are as polarized today as they were at the time, between those who see them as the misunderstood or mis-guided but necessary acts of a modernizing and essentially bene-volent land-owning class, and those for whom they were the brutal expression of commercial landlordism, where profit was placed before humanity. When reduced to basics, the Clearances were the result of a drive to bring debt-ridden Highland estates into profit. Many estates covered huge acre-ages but gave owners little income, mainly from a population of crofting families crowded onto pockets of agriculturally pro-ductive land amidst the uncultivable ground. The small rental income obtained from such tenants was overshadowed by the potential return from switching to stock-rearing, and several estates, most notably those of the Countess of Sutherland and her husband, the Marquis of Stafford, sought to clear their human populations, by eviction if necessary, and replace them with sheep. These Clearances have often been interpreted with a strongly anti-English bias, for the Countess was an anglicized Scot married to an Englishman, but it must be remembered that their principal agents, James Young and Patrick Sellar, were Scots who wholeheartedly pursued this hard-headed and hard-hearted economic strategy. To men such as they, crea-tures of the Age of Reason and the Scottish Enlightenment, Clearance was both a mission or duty and an economic policy, a necessary and overdue improvement that was needed to rescue the primitive Highlanders from a bondsman-like dependence on the land. In the process, they all but destroyed a culture.

The brutality of the Clearances has clouded recogni-tion of the fact that they were but one factor in a protracted episode of profound social and economic change in Highland Scotland. Despite the shortage of agricultural land and the increasingly small parcels of land upon which tenants support-ed themselves, population levels throughout the Highlands had climbed steadily throughout the 1700s, an expansion sustained like that in Ireland by cultivation of potatoes. The late 1700s witnessed some migration from the region, a development partly stimulated by employment opportunities in the expand-ing Lowland industrial towns and by the broadened horizons of young Highlanders who had served overseas in the military, but this trend made little impact on a society almost liter-ally rooted in the thin soils from which it eked an existence. These processes were accelerated by the first evictions after 1814 but were not consequent upon it. To an extent, clearance initially brought a re-distribution of population within the Highlands as communities were removed from inland straths and resettled on the coasts, preferring the increasing poverty of marginalization in their ancestral homeland to the dislocation of emigration. The result by the 1840s was chronic overpopula-tion in parts of the western Highlands and Islands, where the bulk of the population existed at subsistence level, dependent for survival upon their potato harvest.

In 1845, a devastating blight struck the potato crop in Ireland, precipitating crisis and bringing widespread famine and deaths. In 1846–47, the blight spread to Scotland and the potato-dependent crofters were plunged from subsistence to catastrophe. As famine gripped in 1848, a lasting solution to the linked problems of poverty and overpopulation was

called for, mainly by churchmen and politicians from lowland Scotland and England appalled that such suffering could occur amidst the prosperity of early Victorian Britain. Even before 1846, the need for positive action had been recognized and although the newly founded Scottish Patriotic Society offered assistance to crofters and fishermen it developed quickly as a provider of subsidies to fund emigration. Five years later, the Highlands and Islands Emigration Society was formed with a particular view to assisting emigration. The great Highland diaspora and the creation of the landscape of depopulation that is so characteristic of northern and western Scotland had begun.

The 1846–48 famine brought Gaelic Scotland more directly into the awareness of many Britons. Unfortunately, it was the natural wonders of the region rather than its people that caught most of the attention. Certainly, few early photographers saw much that they wished to record for posterity in the Highlanders they encountered, their eyes – and cameras – instead capturing the landscape and monuments of the region. The Scott-inspired enthusiasm for Highland romanticism had waned somewhat by the late 1830s but the Scottish tours of the young Queen Victoria and her husband rekindled its popularity in the later 1840s. When the royal couple bought an estate on Deeside and in 1853 built the fantasy that is Balmoral Castle, the rehabilitation of the Highlands was complete.

Despite the spread of manufactured 'Balmoralization', the revived passion for tartan-clad, romanticized Gaelic culture amongst the middle and upper classes, and the study of the Celtic past by academics, the general attitude to the lot of the ordinary Highlander remained one of indifference until the early 1880s. In 1882 a decisive turning point was reached, symbolized by the 'Battle of Braes' in Skye, where crofter-fishermen resisted the estate factor's attempt to evict them. The violence in Skye attracted national attention and a network of

sympathizers developed throughout the country. Later that year the Highland Land League was formed to agitate for land reform and the establishment of legal rights on behalf of crofters. Prominent establishment figures, most notably Professor John Stuart Blackie, who in 1882 had been appointed to the first Chair of Celtic at Edinburgh University, threw their weight behind the agitation for reform. Already faced with the threat of the Irish Land League, and with rural unrest in Wales, the government was stirred into action and in 1883 set up the Napier Commission to investigate the conditions of the crofters.

Public awareness of the realities of Highland life in this period was heightened by the work of photographers, such as the Aberdonian George Washington Wilson, whose studies shifted the focus from landscape to people and did much to break the Victorian popular sentimentalism towards the crofting lifestyle. The break-through came in the 1885 parliamentary election when four Crofters' Party candidates were elected: Highland land reform became a pressing political issue. The wheels of reform, however, turned slowly, and in 1886, as the Highland land reform bill moved through Westminster, simmering resentment over years of rack-renting and insecure tenures exploded into rioting in Tiree. Although suppressed by the deployment of large numbers of police and Royal Marines, the Tiree riot underscored the tensions within the Highlands.

The 1886 Crofters' Act did not bring an overnight transformation of conditions for the bulk of the Highland population. The Act gave security of tenure, the right to inherit, bequeath or assign crofts, set rent levels, and established the right to receive financial remuneration when they gave up tenure for improvements to the land that crofters had undertaken. A new Crofters Commission was set up to safeguard these rights, to arbitrate in disputes and oversee land allocation.

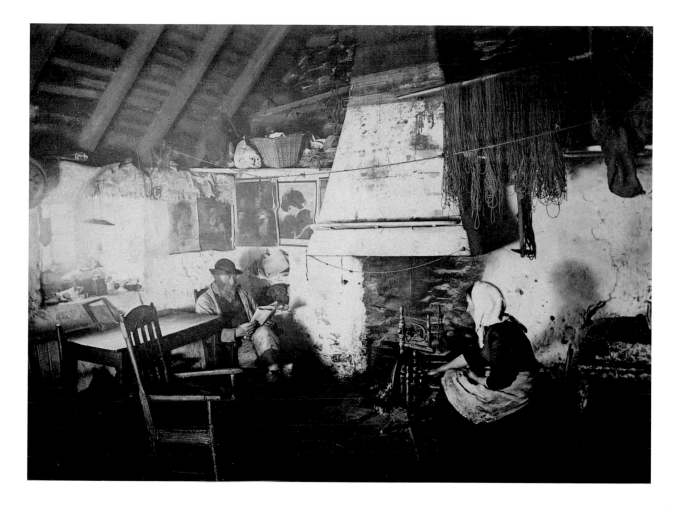

Interior of a Shetland crofter's house, *c.* 1890. The coarseness of the house's construction, with its roughly plastered stone walls, bare rafters and 'hinging lum' over the fire, contrasts sharply with the quality of the furniture and its owner's literacy and interest in contemporary European art, as revealed in the prints on the wall behind his chair.

introduction 15

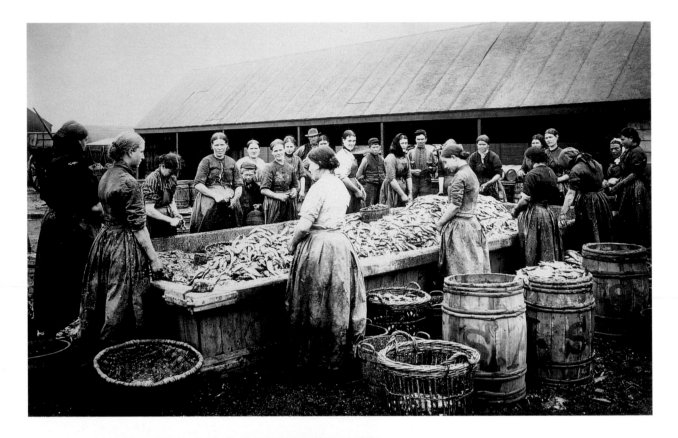

The boom in the herring trade
that began in the late 1870s threw
a lifeline to crofting culture. Young
men and women from the Highlands
and Islands, who served as boat
crews and gutters (above), provided
much of the itinerant labour on
which the industry depended.
Members of the traditional East
Coast fishing communities benefited
too through embracing Victorian
entrepreneurialism, such as these
Aberdeenshire fishwives (left)
who took up railway companies'
discounted fares to bring their
fresh wares to inland customers.

It was a major step, but it was decades before crofters' economic conditions, for centuries the result of public and private mismanagement, could begin to be remedied. Disappointment with the Act's provisions was widespread, and its failure to address the issue of recent evictions was one factor behind incidents such as the 1887 Lewis Deer Raid, where dispossessed crofters overran a sheep farm and deer forest. Overpopulation remained a problem in some areas, especially in the Isles, where crofters had been progressively displaced in favour of livestock farms or sporting estates and restricted to the coastal margins. It was only in 1897 that the Congested Districts Board was established to address this problem. Although the Highland Land League continued to function until 1921, when it became the Scots National League (which later merged with the Scottish National Party), after 1886 the level of agitation nevertheless declined as government investment and the Act's provisions became felt.

Gaelic culture, too, enjoyed a revival on the back of land reform issues. Professor Blackie's political prominence brought Scotland's Gaelic heritage to the public's attention and, although the primary enthusiasts were largely middle-class antiquarians, romantics and academics, their support lent new respectability to what had been long considered an inferior or subversive culture. Private clubs such as the Gaelic Society of Inverness (founded 1871 for 'rescuing from oblivion Celtic poetry, traditions, legends, books and manuscripts') or the Gaelic Society of Glasgow, but especially organizations such as An Comunn Gaidhealach (founded in Oban in 1891), provided the platforms from which a Gaelic cultural revival could begin. Culture, however, does not necessarily mean language and, despite such organizations' activities, Gaelic continued to be squeezed by the inexorable spread of English and official indifference to its fate. For all their efforts, private groups could not provide an alternative to state support. By the 1930s Gaelic was confined mainly to the Western Isles and pockets throughout the Highlands, and it was only in the closing decades of the twentieth century that the first official moves for its preservation were made.

Lowlands: the Rise and Decline of Industrialization and Urbanization

Dislocation, transformation and upheaval were not exclusive to the Highlands. Concurrently with the re-shaping of Highland society, the rural and urban cultures of lowland Scotland also experienced protracted restructuring as the twin processes of agricultural reform and industrialization pulled apart the fabric of traditional Scottish life. The employment offered in the expanding industrial sector in the central Lowlands sucked in labour, at first from elsewhere in Scotland, but increasingly from Ireland and further afield in Europe. The influx of aliens, many of them Roman Catholics, introduced new tensions to Lowland Scottish society: protectionism and exclusivity in employment, sectarianism and religious discord, and an undercurrent of racism. All were deep-seated ills that only began to dissipate with the radical social reconstruction of Scotland in the later twentieth century.

The Scotland of a century earlier had seen an equally radical social re-ordering. In the mid-1800s nearly one in three of the male population of Scotland worked in farming and, overall, a larger segment of the Scottish people was engaged in agriculture than in the coal-mining and textile industries combined. By 1900, the ratio had fallen to around one in seven, and by the outbreak of the Second World War to a little over one in ten. This decline accompanied a steady drop in rural population levels, which had reached a peak in around 1850–70 but by the middle of the twentieth century had fallen to the levels of the mid-1700s. Despite this drop in rural numbers, however, the population of Scotland continued to rise: people

were moving in to new concentrations rather than simply leaving for foreign shores.

Population growth had reached an unprecedented rate by the time of the first government census in 1841. Its recorded population of 2.6 million represented a doubling in numbers since 1775, with most now based in urban centres. Glasgow, with its ring of industrial satellites, had already achieved its numerical dominance within Scotland with a twelve-fold increase in population to reach a then staggering 275,000 souls. Edinburgh could only muster half that number, while the next largest stood at around 70,000. The industrialization of the Central Belt further fuelled the drift towards urban development, as the migration of workers to service the new coal-mining and iron-working industries triggered the transformation of once minor villages into manufacturing towns, or prompted the creation of wholly new settlements at mine or factory gates. As historian Christopher Smout has pointed out, however, even this period of rapid urbanization still left 65 per cent of the population as country-dwellers or living in communities of fewer than 5000 people. The next century, however, witnessed a reversal of that ratio.

It was the serendipitous coincidence of coal and iron reserves in west central Scotland that paved the way for the linked urbanization and industrialization of the region. Together, iron and coal provided a basis for an integrated and increasingly interdependent heavy industrial sector focused largely on shipbuilding. This fortuitous concentration of primary raw materials, together with a localized focus of technical expertise and available finance that had arisen from the first phase of industrial development after about 1775, provided the region with a critical mass that ensured its dominance of the new economy of the mid-1800s. It was the absence of abundant coal supplies, more than any other factor, that dictated that the industrial development of the country outwith the

Forth–Clyde isthmus never achieved a similar scale. By the time that a national rail transport network was established in the 1850s and 1860s, the pattern of urban and industrial development had already crystallized into its still familiar pattern.

Rapid urban growth brought a host of social and economic problems as well as benefits. Demand for cheap accommodation for the new urban labour force produced a double ill in the form of class separation and the creation of slum-ridden working-class ghettoes. Overcrowding brought the attendant problems of water supply and sanitation, both of which were inadequate to the demands placed upon them. Disease, including cholera and typhus, regularly visited Scotland's towns, wreaking a terrible toll on all classes until the local government reforms of the 1850s and 1860s enabled civic authorities to initiate programmes of slum clearance, sewer-building and provision of safe drinking-water. Nevertheless, by the early 1900s little impact had been made on the dense areas of over-crowded and unsanitary tenements that characterized Scotland's industrial towns; even the 'Homes Fit for Heroes' building programmes instituted after 1918 made slow progress in eradicating the recognized social ill of sub-standard housing. In 1939, in some parts of Scotland around 20 per cent of the population still lived in properties that had been deemed substandard over two decades earlier.

In part, the slowness of slum clearance after 1918 was consequent on the protracted economic recession that struck Britain in the 1920s and culminated in the great Depression of the early 1930s. With the British economy struggling generally, the government had few resources to allocate to regeneration programmes. The economic crisis was a global rather than simply a British phenomenon, but it had a particularly devastating impact within Scotland's industrial heartlands. Already stagnating before 1914, Scotland's coal- and iron-based sector

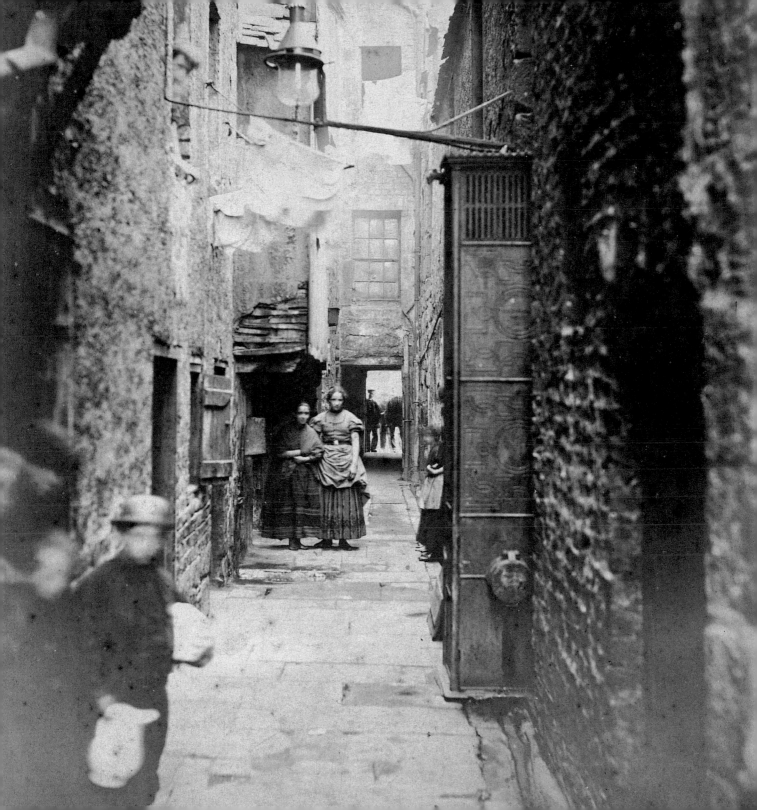

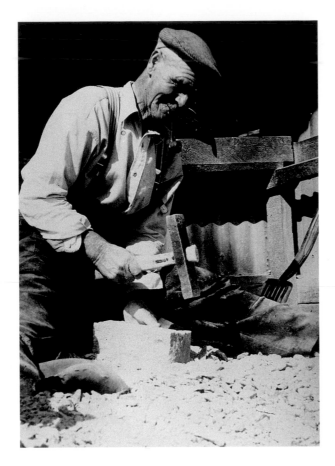

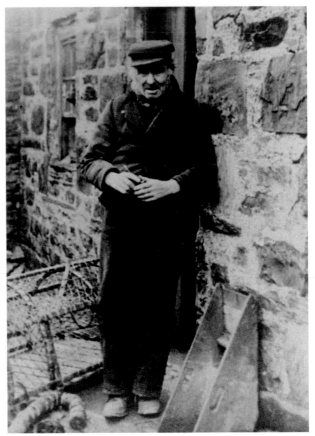

Previous pages: It took more than images such as the graphic record of the unsanitary and crumbling closes off Glasgow's High Street, here at number 37, to trigger the first moves towards social reform in the city. Epidemics of cholera and typhus, which were not socially discriminating, forced the hand of councillors in the 1860s, as did fear of radical politics amongst the un-enfranchised workers in later decades.

A modern focus on industrialization and the role of manual workers (above left) in Scotland's nineteenth-century development has led to a general failure to recognize that as late as the 1880s the rural population of agricultural workers and fisherfolk (above right) formed a larger percentage of the population.

had been given a lifeline by the switch to wartime production. At the close of the War, the industry had expected a prolonged boom on which its wartime expansion could capitalize, with shipbuilding in particular envisaging a renaissance as owners replaced vessels lost in action. Global over-provision in ship-building, however, brought a crash by 1920 and as Clydeside yards scaled back, the integrated industrial complex of coal, steel and iron that fed them with materials was plunged into recession. Elsewhere in Britain, especially in southern England, a post-War housing and consumer spending boom, fuelled by rising wages and higher levels of disposable income, had been accompanied by a diversification into new industries which enabled these areas to emerge more rapidly from the crisis. Scotland, however, where unemployment rates were on average 6 per cent higher than in the south, where wage levels were 11 per cent lower than the British average, and where both business and workforce were reluctant to embrace change, endured a protracted slump. From its position as the world's workshop, a hotbed of genius and dynamism, Scottish industry had declined into a creaking senescence, entrapped in a near obsolete system that, though still capable of world-beating achievements, survived largely as a consequence of Britain's drive to re-arm as Europe slid once more towards war. For Scottish heavy industry, Judgement Day was simply postponed by a second global conflict.

Faith: Schism and Revival to Irrelevance

Victorian Scotland's dramatic social re-ordering confronted the institutions of Church and State with issues that they were ill-prepared to tackle. For the Church in particular, the explosion in numbers and redistribution of population posed an especial problem. How would the Church accommodate these new, urban masses, ensure its relevance to an 'unchurched' workforce, and ensure that their loyalties were not won by new,

politically radical, alternatives? While the Church of Scotland was a pillar of the post-1707 establishment, and remained so into the twentieth century, it was not immune to the profound changes that swept Scottish society, nor was its hold on national religious life absolute. In the mid-1700s, all but a small minority of Scots had been Presbyterians and members of the Kirk. Episcopacy, the rival to Presbyterianism in the 1600s, had been reduced to a still declining rump, tainted by association with Jacobitism, and geographically confined to northeast Scotland and the southern Highlands. Roman Catholicism, except for a handful of high-status adherents amongst the aristocracy, had almost disappeared outwith remote areas of the Highlands and Islands. By 1800, however, the Church of Scotland's dominant position was weakening and over 300 congregations of seceding Protestants had been established, located mainly in the Lowland towns. Within those communities, moreover, were growing numbers for whom church membership was nominal, and who felt increasingly alienated or failed by an institution whose leadership and values were solidly middle class. By 1839, these problems had become chronic and the very nature of the Established Church faced question. The seemingly monolithic fabric of the Church was exposed as a brittle facade that internal tensions might pull apart. The state of the Church in 1839 dominated national debate.

The state of the Church in 1839 dominated national debate. Central to the crisis were issues of patronage and the relationship between Church and State, themselves a facet of an internal struggle between Moderate and Evangelical parties. Even more pressing was the question of how to reach the unchurched masses. The Established Church sought State aid in a programme of church-building which would allow it to reach the potential congregations of the industrial towns, who were being lost to the various secession churches. While

State finance was wanted, however, State involvement was not. Here, the underlying issue was patronage. The recent roots of the patronage crisis lay in 1834, when the Evangelicals had achieved a majority in the General Assembly and immediately set in place legislation that empowered congregations to veto a patron's nominee as minister. This move sparked protracted litigation that was eventually passed from the Scottish Court of Session to the House of Lords, turning what had been a Scottish domestic problem into a national, constitutional issue, and marked the beginning of what was known as 'The Ten Years' Conflict'. The battle lines in the conflict hardened in 1840 and in 1842, when the Evangelicals passed the 'Claim of Right', the fissures within the Church threatened to rupture.

The Disruption of the Church of Scotland in 1843 has been described as the most momentous event in nineteenth-century Scottish history. The walkout of 123 ministers from the General Assembly in Edinburgh, an event commemorated in a series of photographic portraits taken by David Octavius Hill and Robert Adamson, from which Adamson then produced a composite oil painting, led to 454 out of a total of 1,195 clerics, 408 parish and private schoolteachers, and over 40 per cent of the Church's membership following their lead. The Free Church which the seceders established enjoyed an explosion of popular support, albeit at widely varying levels across the country – amongst rural congregations: from over 90 per cent in Lewis and parts of the West Highlands to under 20 per cent in Dumfriesshire; and amongst urban congregations: from 100 per cent in Aberdeen to just over 50 per cent in Dundee – and within five years had assembled the infrastructure of an alternative national Church. It was a blow from which the Church of Scotland never recovered and, although the challenge of the Free Kirk declined rapidly through the 1850s and 1860s as it was itself rent by schism, the centrality of the Established Church to the social and political life of the nation had been shattered. Even re-union with a majority of the remaining Free Kirk congregations in 1929 failed to stem its declining influence.

From Westminster's perspective, the Disruption was comprehensible only as the work of fanatics. It presented the government with a series of pressing issues, for the schism destroyed the seamless join between Church and State that enabled schooling, poor relief and moral discipline to be organized nationally and uniformly at parish level. Although the parish remained the basic unit of organization for both education and poor relief, the administration of these services was removed from Church control. In 1845 new parochial boards were created to administer poor relief, and in 1861 the Church's legal powers over schools were ended. A national schools system emerged only in 1872 under the provisions of the Education Act, answerable in theory to the Scotch Education Department. By then, however, the Church had succeeded in regaining some of its lost authority and, although the new schools were notionally 'non-denominational', they were run by elected school boards in which it was the dominant force. The State may have assumed many of the powers of the Church after the Disruption, but the Church still commanded a potent voice at local level.

Despite the Disruption and the succession of subsequent schisms and unions of both the Church of Scotland and the seceders, Scotland remained overwhelmingly Protestant and principally Presbyterian into the 1870s. The last third of the century, however, witnessed a series of changes in the religious complexion of the country and a shift from doctrinal controversies to sectarianism in some areas. From the 1850s, Episcopalianism enjoyed a revival, based to a large extent on its fashionable status amongst the landed families and the affluent urban middle classes, who provided it with fine new churches. The main development, however, was the growth of Roman

Catholicism, in large part a consequence of the influx of Irish migrants into west central Scotland. The Roman Catholic Church had been slow to respond to this development. At first, many of the migrants had been seasonal workers, often young, single males who showed little inclination to attend mass. Glasgow around 1840 had an estimated 40,000 Irish Roman Catholic residents but only two churches and four priests, and it was believed that fewer than one third of this potential congregation attended mass. By the 1850s, the Roman Catholic authorities were more organized and, as the transient Irish workforce was replaced with permanent settlers, was able to provide an improved level of religious service.

In 1878, the full diocesan hierarchy of the Roman Catholic Church was restored in Scotland. The congregations that maintained this structure were formed largely of immigrant Irish but included also a significant number of upper-class Scottish converts who were dissatisfied with the Protestant churches. Such converts provided lay leadership for the revival of a Church whose membership was overwhelmingly working class in composition. Despite the patronage of a few wealthy families, it is truly remarkable that this humble constituent managed to support financially the enormous building programme necessary to provide the churches and seminaries required to establish and maintain a working system.

Protestants viewed the spread of Roman Catholicism with alarm. For some, the unease was a force to be tapped for religious and political ends. In an overwhelmingly Protestant culture, sectarianism had not been a significant feature other than in the stream of invective still directed from some pulpits towards the shadowy anti-Christ in Rome, but the upsurge in Catholicism from the 1850s onwards and the concentration of Roman Catholic Irish migrants in particular areas bred a new kind of intolerance. The most prominent manifestation of anti-Catholicism was the spread of the Orange Order through west central Scotland. Orangeism had emerged during the political unrest in Ireland in the 1790s and by 1800 had come into western Scotland with migrant Protestant Irish workers. There, it grew in parallel with the militant Protestant tradition of Ayrshire, Lanarkshire and Renfrewshire, but it was only with the beginnings of large scale Protestant Irish immigration to Scotland from the 1850s onwards that it developed significantly. Its most rapid growth coincided with the period leading towards the restoration of the Roman Catholic hierarchy, and by the 1890s there were over 15,000 Orangemen in Glasgow. Most of these new Protestant migrants were skilled labour and, instead of swelling the ranks of miners and navvies, found employment in the heavy engineering industries of the lower Clyde area. The Clyde shipyards and the iron- and steelworks of north Lanarkshire became bastions of Protestantism, where religion and job protection combined to almost entirely exclude Roman Catholics.

In modern Scotland, the most prominent reminder of the sectarianism of the late nineteenth and early twentieth centuries is in the football clubs that substituted warfare on the pitch for religious conflict in the streets. Celtic and Rangers in Glasgow, the former founded by a Marist priest and the latter developed to uphold Protestant honour against the successes of the upstart Catholics, are but the most notorious of the old rivalries, which saw the establishment of Heart of Midlothian and Hibernian in Edinburgh and Dundee and Dundee Harp on Tayside. Celtic–Rangers clashes were – and to an extent still are – times of heightened tension that could spill over into violence on and off the football pitch.

The polarization within communities which came with this sectarianism and sporting rivalry also carried a deeper, political complexion. From the early 1880s onwards, nationalism held a significant sectarian connotation carried

over from the Catholic-Nationalist Protestant-Unionist divisions in Ireland. Unionist politicians in Scotland capitalized on this tradition, proclaiming that 'Home Rule means Rome Rule' and mobilizing the Protestant middle and working class votes against Liberal government moves to bring a measure of political devolution to Scotland. It was a policy employed to great effect through the 1920s and 1930s, and it was only with the break-up of the traditional heavy industries with their often-entrenched sectarianism, and the blurring of barriers between the Protestant and Catholic ghettoes of west central Scotland in the post-Second World War period, that working-class Protestant Unionism declined significantly.

Politics: Conservative, Liberal and Radical

Amidst the social and economic upheavals of this era, the Scottish political landscape likewise underwent a series of seismic shifts in its composition. In common with the rest of Britain, the change began in 1832 with the first Reform Act, which at a stroke increased the electorate from some 4,500 to around 65,000, and began to give recognition to the increasing economic power of the urban areas by enfranchising the middle classes. Often portrayed as a radical move, the Act was in fact aimed at emasculating radicalism by detaching the middle classes from the masses and associating them instead with the ruling landed interest, in effect removing the articulate, educated leadership from the agitation for wider democracy. Recognition of that fact and of the government's intention that no further ground should be given on widening suffrage led to rapid disillusionment amongst the working classes. By 1838 at a British level, that disillusionment had spawned Chartism, a radical movement that took its name from the People's Charter, a document that called for universal suffrage, ending of property qualifications, secret ballots, equal electoral districts, payment for MPs and annual parliaments. Chartism in Scotland drew strength from a radical political tradition that extended back into the 1790s, but its immediate impetus was given by the widely perceived failures of the 1832 legislation, recent suppression of trade union activity, and the deepening economic crisis of 1838–42 that had hit industrial west-central Scotland particularly hard. Despite its radical agenda, however, Scottish Chartism was never a revolutionary movement, arguing instead for political reform rather than the violent overturning of the establishment. As a political force, Chartism was largely spent after parliament's second rejection of the Charter and supporting mass petition in 1842, and by 1848 the movement was effectively dead. Modern assessment of its impact, however, is more positive than this apparent failure might suggest, for it is seen to have reinforced the Scottish working class radical tradition, and its fundamental principles deeply influenced the emerging Labour movement in late Victorian Scotland.

From 1832 until 1886, Scottish politics was dominated by the Whigs, who had delivered the Reform Act, and by their Liberal successors, who were seen as the progressive, reformist and libertarian party in British politics. The Tories, who had opposed Reform, suffered a catastrophic decline in Scotland, losing ground in urban areas and, after their failure to reach a compromise that would have prevented the Disruption of the Kirk in 1843, in the large shire constituencies also. Even Tory legislation for further electoral reform in 1868, which extended the vote to a broad skilled and semi-skilled working

The Lobnitz engineering works at Renfrew (right) stood for the dominance of the coal, steel and shipbuilding complexes of west central Scotland. However, restrictive working practices and a failure to invest in new technology brought the sector to the brink of collapse before 1914.

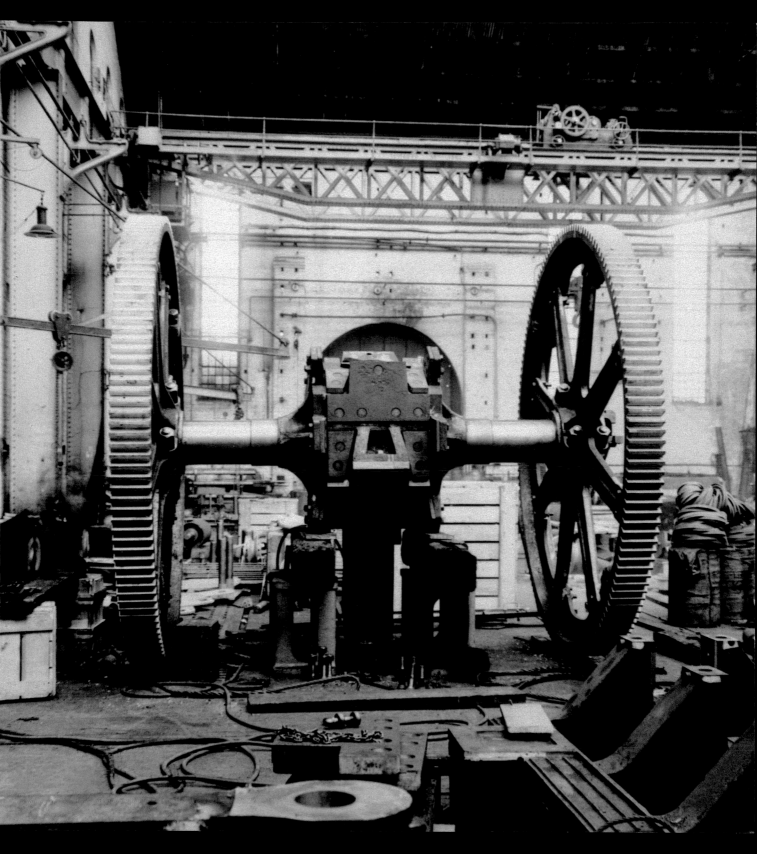

class constituent, failed to deliver any revival in their fortunes. Instead, the newly enfranchised electors handed the Liberals 52 out of Scotland's 60 parliamentary seats. The political landscape that the Liberals controlled, however, was far from quiescent, for radicals amongst the middle classes and workers both considered the 1832 Act as a first step towards full enfranchisement, not the last word. Both groups operated within the framework of Liberalism, but their values and ambitions were significantly different from those held by the traditional leadership of the party and from each other. As a consequence, there was always the potential for schism within Scottish Liberalism, and, with the Tories in Scotland such an insignificant force, Scottish elections often turned into factional contests between Liberals of different hues. Such tensions eventually split the party in 1886.

Despite the radical undercurrents in Scottish politics in the 1840s and 1850s, there was, strangely, no emergence of the strident nationalism that was surfacing in Ireland and throughout Europe. Union and empire, it has been argued, mattered more to the economic and political sensibilities of contemporary Scots, and full participation in those areas had on the one hand brought dilution and erosion of Scottish national identity, but on the other that same identity had begun to subtly alter and reinvent itself to fit into the new circumstances. The dramatic re-shaping of Scotland's demographic patterns, social structures and economic base, together with the upheavals within its one national institution, the Church of Scotland, seemed to break the link with the old self-confident identities of the eighteenth century and earlier. Scotland's one response, the National Association for the Vindication of Scottish Rights, formed in 1853 and wound up in 1856, was concerned more with the refinement of the new status quo than with the aggressive assertion of national identity that was reshaping the European political landscape. That,

however, did not mean that nationalism or national identity in Scotland were irrelevant forces. Scottish identity was, instead, being articulated at a level other than that of national politics, being vested in the urban and local government structures of the country, or expressed through pride in Scottish achievement and the remarkable contribution of Scots to the building of the Empire. Nationalism might not have been a meaningful force in mid-nineteenth century Scotland, but conscious awareness of national distinctiveness was preparing a seedbed for its future development.

Ironically, it was nationalism that proved to be a major factor in breaking the Liberals' hegemony, but in Ireland, not Scotland. A second factor was the Third Reform Act of 1884, which strengthened the radical element within the party through extending franchise to more manual workers and small farmers. The third key element was land reform, where pressure for change along the lines that had been conceded in Ireland in 1881 was driving a wedge between tenants and Liberal landowners. It was Liberal MPs who were defeated in 1886 by Crofters' Party candidates. Finally, socialist parties emerged that had a greater appeal to the newly enfranchised working class voters than did a party regarded as capitalist and free-market driven, entirely antipathetic to the protectionist instincts of the increasingly powerful trade unions. Ex-Liberals were prominent in the formation in 1888 of the Scottish Labour Party (SLP) and in 1893 of the Independent Labour Party (ILP) with which the SLP merged in 1895. The formation in 1897 of the Scottish Trades Union Congress was followed by its close cooperation with the ILP to form the Scottish Workers' Parliamentary Election Committee (SWPEC), a development that signalled belief that working-class interests were no longer best served by Liberalism.

Even before the formation of the SWPEC in 1900, Scottish Liberals were in disarray. Irish Home Rule was

the decisive issue, as even the limited devolution offered by Gladstone had managed to alienate significant segments within the party, ranging from Liberal landowners who feared the implications for themselves of land reform, free-marketeers who saw it as a threat to their economic world view, and working-class Protestants who were swayed by Orangeist claims that Irish Home Rule would subject their co-religionists to Rome Rule. Those most opposed to Home Rule split to form the Liberal Unionist Party (LUP), which managed to capture nearly a third of the Liberal's Scottish seats in 1885. Significantly, many of the defecting voters were in the indus-trial west, where there were strong links with Ulster Protestantism, and the LUP succeeded there in breaking the Liberals' stranglehold on the urban centres. It proved a lasting phenomenon, which, through the LUP's increasingly close relationship and, in 1912, merger with the Conservatives in Scotland to form the Scottish Unionist Party, led to the emergence of a powerful working-class Conservatism in the region. The days when Scotland had been, for all intents and purposes, a one-party state, were effectively over.

It is wrong to dismiss the Liberals after 1885–86 as a party in terminal decline. In the 1906 election they regained an overwhelming majority in Scotland – 58 out of 70 seats. The recovery may have been due in part to the purging of disaffected elements caused by the split in 1885, which allowed the radical remainder to emerge as a much more coherent and cohesive unit. It was also consequent on Labour's still insignificant showing. The Liberals still offered the best chance for representation of workers' interests in parliament and an increasingly well organized Irish Nationalist presence in Scotland continued to support a party that it saw as most likely to deliver Home Rule. In all areas, however, it was the need to deliver on reform – social, economic, political – that the Liberal future rested.

In the pre-1914 era, that pressure to deliver was mounting steadily. Waiting in the wings was Labour and an increasingly influential and active revolutionary left that was tapping in to working-class concerns over unemployment and dilution of skills. By 1911, public lectures on Marxist economic and social philosophy attracted audiences in the hundreds in Glasgow. Labour, however, failed to turn this growing Marxist-socialist factor into electoral success. In 1906, only two Labour MPs were returned. There was also a growing movement within Liberalism that saw Scottish Home Rule as an inevitable concomitant of Irish Home Rule. The party had nodded in that direction since the 1880s and there had been seven Scottish Home Rule motions before parliament in the period down to 1900, but, nationally, there was little support for the move. After 1910, however, pressure on this topic, too, was mounting, as a Scottish parliament was seen as a way of accelerating social reform and removing the interfering hands of English conservatism. In May 1914 a Scottish Home Rule Bill passed its second reading and seemed set to become an Act, but the slide into war over the summer months stopped the momentum dead in its tracks.

As with so many other aspects of everyday life in Scotland, the First World War transformed the face of Scottish politics. Although some socialists, such as John Maclean, were prepared to denounce the war and go to prison for their beliefs, almost all shades of political persuasion united behind the government. By 1915, as the number of casualties mounted, support was no longer unquestioning, and domestic problems emerged that further eroded popular support for the Liberals. In particular, there was growing industrial unrest in Scotland, where the demands of wartime production had seen the arrival *en masse* of the much feared dilution of skills, as increased mechanization and the introduction of unskilled male and female labour into formerly exclusively skilled, male

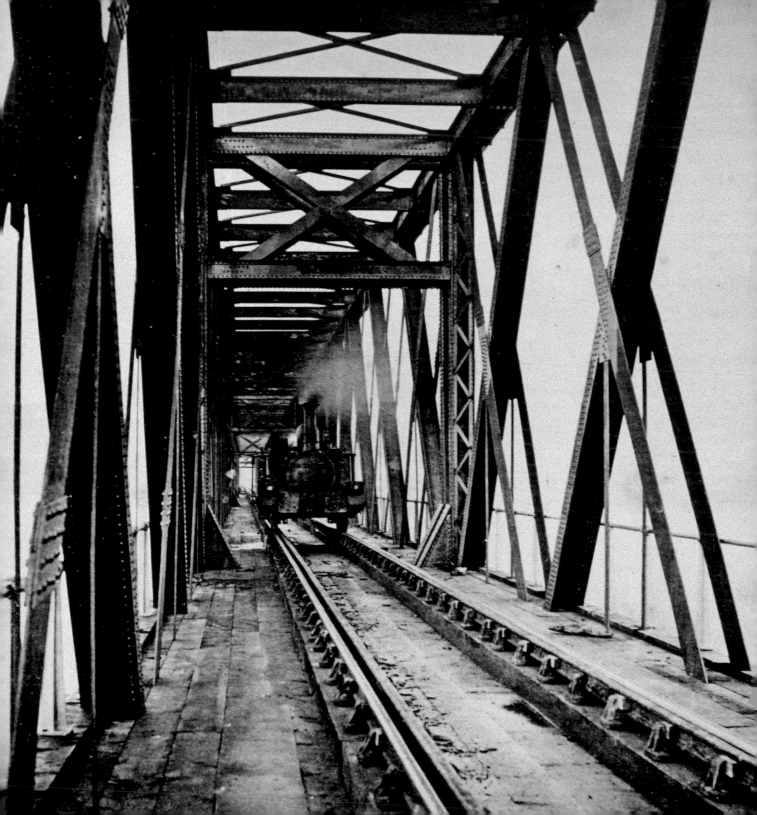

occupations to replace the men serving on the Front triggered a reaction amongst trade unionists. Strikes in the essential engineering industry of west Scotland were met with a government reaction that saw shop stewards 'deported' from the area and the suppression of socialist newspapers. In the eyes of many workers, the Liberals had aligned themselves with the bosses. The deciding factor, however, was the government's inept handling of the 1915 Glasgow Rent Strike, which had been triggered by landlords' attempts to profit from the pressure on housing caused by the influx of munitions workers to the city by raising rents by 12–23 per cent. While the government condemned the strike, but legislated to prevent the rent rises, the ILP threw its weight behind the strikers and emerged with a massive increase in its popular support.

Support for Labour was converted into votes in the 1918 elections but not into seats. The broadening of franchise in 1918 had tripled the electorate, giving the vote to a largely working class constituent. Although some 33 per cent of this electorate now voted for Labour, this translated into only eight seats. Nevertheless, over the next few years Labour's level of support continued to grow at the expense of the Liberals, especially as it became clear that Lloyd George's much publicized promises of post-War social reform had foundered in the deepening economic crisis after 1920. That same crisis sparked radical realignments in Scottish politics, with opinion polarizing around socialist and anti-socialist parties. One key event,

By the early 1900s, engineering marvels such as the Tay Rail Bridge were already decades old, but were still considered as evidence of Scottish industry's world-leading status. By 1930, the traumas of war and economic depression had revealed how hollow that image was.

now regarded as far more innocent than it was presented at the time, was the 1919 40-hour Strike in Glasgow, where heavy-handed policing of a demonstration by 100,000 workers in the city's George Square triggered a 'riot' which the Scottish Secretary reported to Downing Street as 'a Bolshevist rising'. Troops and tanks were deployed in the city, while reports of red flags flying amongst the crowds were relayed around the country by the press, raising an unnatural sense of panic amongst a middle class familiar with the reported horrors of the Russian Revolution. Together with the unrest of 1915–16, the 1919 strike has become one of the symbols of 'Red Clydeside', a semi-mythical period of radical, revolutionary socialism in Scotland's industrial heartland. But the unrest of 1915–19 was reformist and economically driven, not revolutionary, except in the sense that the government's insensitive handling of the situation helped ensure an electoral revolution in 1922. Disillusioned with the Liberals and wooed by Labour's policies and skilful election machine, the working-class voters in Scotland deserted their traditional allegiances in droves. Labour gained 29 seats and 32 per cent of the vote, mostly in west central Scotland. The triumph of socialism seemed inevitable. After 1922, the Liberals and Unionists competed to secure the anti-socialist, largely middle-class vote, a struggle won comprehensively by the Unionists before the end of the decade. Overwhelmingly, Scotland's middle-class establishment – the press, the legal profession and the Church – lurched dramatically to the political right.

The protracted economic crisis of the 1920s and early 1930s produced new tensions in Scotland's political fabric. In 1924, Labour briefly exercized power in government through an alliance with the rump of the Liberals, and succeeded in steering some pioneering reformist bills through parliament, most notably John Wheatley's Housing Act. But at the election in October 1924, Labour and the Liberals were trounced by the

Conservatives. Political recovery came in 1929, when Labour took 38 out of 74 Scottish seats, demonstrating clearly that its appeal had moved far beyond its traditional urban heartland in the west. That commanding position was short-lived, however, for as the Depression deepened the Labour Prime Minister Ramsay MacDonald chose to form a National Government with the Conservatives and Liberals. His decision threw his party into turmoil and schism, with the majority of Labour MPs refusing to support the coalition. As a consequence, in the 1931 election Labour was crushed, seeing only seven MPs returned, with political domination being handed instead to MacDonald's Conservative coalition partners. Until the 1945 election, parliamentary Labour was consigned to the political wilderness in Scotland.

The economic crisis also brought about a significant shift in Labour's Scottish policies generally. In the early 1920s, Labour had supported Home Rule for Scotland, but as its party apparatus became centred increasingly in London and its understanding of the implications of Home Rule in the current economic situation matured, that stance shifted significantly. In 1928, when it was clear that Labour would not deliver an Edinburgh parliament without 'persuasion', the National Party of Scotland (NPS) was formed to agitate solely on that agenda. The Nationalists could have been expected to capitalize to some extent on the anxieties of the electorate over the continuing plight of the Scottish economy, and when in 1932 the left-leaning NPS joined with the moderate right Scottish Party to form the Scottish National Party, they seemed to have found a formula that could appeal across the Labour-Conservative divide. But the new SNP had no credible economic policy to put in place of that pursued by the National Government and within four years the party had almost torn itself apart in factional infighting. National sentiment was instead won over by the government, whose astute Scottish Secretary, Walter

Elliot, drove through initiatives aimed at defusing the appeal of nationalism in the current crisis, of which the move of the Scottish Office in 1937 from London to Edinburgh, giving the symbols of Home Rule without the substance, was the most important. As the economy improved and Britain slipped steadily towards a second war with Germany, the spectre of nationalism faded from view. In September 1939, the Union was as secure in Scotland as it ever had been, but few could have predicted that the late twentieth century would see the Nationalists return to challenge Labour's Scottish hegemony, or that the Conservatives would be all but eliminated as a political force.

Scots were leading experimenters with photographic recording; John Logie Baird (above and right), pioneer of photographic transmission, developed the first practical televisual system in 1929.

chapter 1

people

The confident face of Victorian Scotland's ruling classes. Landowners (above) and the successful middle-class businessmen and professionals (right) dominated the nation's politics and economy. Although national prosperity and income levels overall rose dramatically between 1855 and 1905, there was inequality in the distribution of wealth. The middle class, representing less than 8 per cent of the population, received nearly 22 per cent of national income in this period.

'The Scot' is one of the archetypes in the worldwide repertory of characters. Almost every nation has a stereotypical image of Scots, in terms of both physique and personality. The rugged, rangy redhead stands awkwardly beside the diminutive, pinch-featured keelie, while pawky pugnacity balances parsimony, sanctimony and smugness. The Scots themselves have cultivated a series of self-images, some frank in their self-criticism, others breathtaking in their self-delusion. One of the most deeply entrenched is that of the 'lad o' pairts', the youth from the impoverished background who, through access to the free, world-class Scottish education system, coupled with parental self-sacrifice and ambition, personal determination and strength of character, progressed to university and

emerged in the end as a pioneering scientist or engineer. Such individuals existed, and not just in the novels of Neil Gunn or the minds of his middle-class readers; but for every 'lad o' pairts' there were scores for whom such mystical opportunity never knocked.

Even more enduring is the perception of egalitarianism and lack of class deference amongst Scots. Until the later 1800s, urban Scotland was a barely segregated mix of rich and poor, but the rapid industrialization after 1840 sparked a drastic change. In Dundee, for example, mill-owners and managers originally lived near their factories, cheek-by-jowl with tenements inhabited by their employees, while in Fraserburgh fish-curers dwelt in the same streets as crewmen and gutters. By the 1870s,

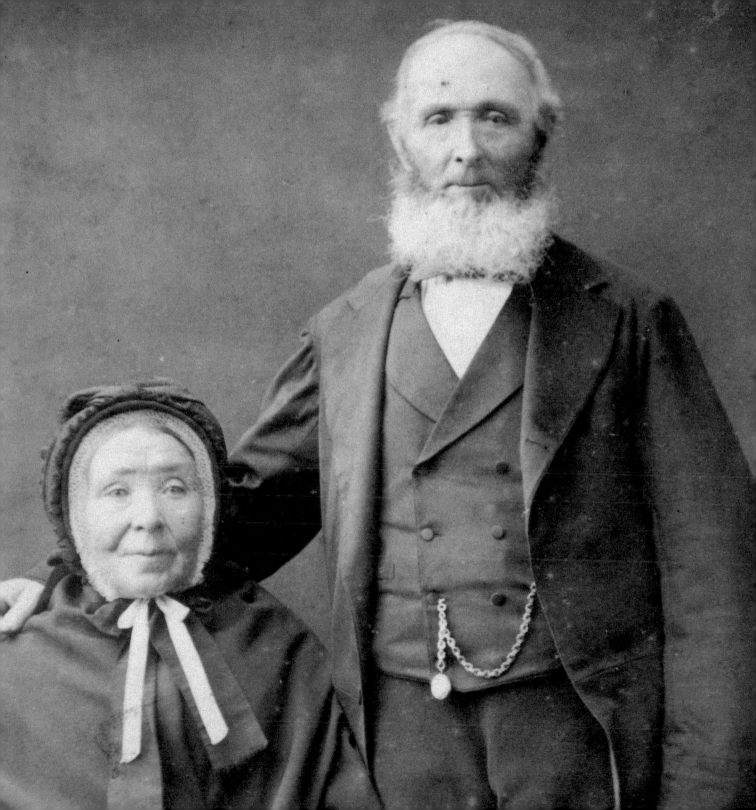

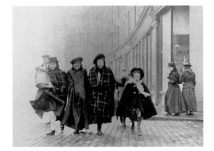

Like inhabitants of two different worlds, these middle-class women shoppers in Aberdeen, *c.*1900 (top), neither knew nor cared about the conditions of work for those who served them (above). The long hours and poor pay of shop-workers and errand-boys, such as the milk-boys in Aberdeen (opposite), drew neither recognition nor sympathy from workers in industry.

however, the classes had begun to separate out: Dundee's 'jute lords' migrated to new-built mansions beyond the city's industrial periphery and Glasgow's elite flitted to new villas and upper-class tenements in the West End in a pattern that was mirrored across Scotland's towns. The counterpoint to the development of upper-class suburbs was the creation of working-class ghettoes clustered around mines, factories and shipyards.

While Scotland's burgeoning towns were powerful magnets that attracted workers, this was also the great era of the agricultural and domestic servant. In a male-dominated industrial society that believed absolutely in 'separate spheres' of male and female activity and in which most industries were male preserves, for women seeking employment other than as housewives, domestic service was one of the few areas open to them. Most households from the lower middle classes upwards employed at least one maid, and the great landed establishments depended on teams of servants for their smooth operation. While farms, especially in the eastern lowlands, employed gangs of men for fieldwork ranging from skilled ploughmen down to unskilled labourers, women were restricted largely to indoor jobs, especially dairying, but by the 1870s over 25 per cent of the agricultural workforce was female, and that percentage increased dramatically at harvest time. Although agriculture remained a popular source of employment for women until well

after 1920, they, like their rural male counterparts, were deserting the countryside in increasing numbers in search of better prospects in the cities.

In contrast to the urban and rural poor elsewhere in Britain, for Scotsmen military or naval service remained unattractive until the late 1800s. Recruitment had been high before 1815 – some 75,000 Highlanders enlisted – but the Clearances drove a wedge between regimental proprietor-colonels and tenants and recruitment numbers plummeted. Nevertheless, the Highland soldier, loyal, obedient and valiant, was an archetype of the Victorian British self-image and the battle honours of the Highland regiments, prima facie, gave the impression that the army was comprised largely of such men. In 1870, however, Scots formed only 8 per cent of the military, and recruitment into Highland regiments was so poor that some contained a non-Scottish majority. This trend was reversed in the later 1800s, consequent in part on growing commitment to British imperial ambitions. This commitment saw development of a jingoistic culture amongst all classes, fuelled by the concept of 'muscular Christianity' in which masculinity and military discipline were pillars of ordered Christian society. Economic necessity made its own contribution, as competition for apprenticeships and rising emigration costs closed other routes to self-improvement. For many youths, enlistment provided security, discipline and 'family' support, opportunities for foreign travel, and

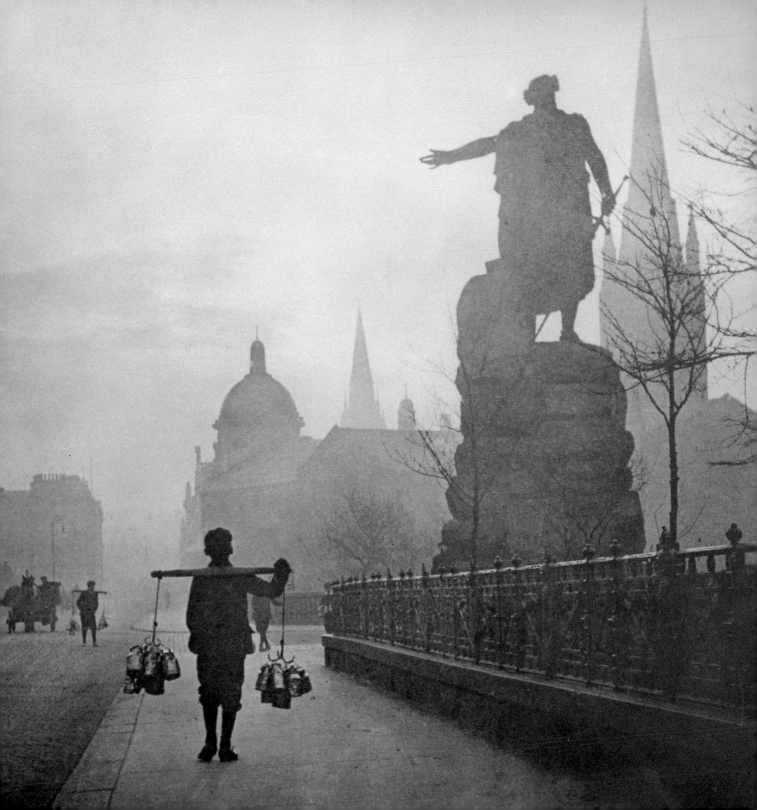

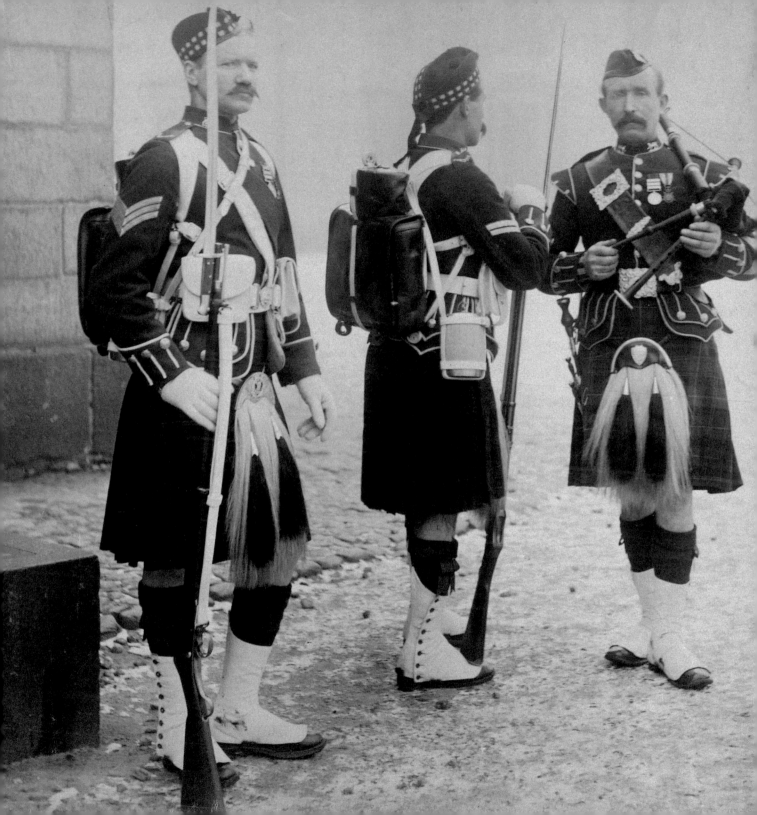

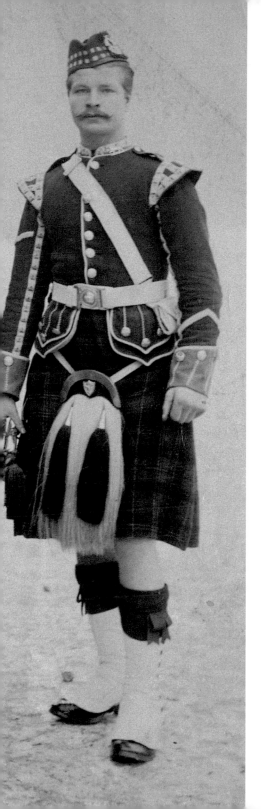

access to skills that could propel them upwards once they had been discharged.

Recruitment soared in 1914. The poor physical condition of many recruits from urban areas – especially Glasgow – highlighted the endemic poverty and ill health of the industrial workforce, a problem equally evident twenty-five years later amongst Glaswegian recruits in the Second World War. Concerns over health and fitness, however, did not reduce the Scots' image as classic shock troops, with the result that a disproportionate number of Scottish regiments were thrown into bloody assaults on German positions. By 1918, some 100,000 Scots, 18,000 from Glasgow alone – over 13 per cent of Britain's total war-dead – had perished. Urban Scotland lost one in 54 of adult males while some rural areas lost as many as one in 27. Although casualties amongst the officer class was a fraction of those among the enlisted men – some 7,000 officers to 93,000 privates and NCOs – the impact on the small Scottish middle and upper classes was devastating. For the working class, most families lost a member, and in some rural areas the slaughter of a generation of youth accelerated the disintegration of traditional communities.

The impact of the Great War on Scottish society can never be underestimated, but in one area its consequences have been greatly overstated. As men were recruited or conscripted, their civilian roles fell to women. Before 1914, female workers were confined largely to the textile and clothing industries, domestic service and, to a lesser extent, teaching and shop-work, but after August 1914 they moved into former exclusively male occupations. It was not just the munitions industry that employed women, but also engineering workshops, the railways, and other public services. Female trade union membership burgeoned, and along with it female militancy. Women featured prominently in the Clydeside rent and industrial strikes of 1915–17, giving voice to deep social concerns that underlay the 'Red Clydeside' phenomenon. It has been argued that women's higher economic and social profile in the 1914–18 era transformed their role and status forever, but demobilization in 1918–19 saw men reclaim their former positions in the workplace. After 1918, female employment was once again restricted largely to those sectors in which they had dominated pre-1914. The War may have hastened the granting of suffrage to women – albeit only for those over thirty (equal voting rights for women came only in 1928) – but it had not resulted in any permanent shift in their economic and social horizons.

NCOs of the 92nd (Gordon) Highlanders, *c.* 1880. Military recruitment, despite popular myth, was not viewed by many working-class Scots as a means of escape from their environment. Indeed, before 1900 many 'Scottish' regiments contained high percentages of non-Scots, especially Irishmen.

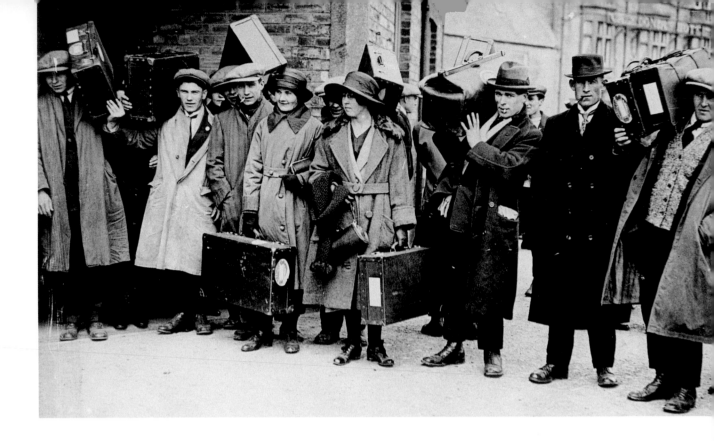

Emigration was the most favoured route to economic betterment for many Scots. The forced emigration of the early nineteenth century from the Highlands was only part of a much larger voluntary movement that carried hundreds of thousands of Scots to every corner of the Empire. There is little sign of regret or anxiety in the faces of these Islanders waiting to board the SS Metagama at Stornoway in the early 1930s.

Another 'traditional' aspect of Scottish life that changed temporarily with the War was emigration. By the 1880s, the chief concern over the level of migration had been not population loss in general but the draining away of particular social segments. Lacking their elders' deep emotional attachment to the land, even after the passing of the 1886 Crofters Act there were few incentives to encourage younger Highlanders to remain at home. Most migrants were young adults, the able-bodied workers on whom the future of all

communities depended. They left behind an increasingly aged society trapped in a vicious demographic circle of poverty and ill health. Such problems for both Highland and Lowland Scotland were compounded after 1918 when many demobilized soldiers, disillusioned with post-War Britain's inability to deliver prosperity and security, chose emigration over social dislocation and economic depression. By 1930, around 10 per cent of the workforce had emigrated to Australia, New Zealand or North America, and it was only the economic

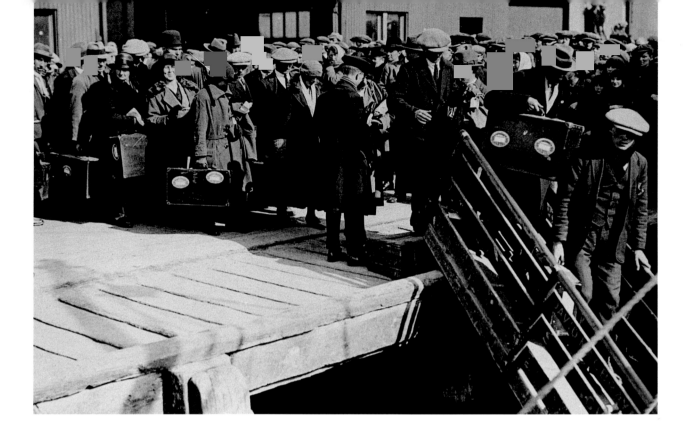

Emigrants embarking at Stornoway, 1930s. Despite the land reforms of the late 1800s, the economic decline of the Highlands and Islands continued in the twentieth century and drove many Scots, especially the young and ambitious, to seek new lives abroad.

crash and global depression of the early 1930s, followed by the Second World War, that stemmed the flow, not any increased opportunities at home. After 1945, the slow haemorrhage of Scotland's people resumed.

An obsessive focus on Scottish emigration obscures the fact that Scotland gained from immigration throughout this period. The largest migration was Irish, at first seasonal transients, then, from the 1840s, permanent settlers. By the 1850s there were over 250,000

Irish in Scotland. Early waves, largely of unskilled Catholic peasants, came from Ulster, but after the Irish Famine migrants came from all over Ireland. There was little friction between Scots and Irish until the explosion of immigration in the late 1840s, when newcomers were viewed with suspicion, resentment and hostility by working-class Scots who feared for their jobs, and by a middle class who considered their culture and religion a threat to Scotland's Protestant values and traditions. Irish distinctiveness was accentuated by a tendency to

Scottish emigration to Canada began in the late eighteenth century and Scots formed one of the largest immigrant groups to the colonies there throughout the 1800s and early 1900s. Emigrants kept in regular touch with 'home' and encouraged other family members to join them through sending photographs. This shows one of the Comrie brothers from Fowlis Wester in Perthshire, sent from Canada *c.* 1910–20.

gravitate towards industrial areas, where they formed substantial communities. Their identity was further reinforced by their Catholicism, on the back of which the tiny Roman Catholic Church transformed itself into a large and sophisticated machine. A separate school system consolidated the distinct Irish Catholic identity and papal decrees against Protestant–Catholic intermarriage impeded integration. The result by about 1900 was the creation of an introverted community within working class Scotland. Loyal war service in 1914–18 promised to break down old barriers, but strong attachment to Irish Nationalist politics after 1916 instead re-inforced divisions. In a Scotland rocked by

the slaughter in the trenches and subsequent economic collapse, a distinct 'alien' element was a focus for fear and prejudice. Between 1918 and 1939, despite the Irish Catholic community's embracing of mainstream politics, sectarianism fed on national insecurity and, although the economic recovery of the late 1930s and the outbreak of war in 1939 removed the underlying factors of tension, institutional anti-Catholicism remained entrenched and full integration was delayed until the late twentieth century.

From the 1870s onwards more exotic immigrants began to arrive. Although few in

Large numbers of emigrants headed south. Scots farmworkers carved niches for themselves in the developing sheep- and cattle-ranches of the southern hemisphere. Robert Harper from Caithness (known as 'Robbie the sheep shearer') found a new life in Rio Gallegos, Patagonia, *c.* 1908 (right), while others headed for Australia (below) and New Zealand, where their expertise was much sought after.

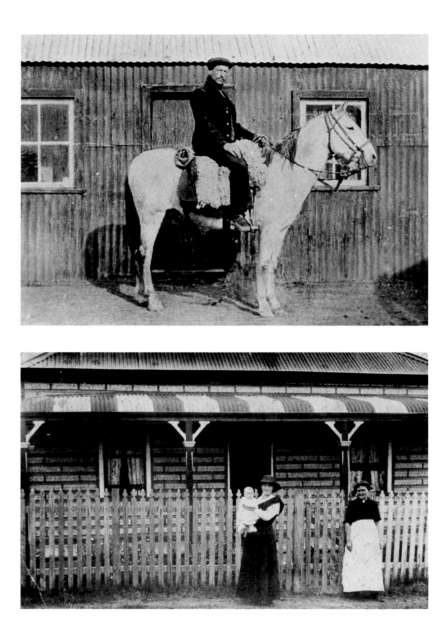

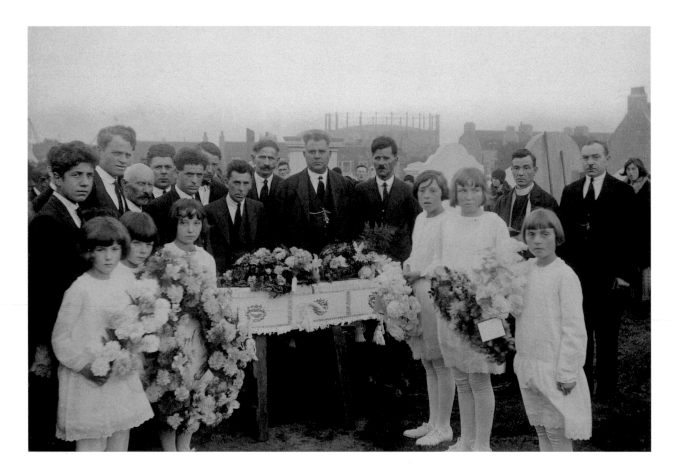

Italian immigration to Scotland peaked in the 1920s. Although few in number and more easily accommodated than Irish immigrants, their adherence to distinctive Italian custom and traditions, such as displayed in this child's funeral *c.* 1930, slowed their integration with Scottish society.

For some immigrants, Scotland was a land of opportunity where their particular skills enabled them to occupy niche positions and achieve prosperity. Aspiring Jewish families encouraged their sons to enter the medical and legal professions (below left), while the families of Italian shop- and café-owners enjoyed the trappings of commercial success (below right).

comparison to the Irish migration, these newcomers added a further dimension to the Scottish population and, in the long term, had an impact disproportionate to their number. Lithuanians and Poles, who moved mainly into the coalfield communities and iron-working trades, for a time attracted the employment-centred suspicions focused formerly on the Irish and endured ostracism from the communities within which they had settled. Within a generation, however, while main-taining some identity through aspects such as the wearing of national dress at religious festivals, they too had integrated with the Scottish working class.

A small Jewish community, mainly from Germany, was established in Edinburgh by the early 1800s, but Russian pogroms in the 1880s and 1890s brought new immigrants from the eastern Baltic. The early Jewish community was composed largely of merchants and successful businessmen, but the new-comers were often from humbler backgrounds and sought employment in the industrial centres of Dundee and Glasgow. There was a great polarization in wealth within the community, with the first generations of the late nineteenth-century migrants gravitating into low-paid trades – especially textiles – and poor working class areas: by the 1920s, there was a Jewish population of

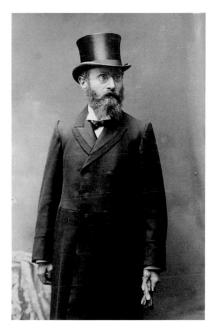

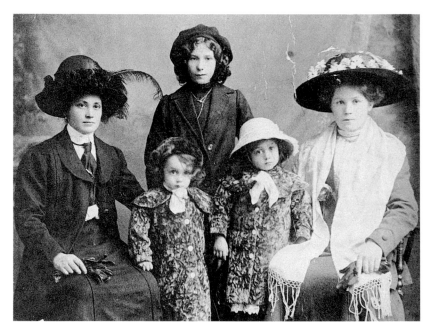

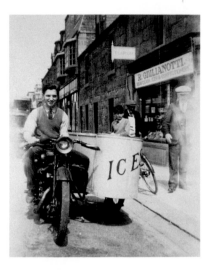

around 20,000 in Glasgow's notorious Gorbals slums. In a community that placed great store by learning, education offered one avenue of escape from poverty, but for others – of whom Emmanuel ('Manny') Shinwell was the most prominent – the answer lay in radical socialist politics.

The final substantial immigrant group were the Italians, who began to arrive in numbers after about 1890. By 1914, there was a small, tightly knit, yet at the same time dispersed, Italian community settled in the major cities and most provincial towns. Many came from the non-industrial south of Italy or from rural villages in the north, and maintained their distinct regional identities in their new environment. It would be a gross caricature to label all these migrants as ice-cream parlour and fish-and-chip shop owners, but many did carve a niche for themselves in catering, providing Scots with their first taste of what is an enduring national attraction to 'fast food'. This specialization dictated dispersal rather than concentration in distinct communities, although about 3000 out of roughly 5500 Italians in Scotland by 1939 were settled in Glasgow. This dispersal and focus on businesses where there was no pre-existing Scottish equivalent helped the Italians to avoid much of the hostility that the Lithuanians, Poles, and Irish before them, had encountered. Nevertheless, their failure to integrate fully with Scottish society and their maintenance of a strong, Italian identity brought violent repercussions when Mussolini declared war on Britain in 1940.

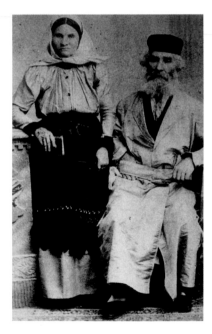

First-generation immigrants often found it difficult to integrate, clinging to the fashions and traditions of their native cultures, like this elderly Jewish couple from the eastern Baltic, *c.* 1890 (below left). Others outwardly embraced their new environment and its commercial opportunities. The 'Tallies' capitalized on the Scots' notoriously sweet tooth as providers of ice cream (above left).

An elderly musician (opposite) poses for the photographer, probably in return for a payment. Hard work did not always guarantee prosperity and security, and old age for many Scots brought grinding poverty and dependence on cold charity.

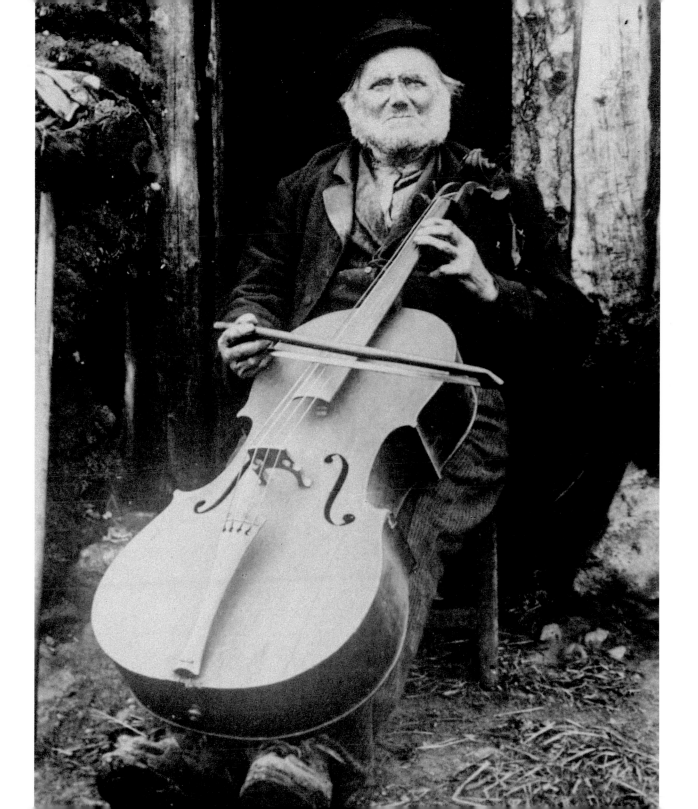

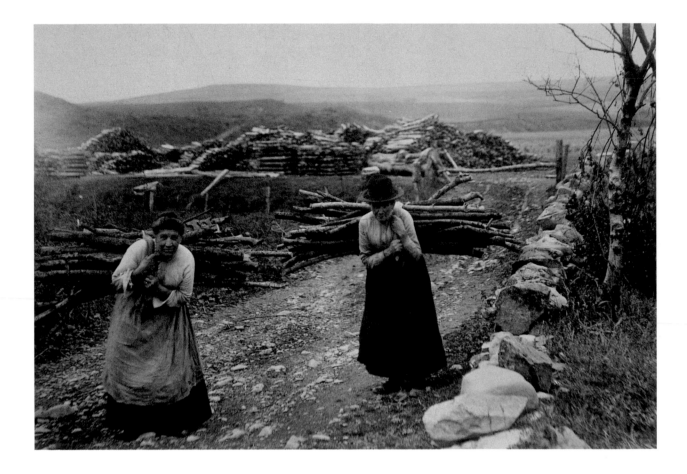

Old age usually did not bring comfortable retirement for those without families, or whose children would not or could not support them. Self-help was a virtue in Scottish culture, and these elderly women carrying off-cut branches from the lumber-yard, either for their own use or to sell as firewood, would have been seen as independent and self-reliant rather than viewed as living on the margins of society.

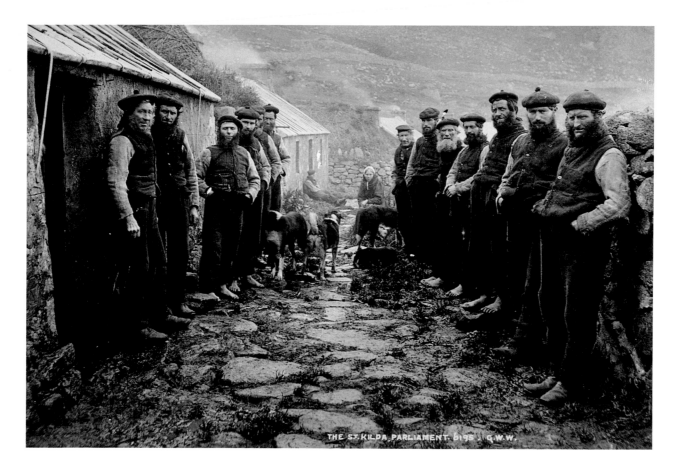

THE ST. KILDA PARLIAMENT. 6195 G.W.W.

St Kilda, 'The Parliament', *c.* 1880.
Many Victorians saw St Kilda, the
remotest of the Hebridean island
groups, as home to an archaic form
of Gaelic culture that had largely
escaped the influences of contemporary
society. A council of male elders – the
'Parliament' – made decisions on behalf
of the islanders. St Kilda's population
went into rapid decline in the later
nineteenth century and dropped to
an unsustainable level in the 1920s.
At their own request, the remaining
inhabitants were evacuated in 1930.

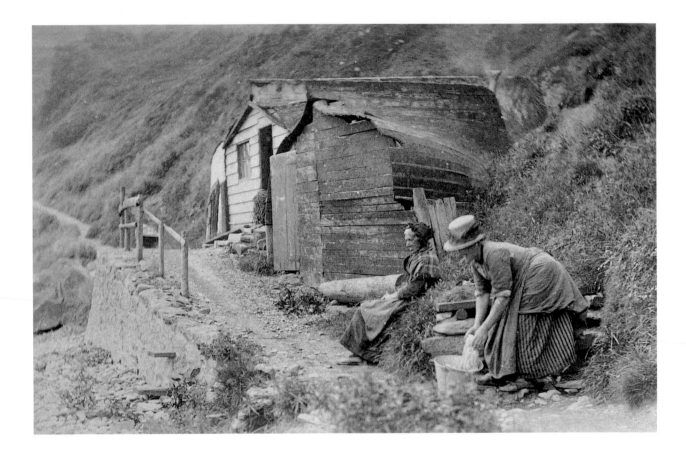

Thrift and recycling were further 'virtues' required of many of the rural poor. For an East Coast fisherman and his family, a boat that has reached the end of its sea-worthiness could find a new use as home and store-shed. Such quaint scenes, photographed for their picturesque curiosity, disguised the marginalized existence of the poorest members of society.

Itinerant tradesmen (opposite) were common figures in the towns and countryside of Victorian Scotland, bringing goods and services right to the door. For many, however, the tools they carried with them were all that stood between survival on the economic margins and destitution.

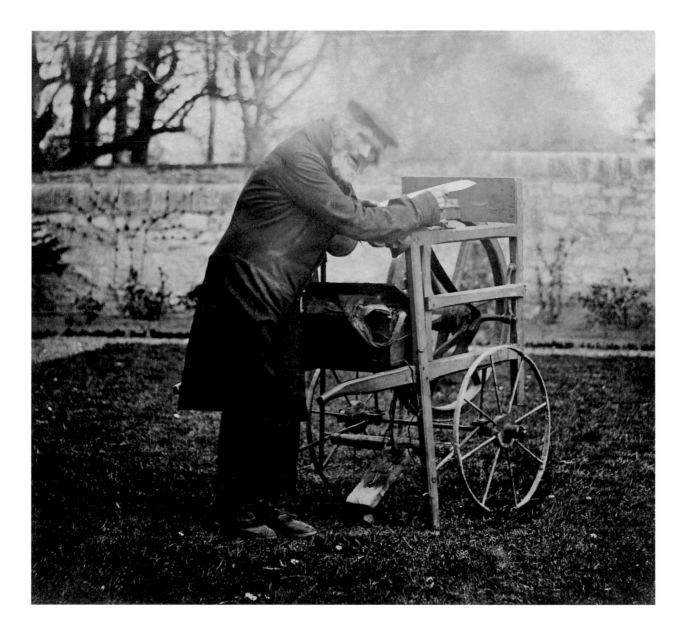

Victorian photographers looked
for diamonds amongst the dross.
(below) Here a young Shetland
woman's beauty contrasts with the
physical burden of her peat-laden
creel under which she bends, while
in the picture of the young woman
pouring pickling brine into a herring
barrel (right) it is her work-worn and
fouled hands that form the focus of
the image rather than her face .

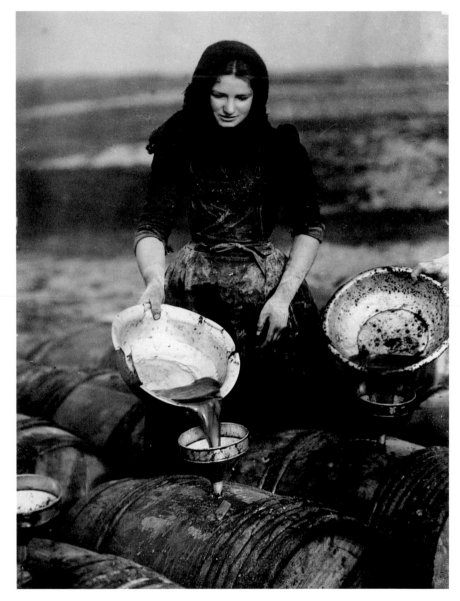

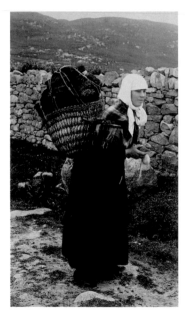

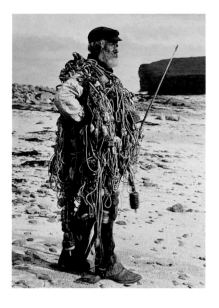

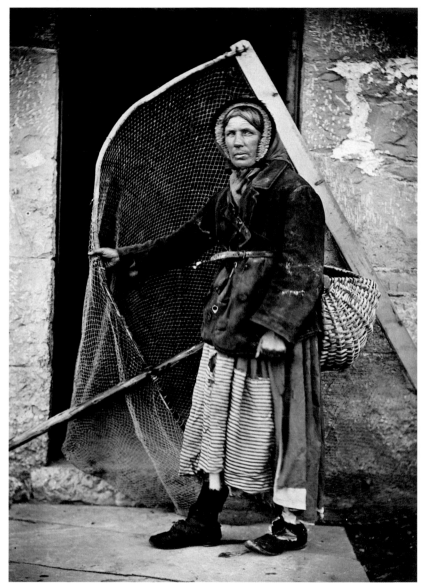

Exploitation of inshore waters provided a small income to a large number of Scots. Line-fishing (above) and shrimp-netting (right) required little by way of capital investment, but both were gradually squeezed out by the steady expansion of commercial fishing after *c.* 1880.

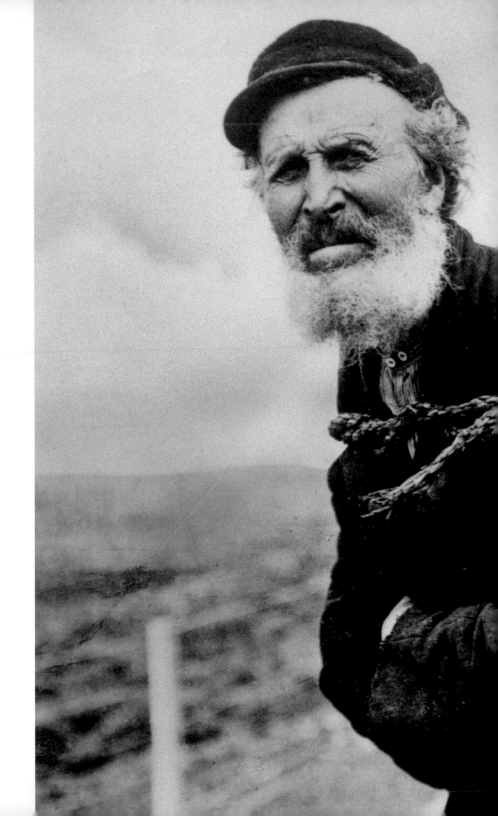

A celebration of the nobility of rural labour: a peat carrier in Shetland in the early twentieth century. In most of the Highlands and Islands, peat was the main fuel type into the later twentieth century. Peat-cutting was usually a community activity, as it could take one man working full-time for a month to cut and transport sufficient to last for a year. By the 1800s, most peat banks were distant from settlements – in some Shetland communities they were on different islands – and the transporting of cut peats was an arduous task.

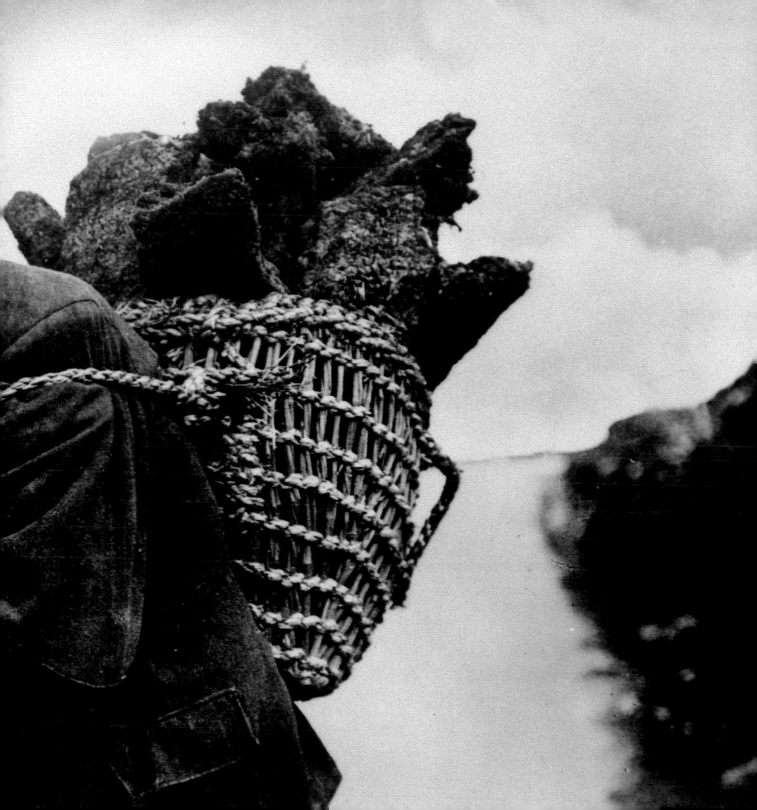

Dress and demeanour reveal the
social class of the sitter. The Misses
Binny (right), *c.* 1865, and the
unidentified women (below) display
the confidence and trappings of
middle-class affluence.

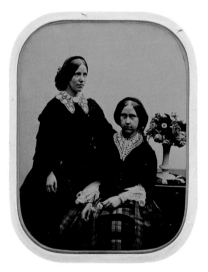

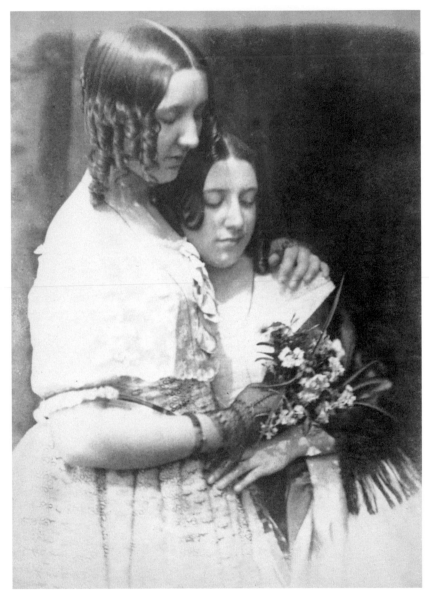

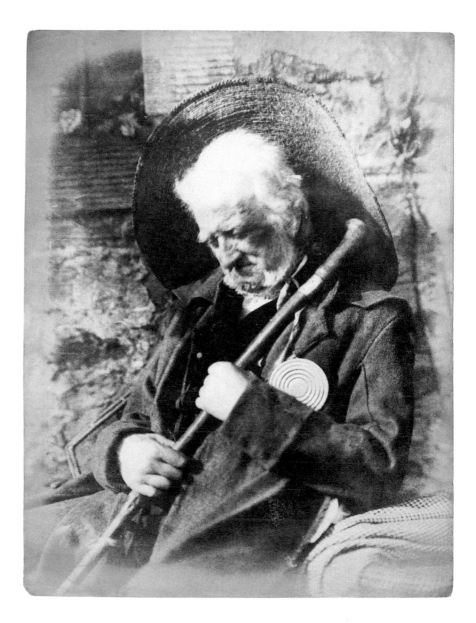

Photographic portraits, as produced by David Hill and Robert Adamson in the late 1840s, brought portraiture into the financial reach of many less affluent Scots but was at first a luxury affordable only by the rich. Hill and Adamson, however, also experimented with the composition of portraits and sought strong subjects, such as this elderly gentleman, to sit for them.

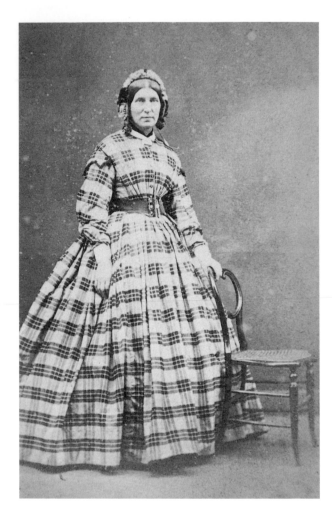 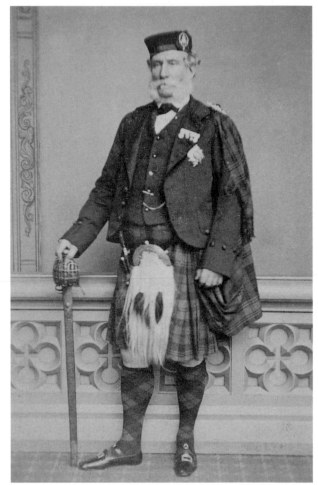

Portraits – lady in tartan dress and gentleman in Highland regalia with sword. Portrait photography boomed in the later nineteenth century as process costs fell, making it affordable to even working-class customers. Formal photographs were especially popular with the middle classes, for whom traditional portrait painting was still prohibitively expensive.

Telegram boy, *c.* 1880. Pride in status was not restricted to the elite. Civic officers and civil servants posed for portraits in their uniforms and with the symbols of their occupation.

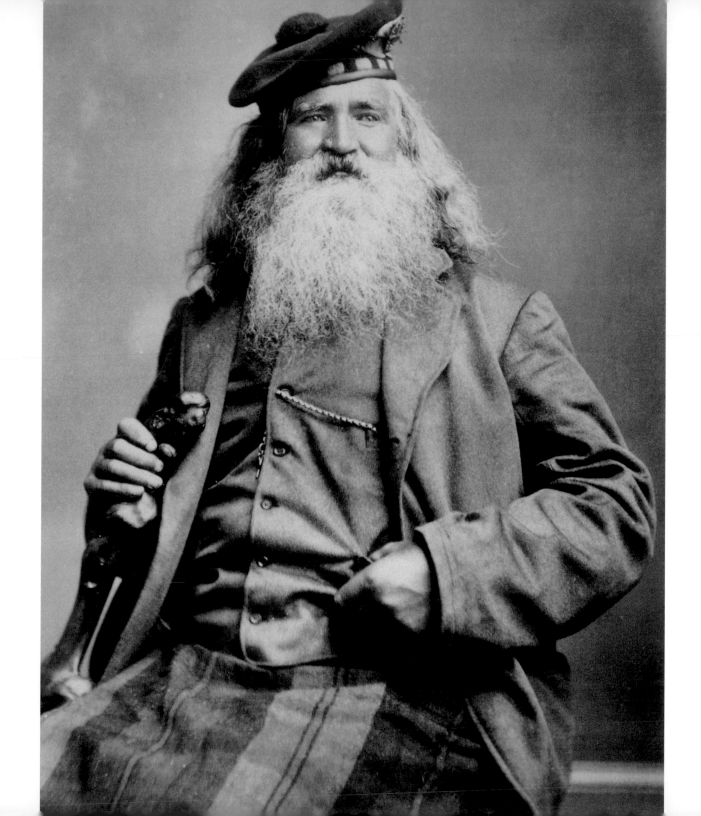

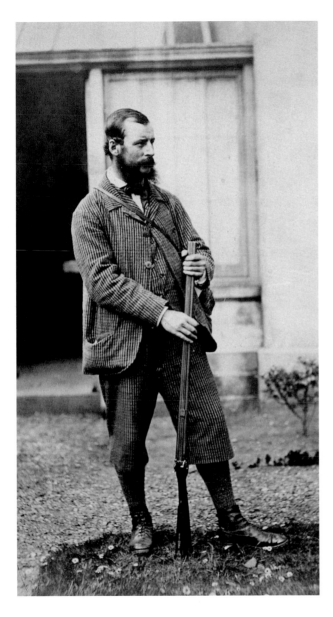

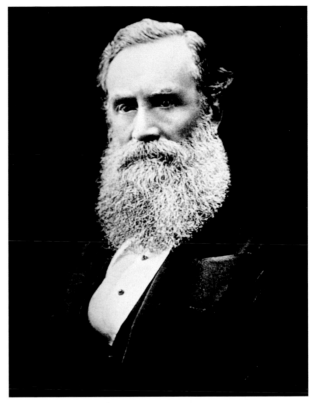

Images of famous sportsmen and other prominent Scots were circulated widely. The skill of ghillies and anglers, such as Will Duff on the Spey (opposite), *c.* 1880, established fly-fishing as a game-sport for the middle and upper classes. Colonel Lord Alexander Rupell (left) was a respected sportsman and marksman. William Teacher (above), founder of the Kilmarnock-based whisky blenders and bottlers, personified the successful Scottish businessman.

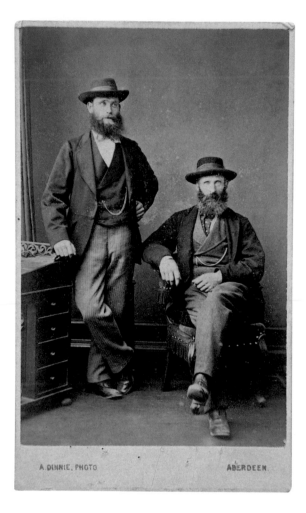

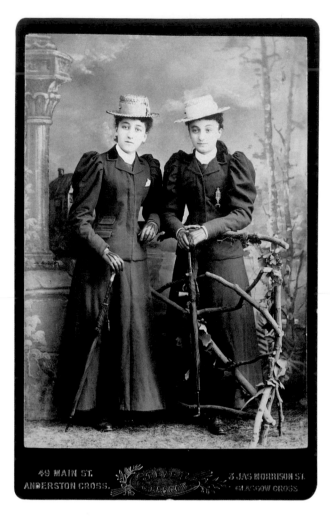

The small format of the *cartes de visite* photographs made them a highly popular genre with all social classes. They could be produced in numbers and given to family and friends, sent cheaply through the post, and used as keepsakes and mementoes.

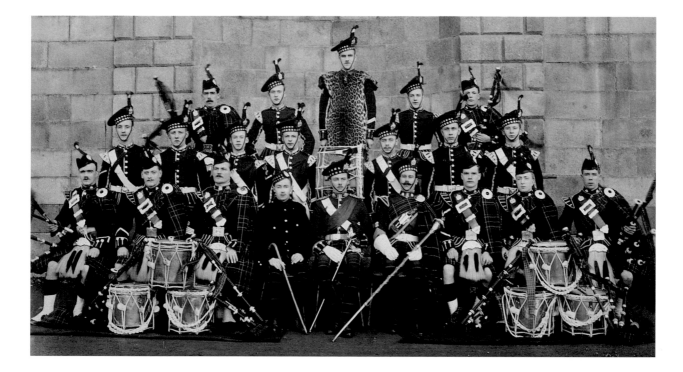

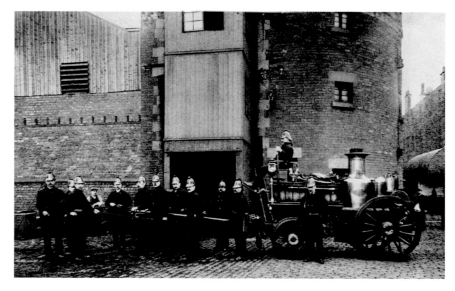

Early group photography carried the same posed formality as the portraiture. The stiff bearing of the military pipe band (Gordon Highlanders, *c.* 1890, above), however, had been replaced by greater casualness in the brewery fire-brigade group (*c.* 1910–20, right).

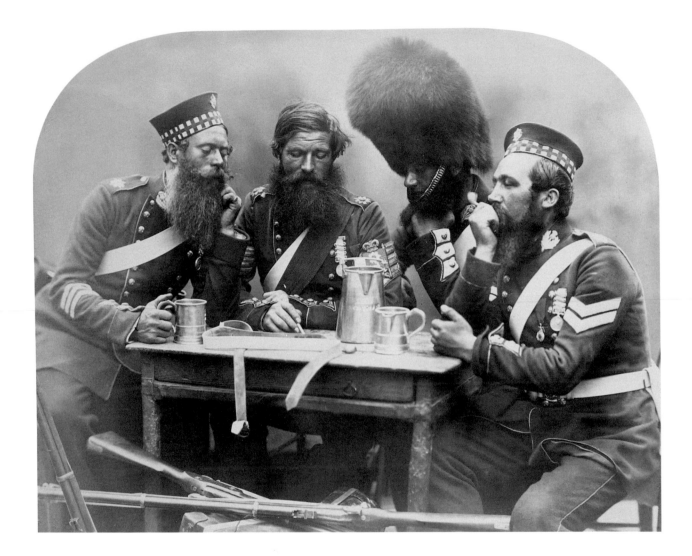

NCOs, Coldstream Guards, *c.* 1860.
Military service was a prominent
aspect of Scotland's role in Britain's
imperial adventures. This image,
commissioned for Queen Victoria,
lionized Scottish heroes of the
Crimean War.

Pipers, Gordon Highlanders, *c.* 1890
(right), drinking whisky from buckets
at New Year, encapsulate the hard-
drinking ruggedness of the Highland
warrior, an image cultivated by
the Army and set in the public
consciousness at home and abroad.

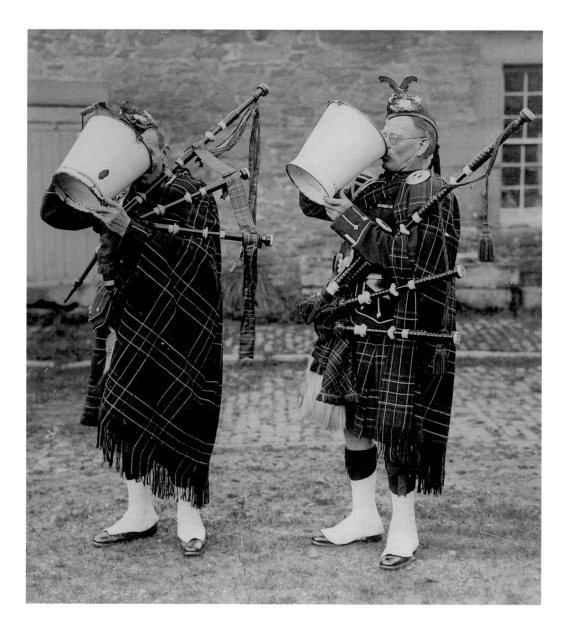

chapter 2

places

(above) **Mons Meg, Edinburgh Castle**, 1843. One of the earliest surviving calotypes by Scottish photographic pioneers David Hill and Robert Adamson, this image of the medieval cannon typifies the photographers' interest in the symbols of a turbulent but rich past. Scotland's archaeological heritage, such as Broch of Mousa, Shetland, photographed *c.* 1880 (opposite), provided a wealth of subjects for photographic pioneers.

The Scotland captured through the lenses of the early photographers was a country of contrasts and extremes. Their images are of a land and a society at once seemingly immutable but also caught in a state of permanent flux. The landscapes offer a sense of timelessness, of untamed nature, representing the idealized romantic view of a world in which man's efforts could be dismissed as transitory and feeble in comparison. On the other hand, the cities offered the opposite view, representing human mastery over Nature. Throughout, however, there is clearly acute awareness of the costs of that achievement in terms of human suffering and, to an extent, environmental degradation.

Photographic images of nineteenth- and early twentieth-century Scotland are imbued with a powerful sense of place. That locational sense is, moreover, saturated with an equally powerful sense of time. The development of photographic technology in the 1840s coincided with a re-awakening and heightened awareness of the rich historical legacy that surrounded the modern Scots. Art, architecture, literature and even politics woke up to the potential of the past to enrich or empower the present. Antiquities were photographed not only for the compositional qualities of the scene, although the play of light and shadow in the semi-natural forms of Scotland's prehistoric monuments and the architecture of its many ruined medieval monasteries and castles, allowed photographers to demonstrate their observational and technical skills, but were used to capture a sense of history, to encapsulate the depth of time to

Although the absolute antithesis of post-Reformation Scotland's dour Calvinism, Victorian architects drew inspiration from the exuberance of medieval Catholicism represented by Roslin Chapel, Midlothian (below), and (opposite) the High Kirk of Edinburgh (St Giles' Cathedral), both photographed *c*. 1890.

be seen in the Scottish landscape. Historical subjects – the burial places of Scotland's heroes, battlefields, castles and churches – gave texture to the rich heritage that Scots were re-discovering in the later nineteenth century and an added resonance to their new role as partners in Empire. For many Scots, the images of place and time reinforced their identity in a world of expanding horizons.

Cities and towns represent one facet of the Scottish image, and it is a side with its own contrasts and subtleties. Glasgow, by 1911 revelling in its self-awarded status as 'Second City of the Empire', was a brash, bustling metropolis of a million souls, dominating Scotland's domestic and export economy, but riven by social extremes and home to growing political radicalism and religious sectarianism. It was a city of divisions, most based on wealth. By the 1840s, the city's elite had almost completed their drift into the spacious new western suburbs, abandoning the historic core of eastern Glasgow to the poor. Already by the 1830s, the area framed by the High Street, Saltmarket and Gallowgate was a warren of slums into which upwards of 20,000 people were crowded, a figure that climbed yearly as fresh waves of migrants sought the city's cheapest housing. Crime and disease walked hand in hand with poverty and squalor. Glasgow suffered heavily in the epidemics of typhus and cholera that struck Scotland between 1832 and 1866, but – once it was recognized that the linked problems of poverty

and health were social and economic rather than moral issues – it also led the way in initiatives to improve public health. The municipally funded water-supply system, which piped fresh drinking-water from the Trossachs to the city, was completed in 1859, but it was not until 1894 that Glasgow stopped dumping its sewage into the Clyde. Fresh drinking-water offered only a marginal improvement in what was a chronically pol-luted environment. In the 1870s, the problem of the worst slum housing began to be tackled, with extensive clearance in the most overcrowded areas of the old city. But the demolitions only shifted the problems elsewhere, and in place of the Saltmarket and Trongate slums there emerged the notorious Gorbals. More than any other single factor, it was the acute overcrowding in Glasgow's slums that brought Government intervention in the post-War years, starting with the Housing and Town Planning (Scotland) Act in 1919. This started a process in Glasgow, mirrored elsewhere across Scotland, of slum clearance in the inner cities and the removal of population to new council-built housing estates on the peripheries. Hailed as the answer to Glasgow's century-old interlinked problems of squalor, crime and ill-health, within three decades many of these largely single-class areas had become the new ghettoes.

Glasgow dwarfed Edinburgh, which clung on to shreds of its former dignity as capital, but its middle classes dominated Scottish legal,

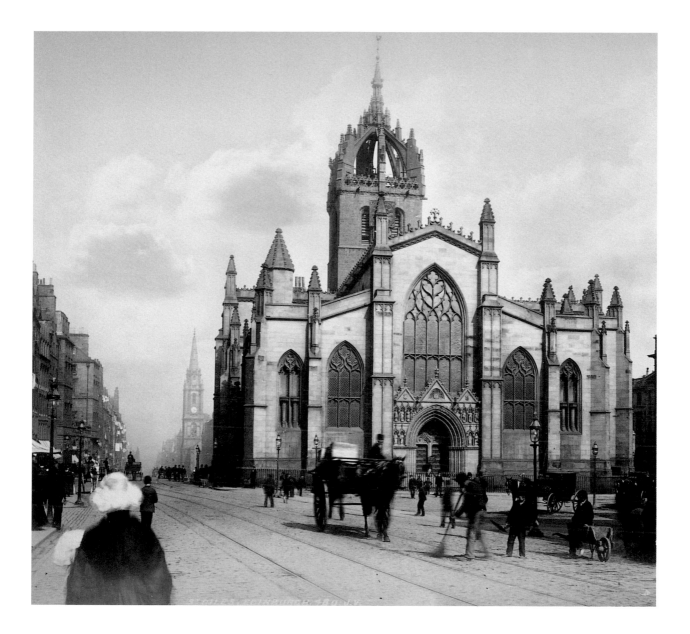

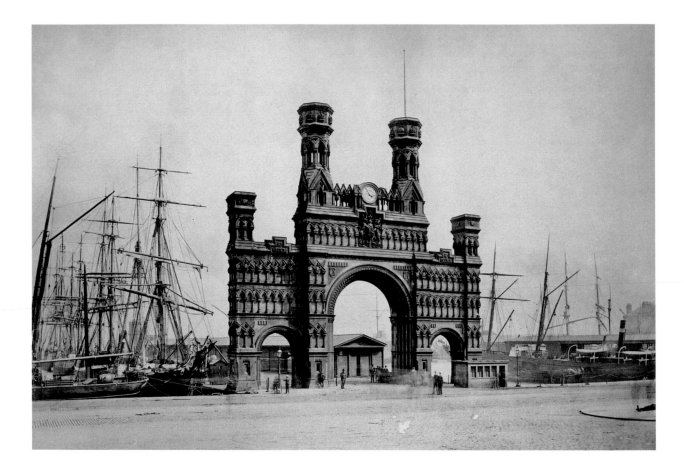

A symbol of civic pride, the Royal
Arch, Dundee, photographed here
in the late 1880s, was built in 1848 to
commemorate the arrival by sea in
Dundee in 1844 of Queen Victoria,
the first monarch to visit the city
since 1650. It was demolished in
the 1960s to make way for the
approaches to the Tay Road Bridge.

A haze of rain and coal-smoke in *George* Street, Edinburgh, early 1920s. Air pollution choked Scotland's major towns in the late nineteenth and early twentieth centuries. Ubiquitous coal fires produced a legacy of soot-encrusted and sulphur-corroded buildings and caused untold damage to the health of generations of Scots.

religious and banking life. Edinburgh was also a city where extremes of poverty and wealth were juxtaposed, seen most strikingly in the squalor of the Old Town that squatted like a noxious vagrant in the midst of the genteel city of parks and squares that had developed to its north and south in the late eighteenth century. Like Glasgow, Edinburgh had its problems of overcrowding, poor sanitation and ill-health, which were again tackled from the late 1860s onwards. Opinions differed over how improvement could be best achieved, with the demolition and transplantation programmes being opposed by those who called for regeneration, conservation and careful planning. Men such as social reformer and urban planner Patrick Geddes argued for integration of residential and recreational areas, and for mixed housing types to avoid social partitioning, but the realities of Scotland post-1918, where economic decline limited the funds available to tackle the nineteenth century's monstrous legacy, ensured that his ideas had little impact.

The Glasgow and Edinburgh experience was reflected across Scotland's other cities and towns. In common with the two major centres, the other communities displayed the shocking contrasts of wealth and squalor that struck so many English and foreign visitors. Slums stood cheek-by-jowl with the grand new civic and commercial centres that were built to display the wealth and power of the

urban elites. In Dundee, the tightly packed, weather-protected heart of the medieval city was ripped out and replaced by broad streets flanked by smart shops and banks, while behind the new facade festered crumbling tenements and foetid closes. Aberdeen, too, sought to sweep away its huddled medievalism, replacing its winding lanes and shelter-offering buildings with the regimented wind-tunnels of uniform grey granite that are the characteristic of the city's later nineteenth-century townscape. From Lerwick to Wigtown, it was a regularly repeated pattern.

In the countryside, too, extremes confronted the visitor everywhere. The close medieval relationship between lord and people had been progressively strained until finally broken in the later eighteenth century as the nobility sought to sweep away the ancient fermtouns that had clustered around their homes. Now, they kept their occupants at arm's length in new settlements located out of sight beyond the boundaries of the formal gardens and parkland with which they chose to surround their homes. Lairds, though, maintained a close control over and interest in the communities that they had caused to be founded, often providing the main public buildings – church and townhouse – and setting down strict rules on the form and layout of other buildings. From Galloway to Caithness, the great landowners exercized tight controls over the many small towns and

villages that had sprung up since the 1780s, enjoying an authority that was to be eroded only gradually by successive local government Reform Acts through the mid- and later 1800s.

By the early nineteenth century, the 'big house' stood in isolated seclusion, screened from prying eyes by carefully planned woodland and high estate walls that encircled their 'policies'. Each was a community in itself, supported by 'indoor' and 'outdoor' staff whose numbers might match those of many small villages. The increasing opulence and scale of these great houses contrasted jarringly with the poverty of the rural labour force, whose homes, once portrayed as part of the rural idyll, were seen increasingly as hovels unfit for human habitation. Social reform was not just a war being waged in Scotland's cities, but was fought out in the rural districts, with reformers seeking to force landowners to provide suitable housing for their workers and so encourage them to stay in the countryside. A chronic shortage of good standard rural housing, however, remained a major problem even after new home-building programmes were set in place in the early 1920s, and many younger families opted to move into the cities. But this was only one side of the coin, for increased mechanization was progressively reducing the need for a large workforce and by the early 1900s rural poverty and unemployment was driving increasing numbers from the land. By the 1930s, the rural society of nineteenth-century Scotland was a shattered fragment of its former self.

Victorian Scotland deluded itself with ideas of its democracy and social mobility, but it was still a land of extremes of wealth and poverty, power and helplessness. Self-confident and aloof, like the young woman on horseback (above), the elite enjoyed a privileged lifestyle, far removed from the squalor of the urban masses.
Queen Victoria's Deeside holiday-home at Balmoral Castle (right), built 1853–55, consciously echoed the architecture of Scotland's ancient nobility, such as sixteenth-century Castle Fraser (opposite), in a bold statement of the ruling elite's continuity of power and wealth from the medieval past.

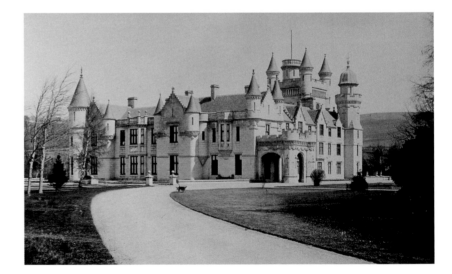

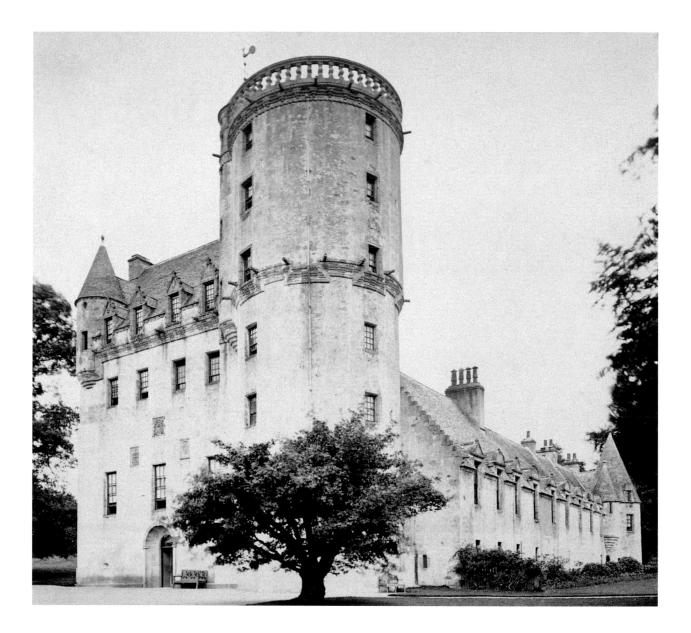

Scotland's richly textured archaeological and historical landscapes were the focus of antiquarian and archaeological endeavour throughout the nineteenth century. A distinctive past, whether from the remote prehistory of the Ring of Brodgar, Orkney (opposite), Columban Christianity, symbolized by St Martin's Cross, Iona (right), or Gaelic culture as represented by the medieval grave sculptures of Iona (below), gave Scotland a unique identity within the expanding Empire.

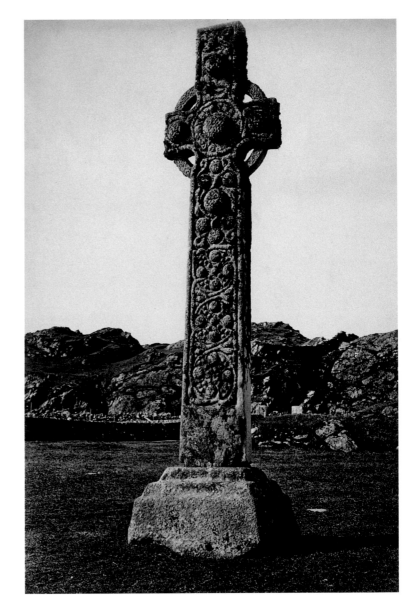

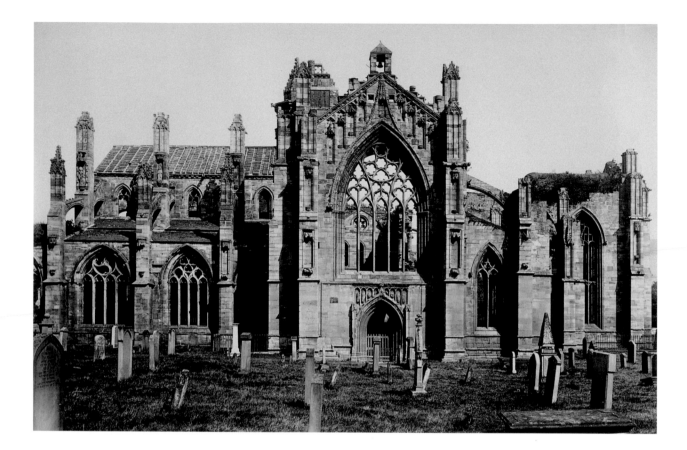

The 'romantic medievalism' of the early 1800s inspired by Sir Walter Scott, which first drew visitors to the ruins of Melrose Abbey (above), was replaced by scientific measurement and systematic recording in the later nineteenth and early twentieth centuries as such iconic symbols of the nation's past were taken into the guardianship of the State.

The architecture of Scotland's medieval past, such as the rhythmical arcades of Jedburgh Abbey (opposite), provided models in architectural pattern-books which were reproduced in new churches, mansions of the elite and 'baronialized' villas of the middle classes.

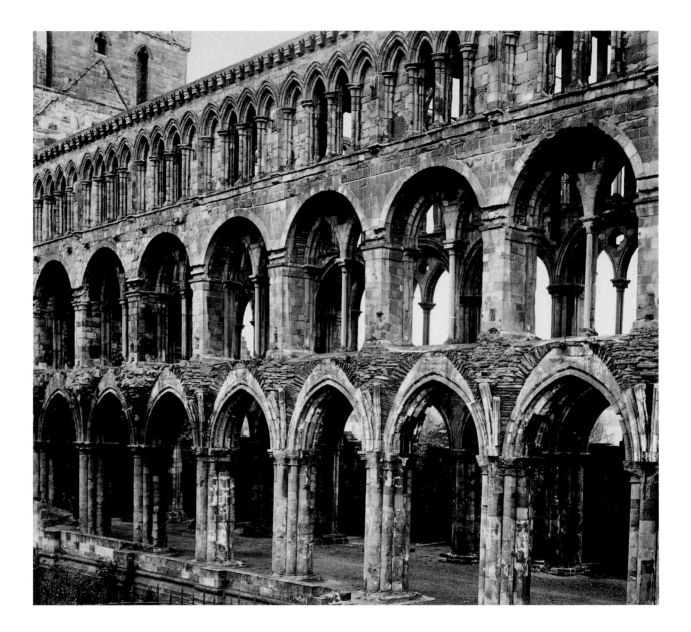

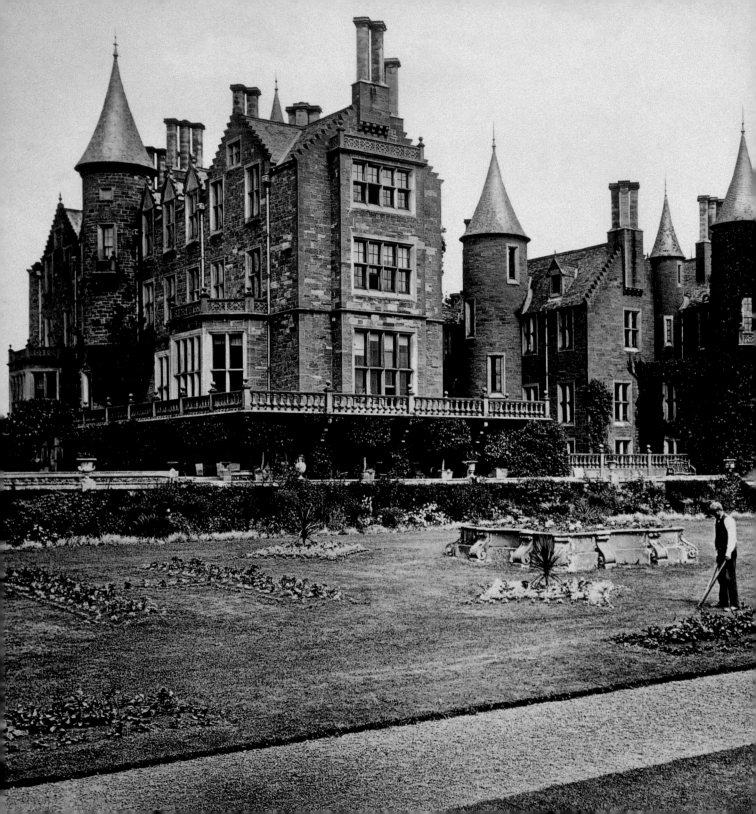

The architectural vocabulary of Scotland's medieval past was plundered for ideas by architects whose patrons, both ancient and noble like the Earl of Haddington at Tyninghame House, East Lothian (left), and nouveau riche, like the Hong Kong opium-trading Mathesons at Ardross in Easter Ross (below), sought the stability, security and status of antiquity in a rapidly changing world.

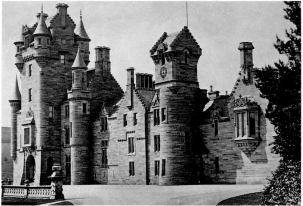

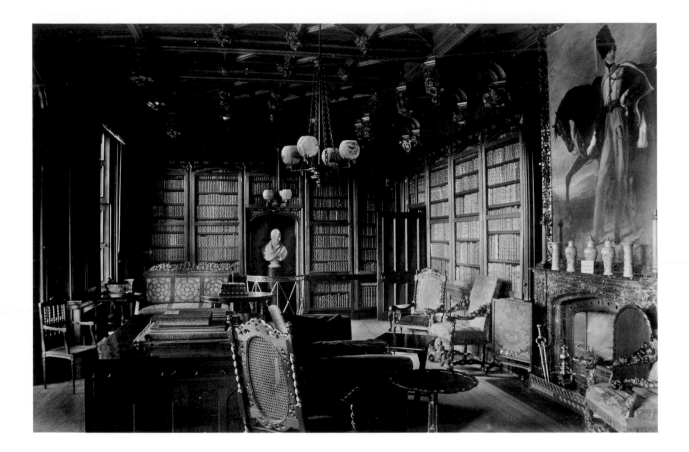

Sir Walter Scott's home at
Abbotsford in the Borders, built
largely in the 1820s, set the fashion
for most Scottish country houses
built during the nineteenth century.
The lavish Gothic interiors, as in the
library (above), provided a model
embraced enthusiastically by the
upper classes.

The great houses of the aristocracy
and gentry continued to function
as the focus of social life for much
of rural Scotland. Their owners, as
heads of great households, as in this
family group photographed near
Stonehaven in the 1880s (opposite),
sought to present themselves as the
heirs of a tradition rooted in the
nation's medieval past.

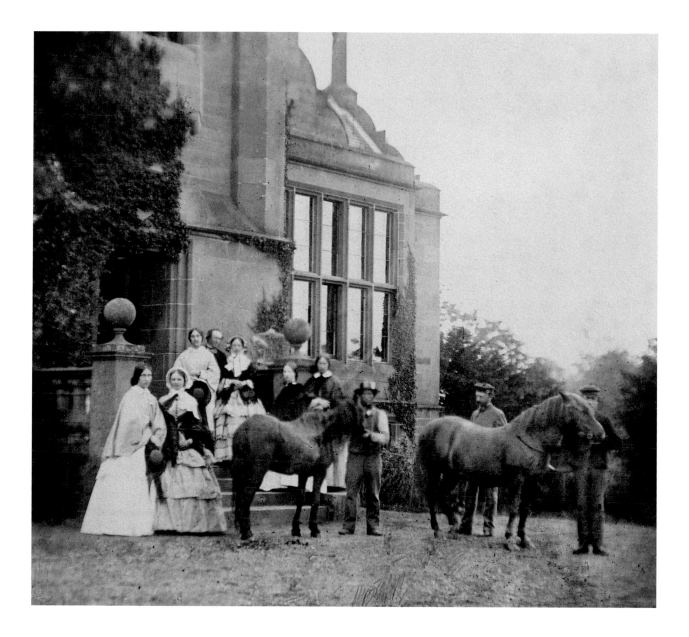

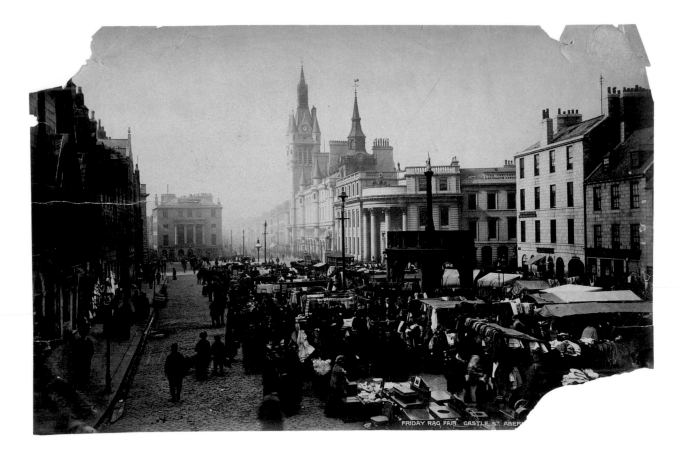

FRIDAY RAG FAIR. CASTLE ST. ABER

Tradition and modernity rubbed
shoulders in Scotland's towns, often
revealing the sharp social cleavages that
still existed. Aberdeen's 'Friday Rag
Fair' in Castle Street, the resort of the
poorer members of the city's population,
photographed here in the 1890s,
clustered around the medieval market
cross. Behind stretches Union Street,
whose smart shops were patronized by
more prosperous Aberdonians.

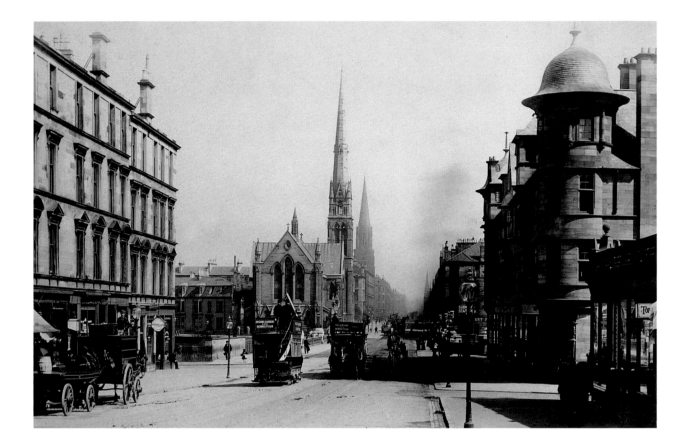

The separation of rich and poor was sharply exposed in cities such as Glasgow, where the middle and upper classes moved out into smart new townhouses and tenement flats, such as these shown here on Great Western Road at Kelvin Bridge in the 1880s.

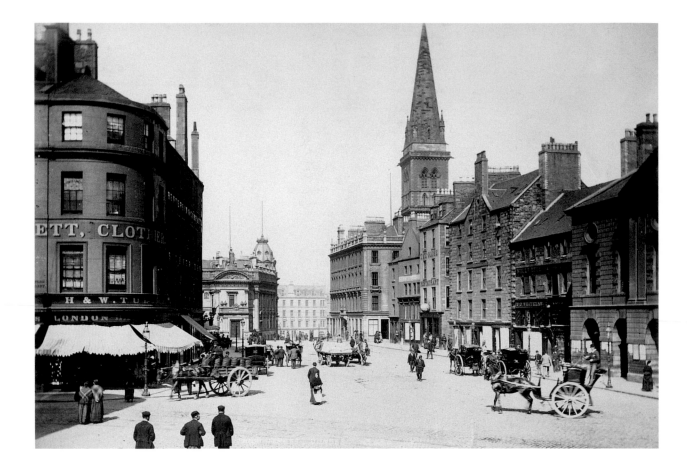

Some cities, such as Dundee, sought
to throw off their links with the past.
By the 1880s, many of the sixteenth-
to eighteenth-century buildings that
clustered around the High Street had
been torn down to create a sense of
light and space, destroying the sheltered
enclosure of the medieval market and
forming a windswept piazza.

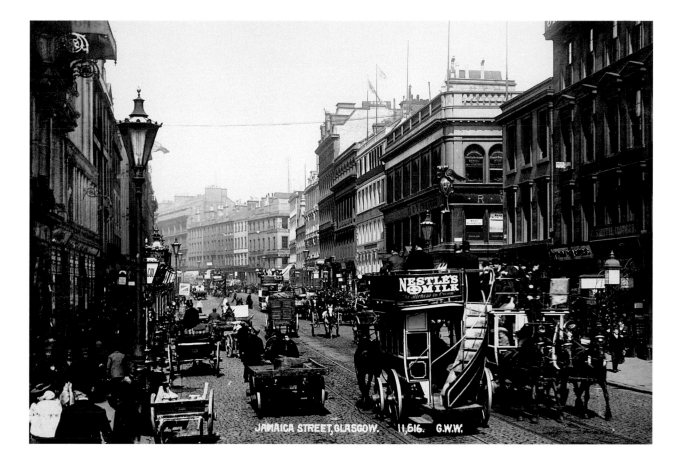

Jamaica Street, Glasgow, *c.* **1890**.
The bustle and noise of the 'Second
City of the Empire' is captured
in this detail-filled photograph
of one of its main commercial
thoroughfares. Even in the pre-
motor car era, the street is crowded
with vehicles, horse-drawn trams,
cabs and goods carts.

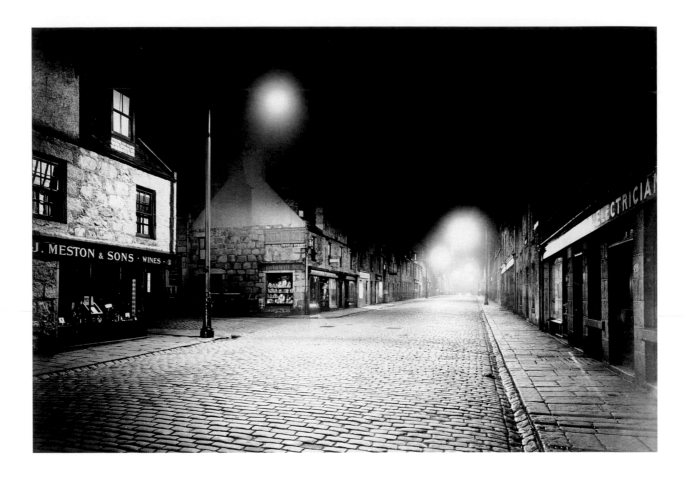

**By the middle of the nineteenth
century** gas lighting had begun
to be introduced in the streets of
Scotland's major towns, being
replaced gradually by electric
lighting in the 1920s and 1930s, as
here in Aberdeen's George Street
(above) and Castle Street (opposite).
The lighting of shop windows, signs
and public buildings, however, was a
late twentieth century phenomenon
and nightfall still brought an end to
most respectable commercial and
leisure activities.

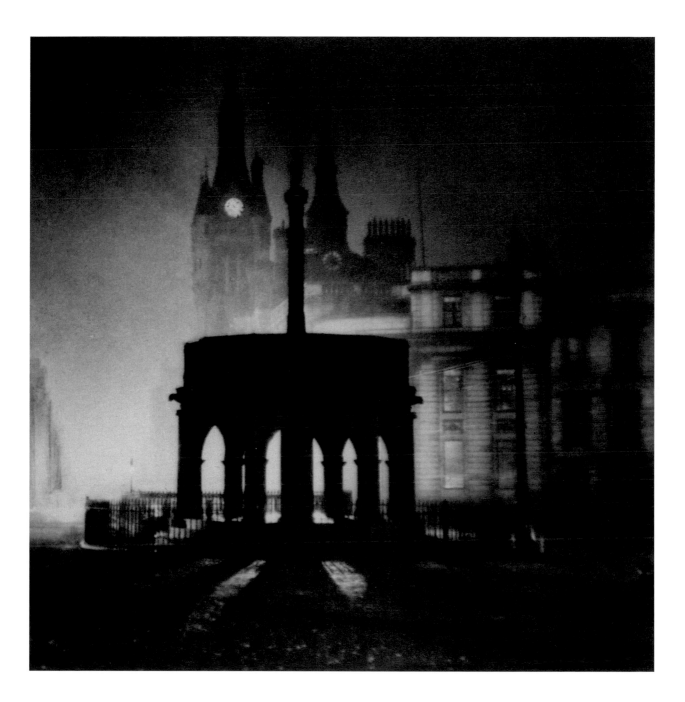

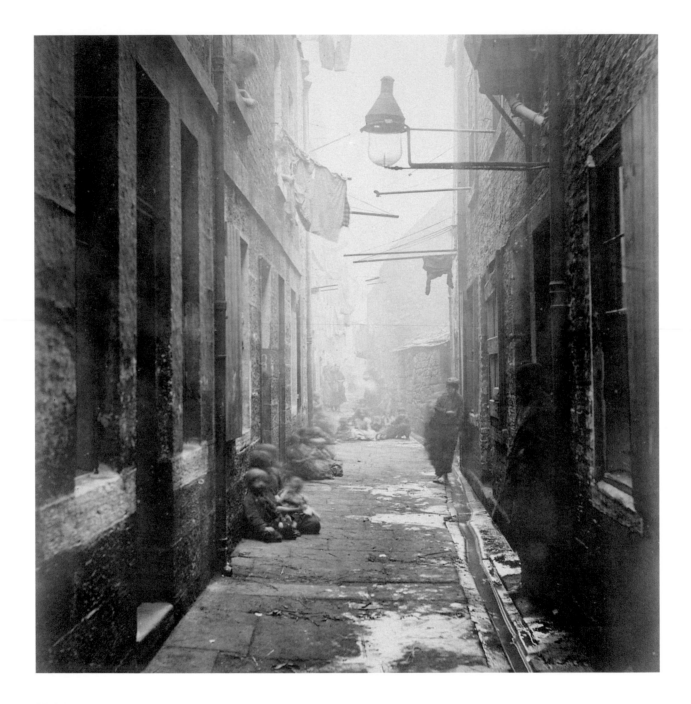

86 places

Little light, natural or man-made, penetrated the gloom of the poorest working-class homes in Glasgow. Photographs such as that of the close at 80 High Street (left) were used by social reformers in the 1870s and 1880s to expose the squalid conditions in which thousands of the city's poorest inhabitants dwelt.

Scott Monument, Princes Street, Edinburgh, *c.* 1845 (right). This Gothic fantasy was the result of a public competition to design a memorial to Sir Walter Scott (d. 1832), who almost single-handedly created the image of romantic 'Celtic' Scotland through his novel writing. To the outrage of the architectural establishment, the winning design, a confection of Gothic pinnacles, buttresses and niches filled with statues of figures from Scott's *Waverley* novels, was produced by a self-taught draughtsman, George Meikle Kemp. Completed in 1846, the monument towers over a Carrara marble statue of Scott by Sir John Steell, the leading Scottish sculptor of the day. One of the most photographed features of the Edinburgh cityscape, this rare image captured the monument as it neared completion.

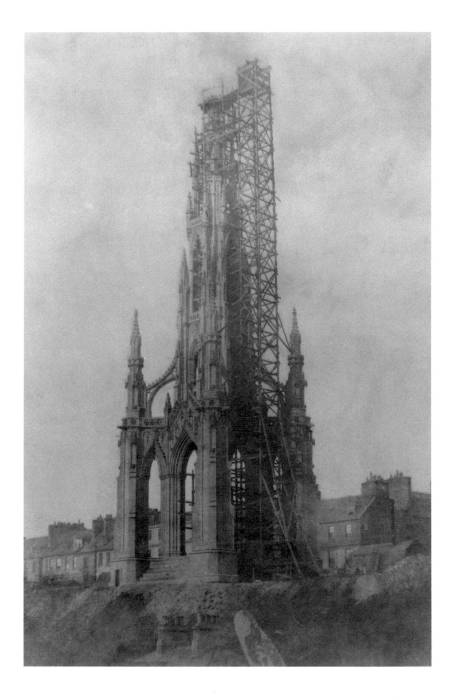

Scotland's historic heart: Edinburgh Castle from the Grassmarket, *c.* 1880 (right). The Castle symbolized state power in Scotland until the return of government functions to Edinburgh in 1938. Its central place in Scottish history ensured its selection as the location for the National War Memorial to the 100,000 Scots killed in the First World War, completed in 1928, and the United Services Museum, established in 1930. (below) John Knox's House, High Street, Edinburgh, *c.* 1880. Religious controversy in the 1840s raised the profile of the sixteenth-century Reformer, with the splinters of the Church of Scotland claiming the legacy of the man regarded as the founder of Scotland's Protestant tradition. Images of the house that bears Knox's name were as common as images of the man himself.

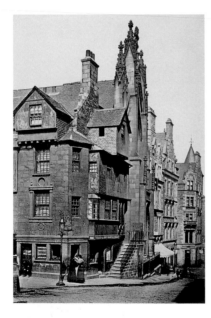

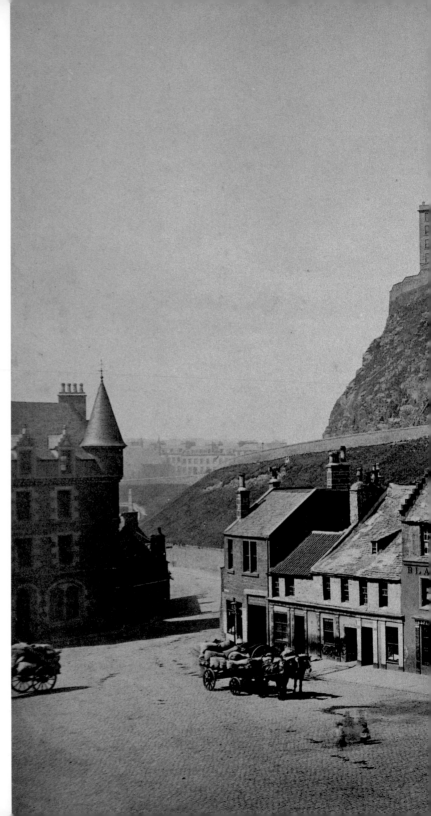

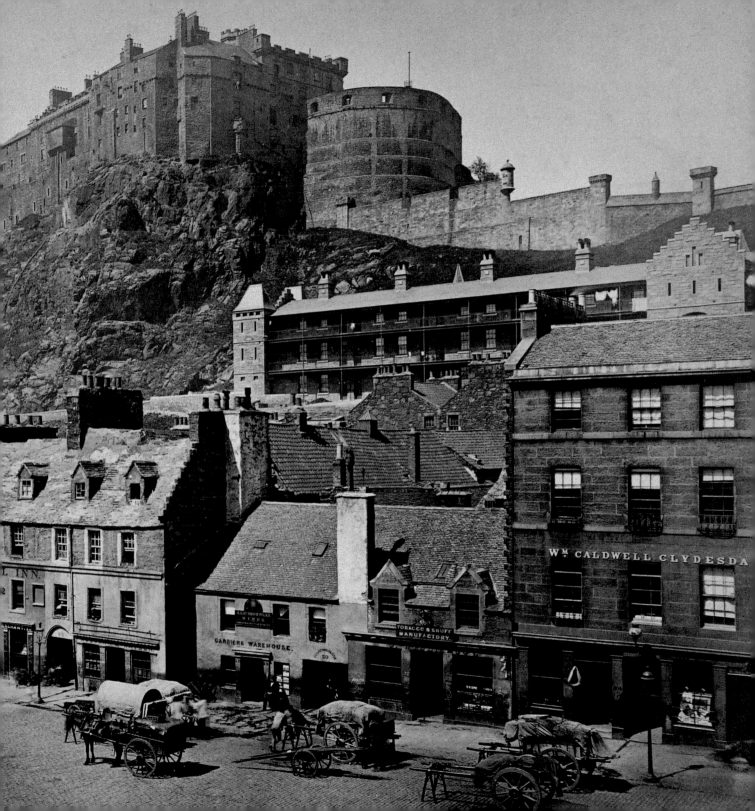

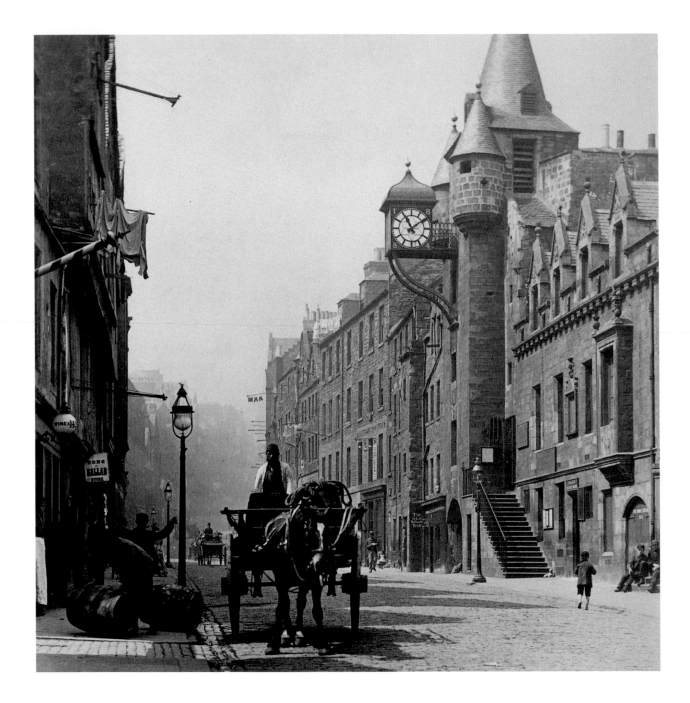

90 places

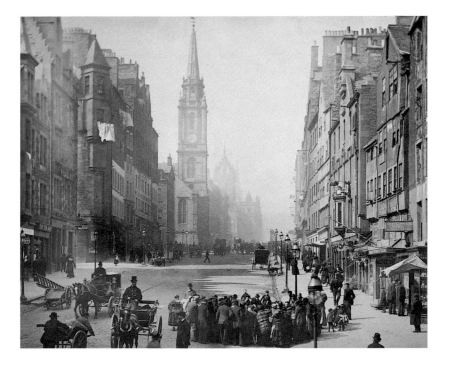

Edinburgh street scenes: (left) Canongate Tolbooth, Canongate, Edinburgh, 1890. From the 1100s until 1856, the Canongate, the lower part of the 'Royal Mile', was a self-governing burgh with the Tolbooth (whose spired late sixteenth-century tower with clock dominates this view), where the burgh council met, at its heart. After the upper classes abandoned the overcrowded Old Town for the elegance and space of the New Town to its north (below right), the High Street (above right) and Canongate degenerated into squalid slums.

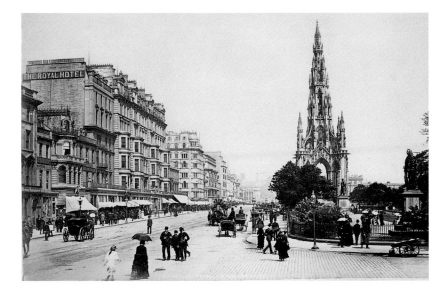

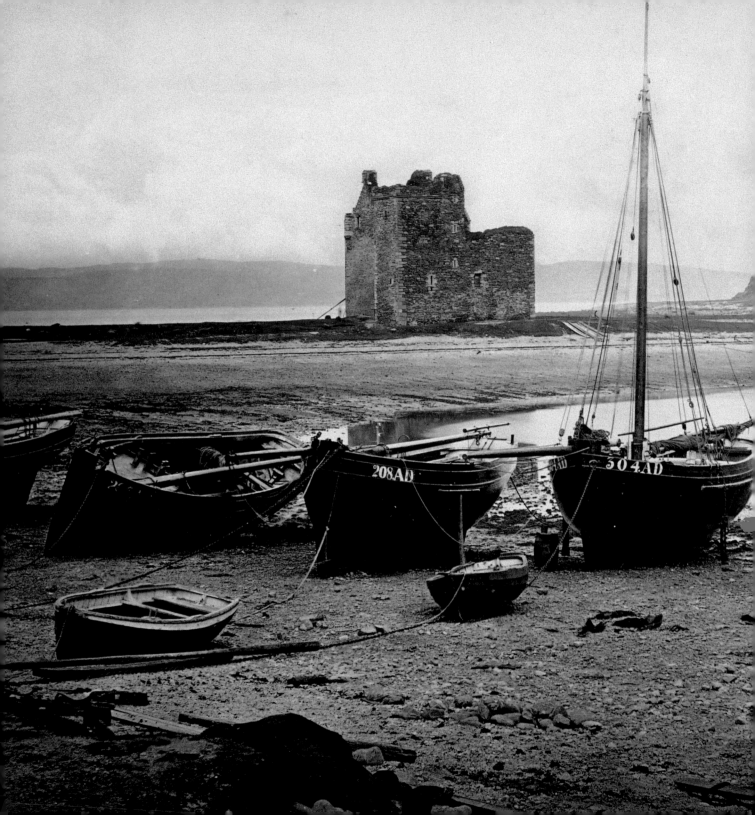

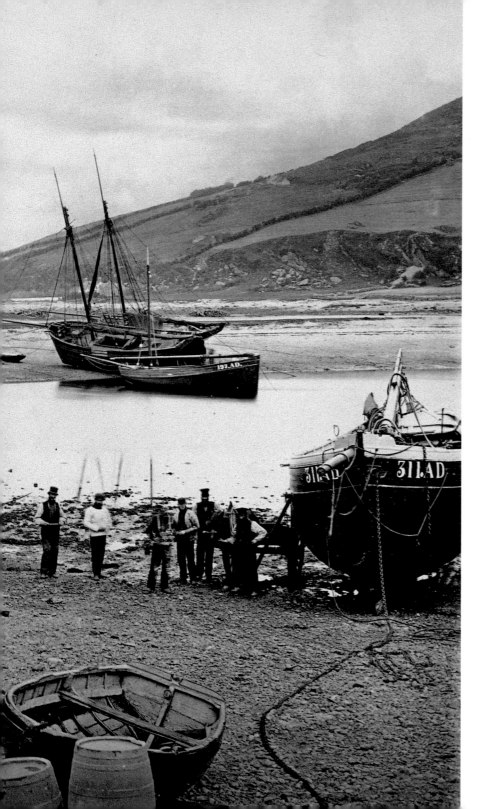

The photographers of Scotland's countryside offered contrasting images of the romantic and sentimental and gritty social realism to the public. This view of Lochranza on Arran presents a romantic sense of timeless continuity from the medieval stronghold in the background to the fishermen by their boats, who may have been descended from the men who rowed the galleys of the castle's lords.

places 93

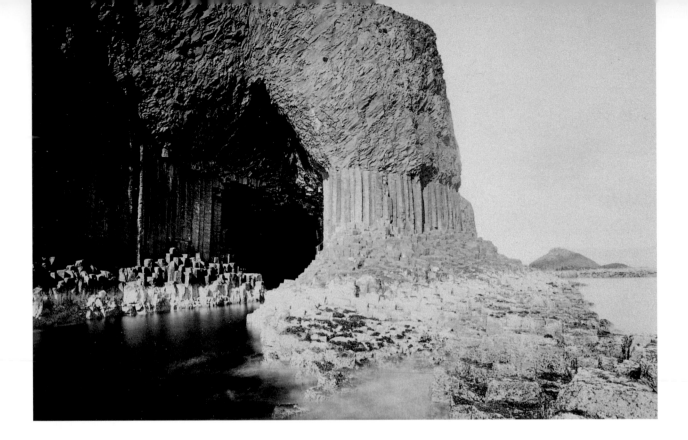

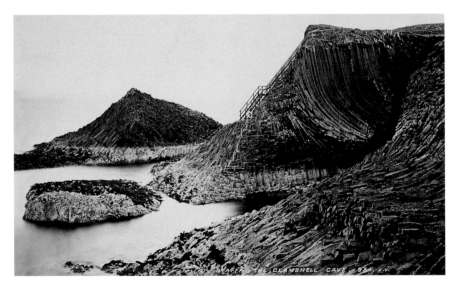

STAFFA THE CLAMSHELL CAVE 934 J.V.

Fingal's Cave (above and opposite) and Clamshell Cave (left), Staffa. Scotland's natural wonders were popular subjects for early photographers and postcard-makers. The basalt formations of Staffa and their association with the mythical Celtic hero, Fingal, already drew visitors in the eighteenth century, but the development of steamer services around the Hebrides from the 1850s placed it firmly on the tourist map.

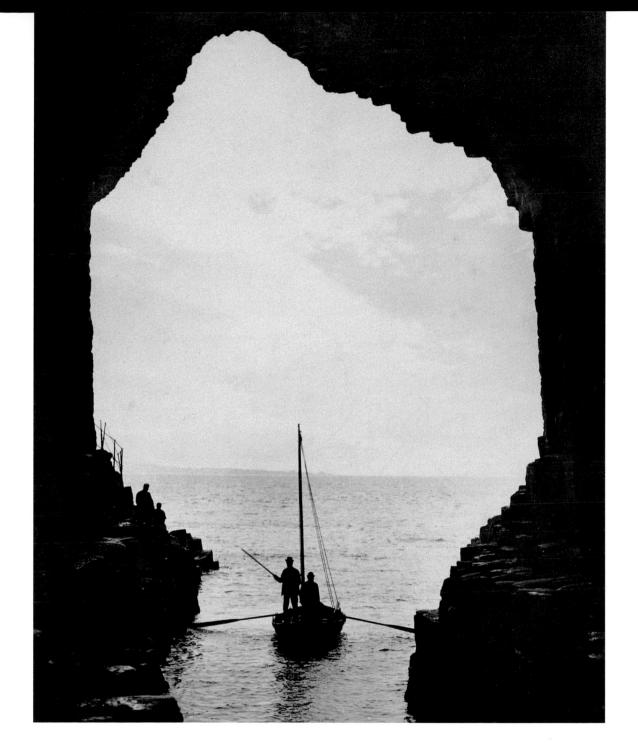

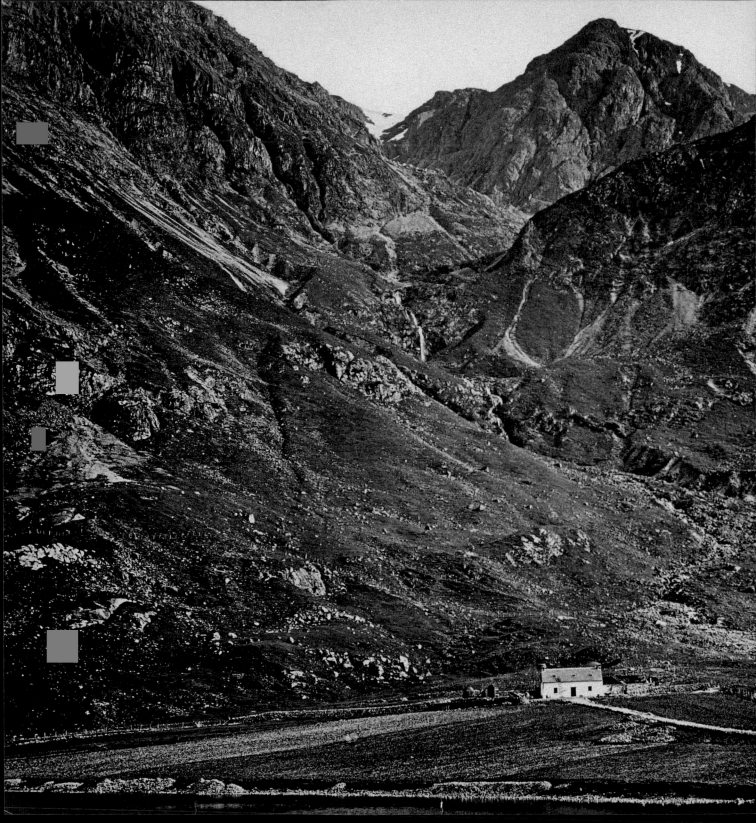

Highland Scotland's mountainous landscape drew tourists from the late eighteenth century onwards. The rugged wildness and grandeur of Glencoe (left), with its history of betrayal and slaughter, formed part of the romanticized package of Gaelic Scotland which led even lowland Scots to lay claim to a spurious Highland heritage. Travel within the Highlands remained difficult and dangerous, despite eighteenth- and nineteenth-century road-building, with the vagaries of weather (below) and shortage of facilities to contend with.

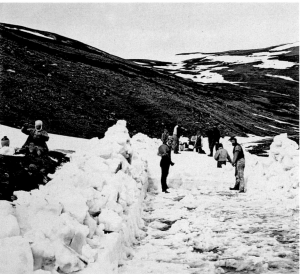

The **'Marriage Tree', Inverary, Argyll** (below), and an aged chestnut at Skene House, Aberdeenshire (right). The recording of nature formed part of both the scientific quest of the Victorian era and of the romantic aesthetic of the age. Trees were admired for their form and beauty as well as being valued for their timber or shelter.

chapter 3

coastal and rural life

Despite the marine wealth around Scotland's shores, it was only in the late eighteenth century that an indigenous commercial fishery began to develop. As late as the 1870s, fishing was largely undertaken from small, inshore boats (above) using simple nets and lines, or revolved around creel-fishing in coastal waters (right).

Rural and coastal life forms the counterpoint to the traditional image of industrial Scotland. One of the great shibboleths of nineteenth-century Scottish history is the image of a countryside depopulated, either through forced Clearance or economic pressures that drove the bulk of the rural population – Highland and Lowland – to migrate to the towns or to emigrate. Much of the image is myth. Despite the explosion in Scotland's urban population through the nineteenth century, for most of the 1800s the bulk of the people still lived and worked on the land. Indeed, farming and fishing employed the largest percentage of labour and, down to the outbreak of the First World War, contributed alongside manufacturing industries to the export trade. The buoyancy in demand for rural labour emphasizes the vibrancy and growth of agriculture. There has been a tendency to view land 'Improvement' as a late eighteenth- or early nineteenth-century phenomenon, but the greatest expansion of agriculture in Scotland occurred in the 1830s and 1840s, and continued at a significant level into the 1870s. From 1807 until 1877 in Kincardineshire, for example, the acreage under the plough increased by 70 per cent, and such was the demand that improving tenancies on even the poorest land were competed for. In many senses it was pioneering work, involving back-breaking labour in clearing land of stones and boulders to prepare it for the plough, digging drainage ditches, laying tile pipes, or building dykes, all presented in terms of the march of human and scientific Progress

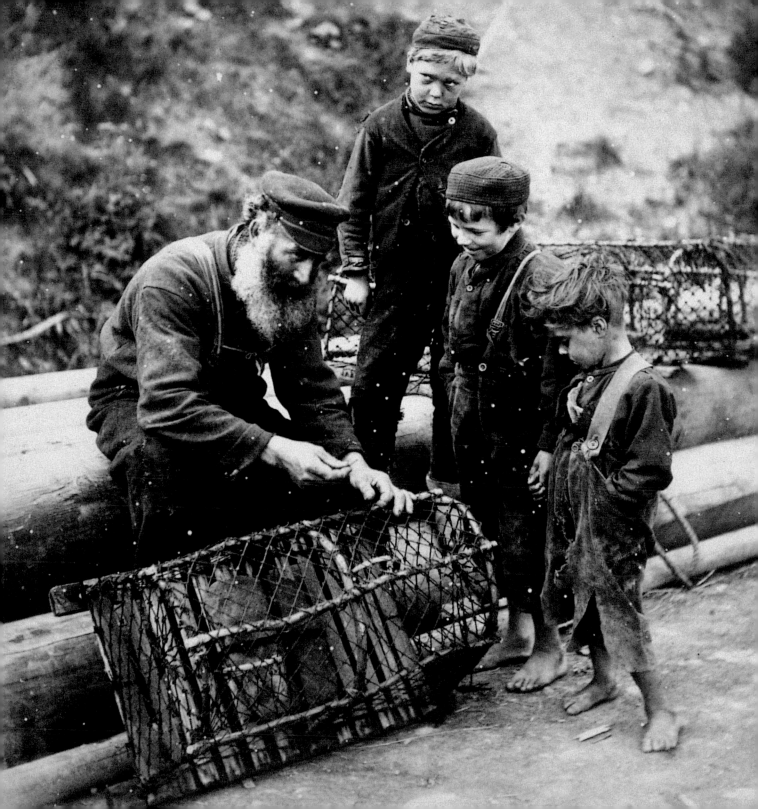

The grain mill stood at the heart of the rural community until the mid-twentieth century development of industrial milling and flour distribution companies based in the major cities. Maryculter Mill, Aberdeenshire, *c.* 1910 (below), and miller and assistant posing on top of the mill-wheel, Orkney, *c.* 1900.

over wasteful Nature. It was an image beloved of Victorian moralists and romantics, who saw in those herculean labours the effort and rewards of godly endeavour and the seedbeds of imperial greatness.

This view of manly rural endeavour formed part of a Victorian rural idyll. To some social engineers in the mid-nineteenth century, such as Thomas Chalmers, the lowland rural communities, with what were seen as laudable traditions of self-help, self-reliance and close, common identities, were models to be followed in tackling the problems of urban pauperism. Superficially, rural society seemed to be one that worked, but its apparent strengths were little more than skin deep. This image of strength, bolstered by the superior physical condition of many country-dwellers who enjoyed a better diet than their urban brethren, masked a reality of insecurity and grinding poverty rooted in a tradition of short leases and transient or seasonal labour. Land reform and economic realities largely ended the first problem, but the latter was to remain an issue into the 1930s.

Rural labour traditions, of course, changed profoundly in the nineteenth century. Around 1800, except on some bigger farms, there was little separation of masters and servants. Single men, who provided much of the field labour, were boarded with the master's family, eating and sleeping under the same roof. In the northeast, there was a developing tradition

of such men living in separate bothies, with the farmhouse reserved for the family and female servants. By the 1830s, variants on this arrangement were common throughout eastern Scotland from Lothian to Caithness, but there were widespread concerns over its impact. Most bothies provided substandard accommodation and many lacked even basic amenities into the 1920s, by which date, however, the system was in terminal decline. The chief criticisms expressed, however, were not over the physical health or welfare of the men, but over the moral dangers of such an environment. As early as 1836, bothies were described as 'hot beds of irreligion, immorality and vice,' where innocent boys were exposed to the corrupting influence of older men. Nevertheless, so long as single male labourers formed the dominant element in the rural workforce, particularly after about 1880, the bothy was a fixture of rural life.

Young, unmarried males provided the backbone of the rural workforce between about 1880 and 1930. They were purely transient, selling their labour on a six-monthly 'term' at 'feeing fairs' and rarely staying at one farm more than two terms, although they might return later once they had risen up the labour hierarchy. Low wages and a shortage of affordable accommodation combined to ensure that few such men married young, although they would often form unofficial partnerships with women and father children who were legitimized when their parents

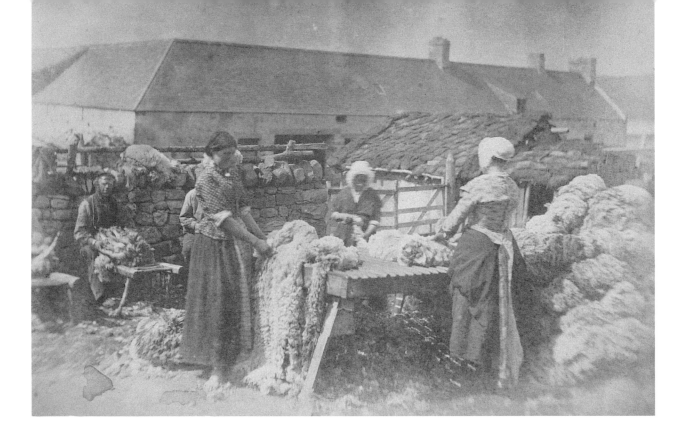

Cleaning fleeces before baling (above), *c.* 1870. Sheep have played a significant role in the Scottish rural economy since the twelfth century. The import of cheap wool from the southern hemisphere all but destroyed large-scale wool-production in the High-lands by the mid-nineteenth century, but Scottish wool was still in demand for manu-facture of tweeds and other Scottish cloths. The shearing was a high point of the agri-cultural year, with skilled shearers much in demand. Cattle, too, played a major role in the Highland economy (right), but the demand for beef cattle diminished as South American imports undercut Scottish prices.

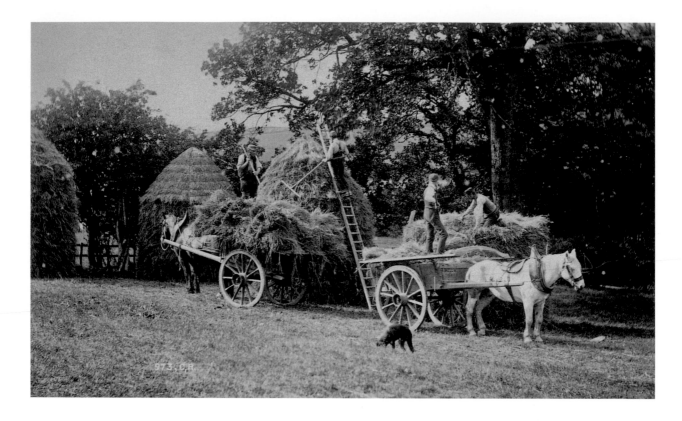

The hay-cutting and the 'hairst'
represented the peaks of the
agricultural year, when additional
itinerant workers would be
employed to harvest the crops.
Building hay and cut grain into
cocks and stooks to keep it dry and
free from vermin was an art that
died out only with the advent of
combine-harvesters and mechanical
balers after the Second World War.

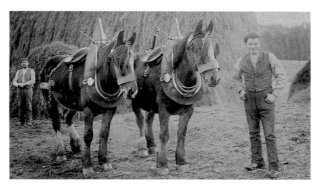

married. The high rate of illegitimacy in some rural areas prompted the severest criticism of agricultural labour traditions, especially the 'bondager' custom, where a labourer was expected to provide a female servant – often, but not necessarily, his wife – as part of his employment package, and his earning prospects increased if they had children who could work alongside them.

Contrary to the image of an unrelenting haemorrhage of population from country to town through the nineteenth century, the percentage of the population involved in farming instead grew for much of the 1800s until the introduction of new, mechanical technology. Mechanization signalled the end of a whole way of life. Throughout the nineteenth century, the ploughman had stood at the apex of the hierarchy of the rural labour force, and their horses were the objects of fiercely competitive pride between individual teams and neighbouring farms. With the end to dependence on horse-power passed the need for teams of men to look after and work with the horses, as well as the smiths and farriers who serviced them. A whole segment of rural life almost disappeared. By the later 1930s, although a few farms in Angus and Lothian still clung to traditional horse-powered methods, the introduction of the tractor meant that one man could do the jobs once done by four or five. The unemployment and rootlessness of the Depression was not a uniquely urban experience.

To divide rural life from fishing is to impose a very modern separation on what were for centuries closely related spheres. Scots have fished the waters round their shores for millennia and, by the Middle Ages, there were communities that specialized in fishing scattered mainly along the east coast of the country, but none where fishing was an exclusive occupation. For most, it was a seasonal trade practised alongside agriculture, either supplementing diet or providing a saleable commodity or element of rent in a tenancy agreement. This began to change in the later eighteenth century, and in the 1800s fishing developed on a commercial-industrial scale.

Stimulated by demand for cheap and abundant food for the burgeoning urban populations, the east coast fish trade exploded onto the national scene. The Board of Trustees for Manufactures and Fisheries, established after the Union of 1707, had provided some capital for commercial operations, but the chief initiatives stemmed from the British Fisheries Society, who from 1786 began the development of fishing stations in northern and western Scotland at places such as Tobermory, Ullapool and Pultneytown (Wick). In the early 1800s, some clearance evictees were also settled in coastal areas on plots inadequate to support a family, their landlords' intentions being that they should mix agriculture and fishing. Such attempts to develop commercial fishing in the Highlands and Islands, however, largely failed

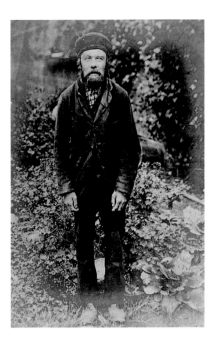

Until the arrival of intensive mechanization in the 1920s, Scottish agriculture relied on a workforce of transient and seasonal labourers. Single men, who worked on farms for terms of six months, formed the mainstay of the labour force in the arable East Coast districts. It was a rootless existence that social reformers saw as immoral and spiritually degrading.

The Victorian view of Scotland's agricultural society swung between extremes of sentimentality (below) and outrage at the poor living conditions, ill-health and moral laxity of the rural workforce.

due to competition from better-organized east coast- and Clyde-based operations, and also due to the fact that much of the income obtained from it was taken as rent by landlords, which left little for crofters to spend on developing their business or improving equipment. For most Highlanders, fishing remained a supplementary occupation restricted largely to inshore waters. The herring boom of 1870–1920, however, transformed this situation and reshaped the face of fishing communities around Scotland. During this period, fishing emerged as the largest single source of income in the Highlands, by about 1900 providing employment in some form to around 75 per cent of the population and constituting up to 90 per cent of earnings. Seasonal labour forces – male crewmembers and female gutters and packers – followed the herring shoals around the country from Lewis to Shetland, then down the east coast to Yarmouth in England, swelling the populations of host ports up to four- or fivefold. Earnings, remitted back to families in the Highlands and Islands, provided an essential lifeline for a way of life that had stumbled from one socio-economic crisis to another through the nineteenth century. When the fishery collapsed in 1920, turning off this cash flow, a traditional way of life collapsed with it.

Although the herring fishery had been a source of wonderment for tourists in northern Scotland, and its workers objects of fulsome Victorian praise and admiration, the scale and

energy of the operation hid its darker side from those awed observers. The migrant workforce on whom the herring fishery had depended faced its own problems, social, moral, economic and political. Poorly paid fishermen and fish-processors faced poverty, while the curers who controlled the trade grew rich, and the industry was often riven with conflict as boat-owners sought to secure guaranteed prices for their catches from reluctant or profiteering merchants. Employment was seasonal, and poor catches brought short seasons, low earnings and the prospect of a bread-line existence for the intervening months, with the attendant threat of ill health. Low incomes for most workers in the trade added to the social problems already troubling the expanding towns. Transients, faced with extortionate rents, crowded into unsanitary, sub-standard housing, bringing all the problems of urban slums to coastal communities. Despite a raft of legislation from the 1860s onwards and a sustained programme of house-building after 1918, in the late 1930s it was estimated that around 20 per cent of the population of some fishing centres still lived in overcrowded conditions, and it was not until after 1945 that a significant impact was made on the problems of substandard housing in Scotland's ports.

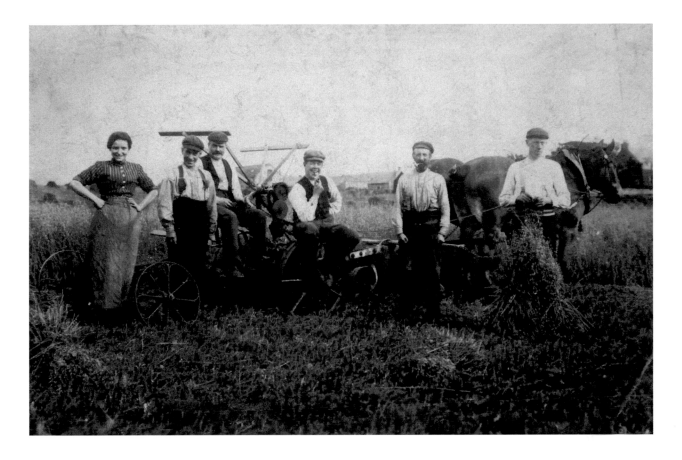

Harvesting machine, Pubbystyle farm, *c.* 1880. Horse-drawn mechanical reapers sounded a death-knell to traditional large-scale seasonal employment at harvest-time. Increasing mechanization had halved agricultural labour-forces by 1914 and declining employment prospects continued to fuel rural depopulation.

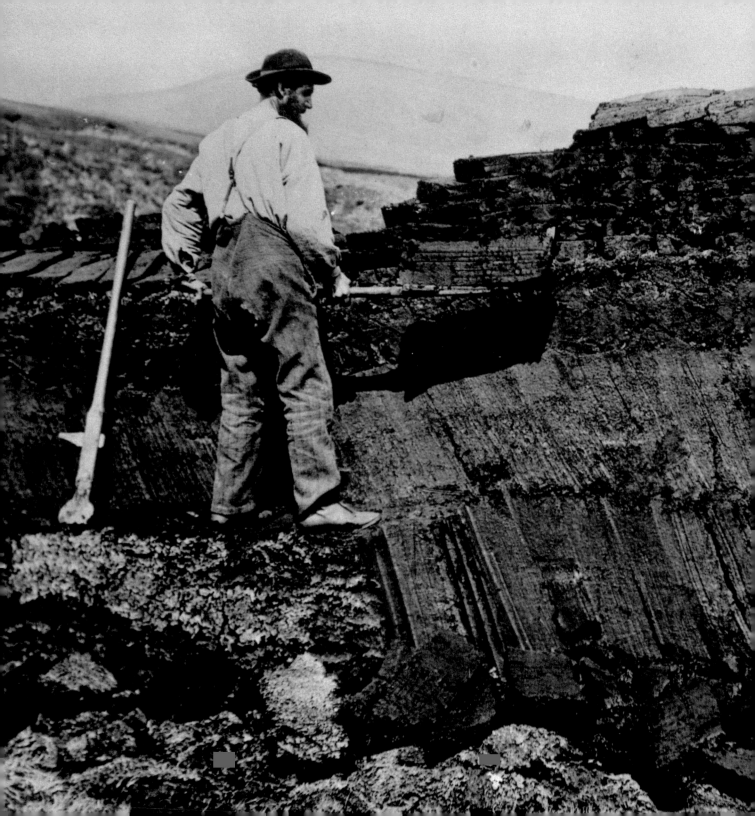

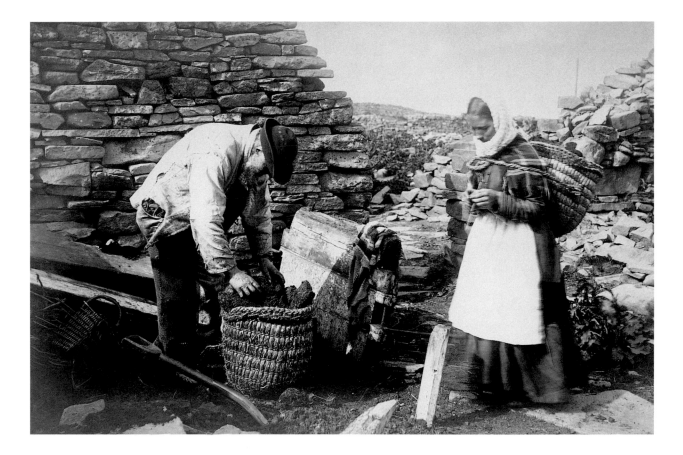

Peat-cutting using a tusker in Shetland,
c. 1880 (left); packing dried peats in creels
to carry back to the house (above). In most
of the Highlands and Islands, small-scale
farming or crofting was the norm. Most of
these holdings were deliberately made too
small by landlords for the tenants to subsist
entirely on the produce of their land,
forcing them to divide their time between
different activities, such as fishing or crafts.

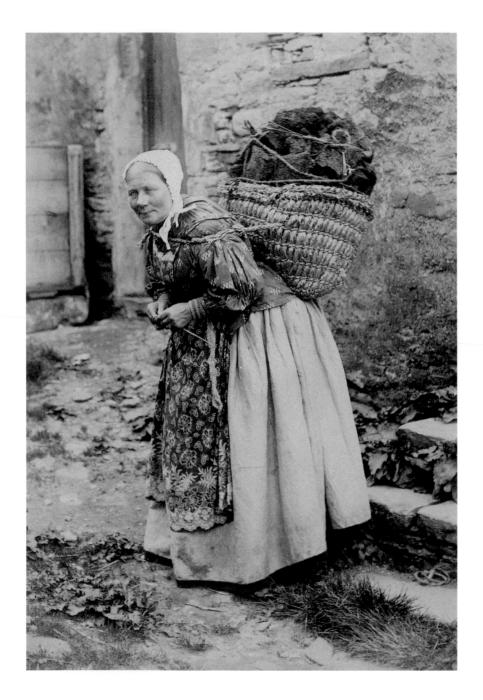

Carrying peats in a creel, northern Highlands, *c.* 1890. Several thousand peats per household were needed each year for heating and cooking fires. Until physically incapacitated by age or ill health, no one escaped the burden of bringing home the necessary supply.

In contrast to the areas of intensive arable cultivation in the east, large-scale water-driven mills were scarce in parts of the western Highlands and Islands. Oats, which needed careful drying before they could be ground, were milled into meal in rotary hand-mills (right).

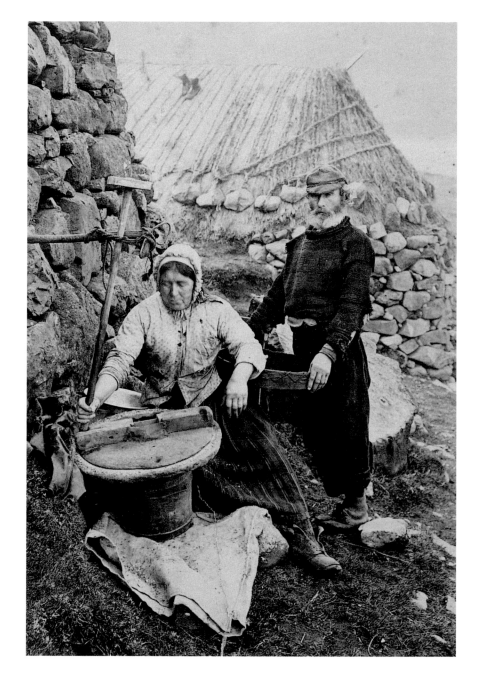

Before the development of mass production and mechanization, agriculture in both Highlands and Lowlands was dependent on the services of blacksmiths to make and mend iron tools and equipment, from wheel-rims to plough-shares. Right, the forge at Kinlochewe, Wester Ross, *c.* 1875.

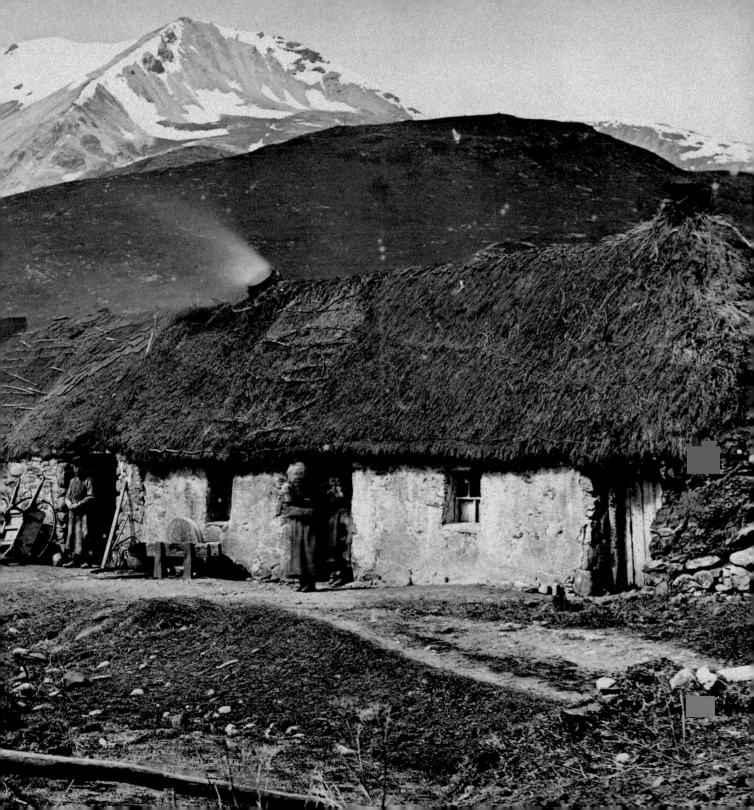

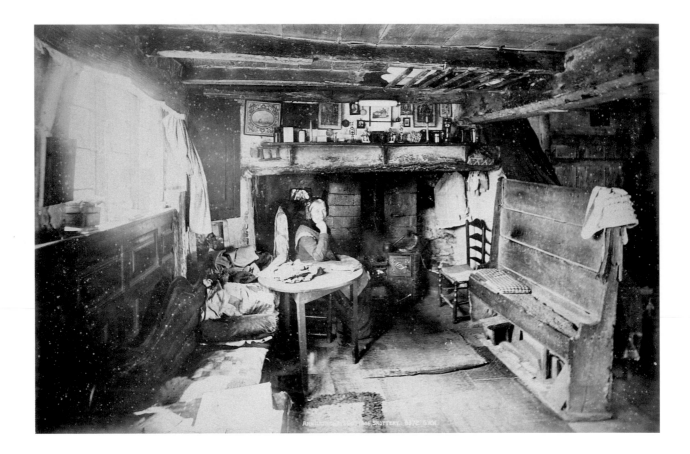

Standards of housing for the majority of the rural workforce were generally very poor and improvements lagged behind housing reform in the towns. As in the example above, accommodation could be very cramped, with the main room serving as a living, cooking and sleeping area. Few houses possessed sanitation of any sort.

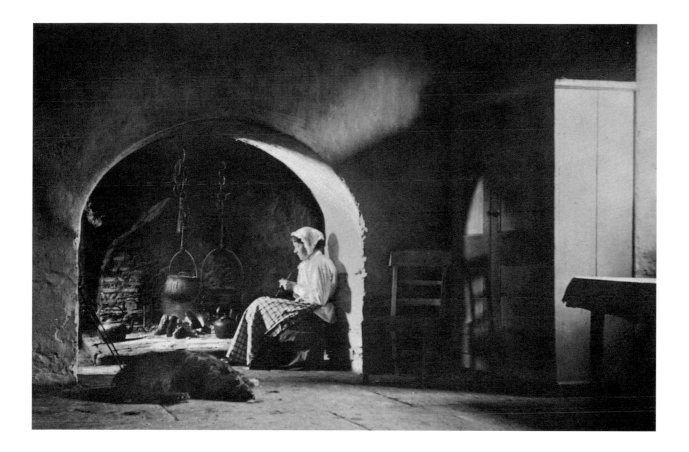

There was a great gap in standards
between the homes of most
agricultural labourers and those of
their employers. Regional cultural
differences played a significant part
in this division, as can be seen in
this Orkney farmhouse, where the
kitchen was a separate working
and eating area from the living
accommodation.

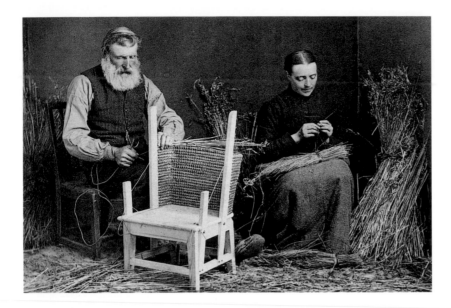

By the late nineteenth century, traditional craft skills such as making straw-backed chairs in Orkney (above left) were being threatened by the arrival of cheap, mass-produced items, imported from the industrial cities or ordered by catalogue. In crofting communities, where income from areas other than agriculture and fishing was vital for economic survival, development of woollen manufacture, especially the weaving of tweeds (below left), was encouraged.

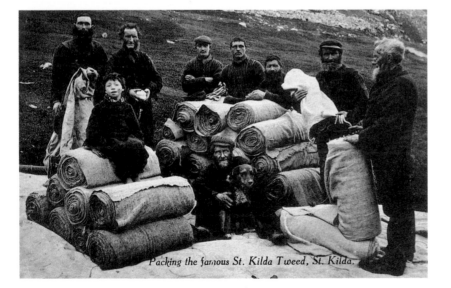

Packing the famous St. Kilda Tweed, St. Kilda.

The weaving of tweed itself was an exclusively male preserve, but the making and preparation of the yarns, dyeing, waulking and trimming of the cloth, was carried out by the women. Most Hebridean households possessed a spinning wheel for making the woollen yarns (right) until the practice of buying industrially spun yarns became commonplace in the early 1900s.

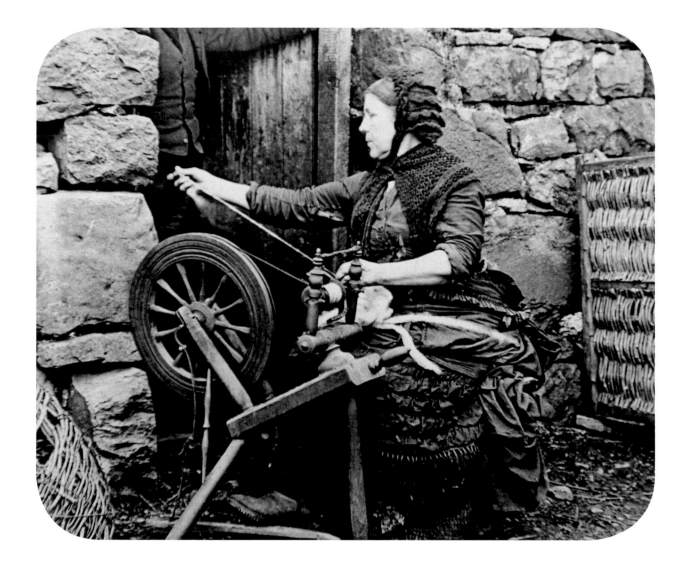

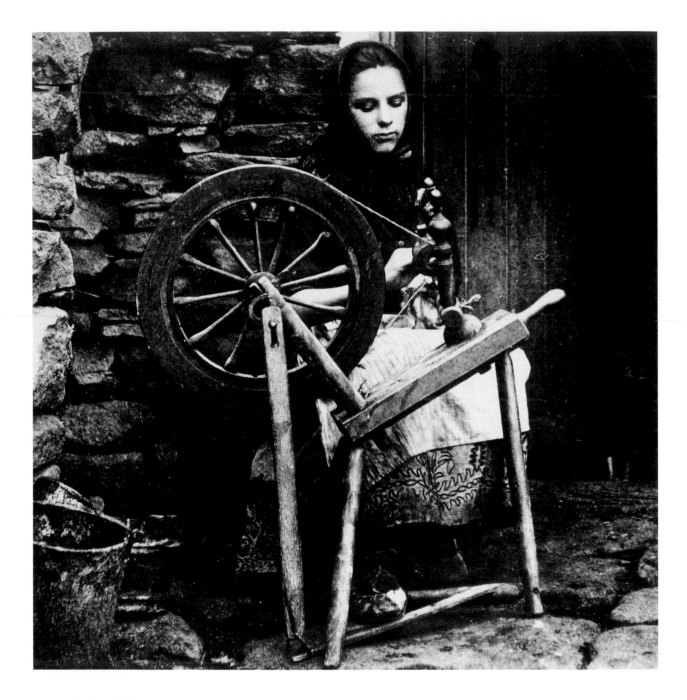

118 coastal and rural life

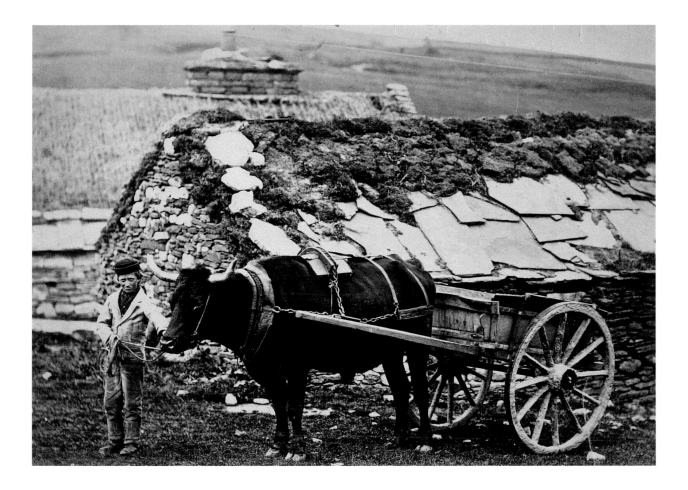

Spinning yarn (left) in the Western Isles, *c.* 1880.

To many city-based Scots, the life of their country-dwelling kin was alien, incomprehensible and, sometimes, risible. Far-removed from the sophisticated trams and trains of the industrialized lowlands, traditional modes of transport like this Orkney ox-cart in the late 1850s or 1860s (above), labelled the 'Hoy Express' by George Washington Wilson's studio, were photographed as remnants of a fast vanishing world.

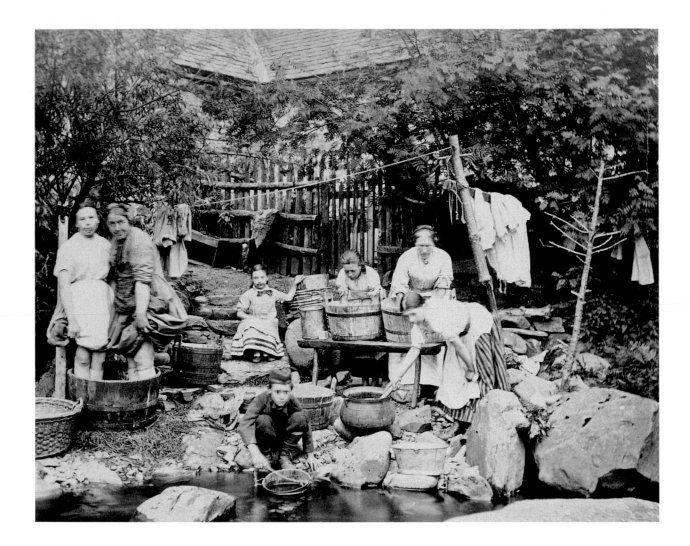

Scenes of Highland rural life were
often staged and photographed
for commercial purposes, and
presented as curious or ridiculous
to a public for whom such activities
were further evidence of the
primitiveness of the Highlands.

120 coastal and rural life

For many photographers, however, rural Scotland was a source of aesthetic composition in which the basic elements of earth, stone and iron encapsulated the strength of the land and its people.

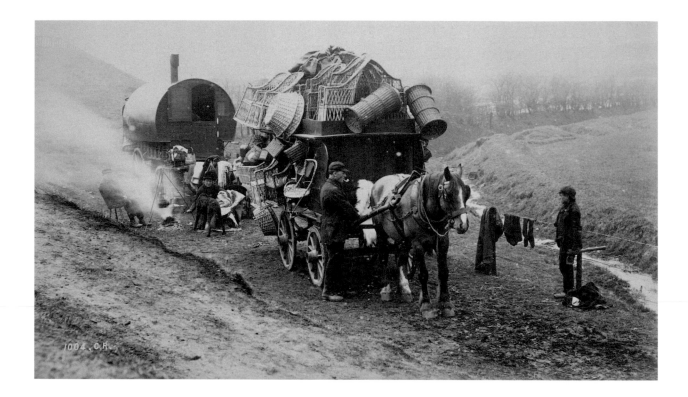

Gipsies and tinkers (above and opposite) were a common but not always welcome presence in rural Scotland. The two groups had quite different origins but were often treated as one and the same. Tinkers were originally itinerant craftsmen whose skills were much valued by country-dwellers, but they were looked down upon as socially inferior by the settled rural population.

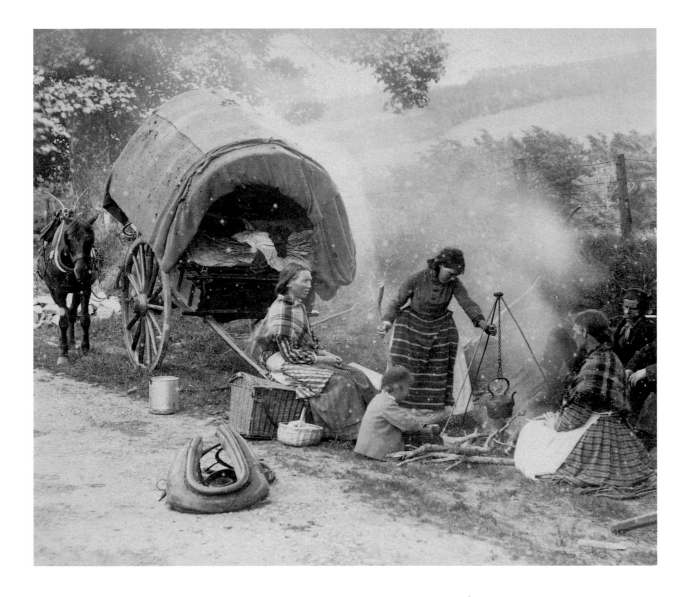

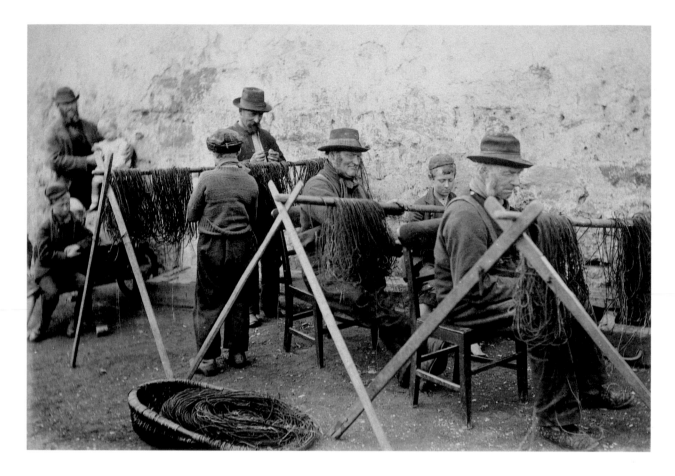

Until the later nineteenth century, most sea-fishing in Scotland used baited lines rather than nets. Cleaning, repair and preparation of the lines – 'reddin' – before baiting them was a male job (above), done usually immediately by the boat crews on their return to shore. After the reddin, the children and women would bait the hooks.

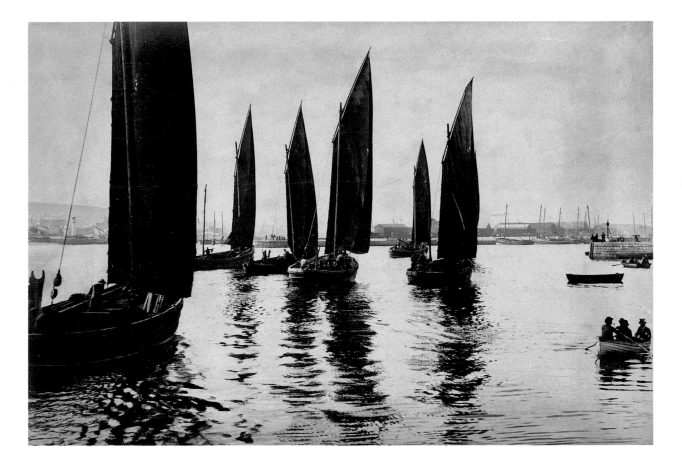

From the late 1870s, herring fishing using nets replaced line-caught white fish as the main commercial fishery in Scottish waters. Between *c.* 1880 and 1914, fleets of several thousand boats followed the shoals from the Western Isles round to Wick, Fraserburgh, Peterhead and Aberdeen (above), before sailing south to the final fishery of the season off East Anglia.

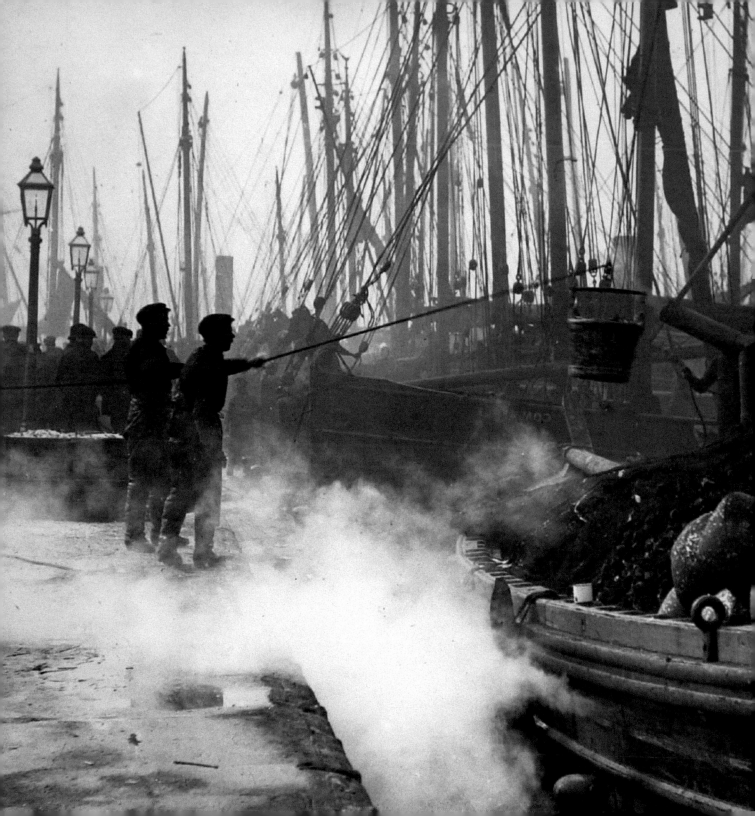

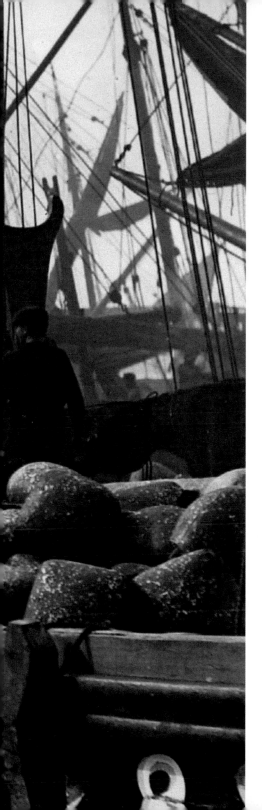

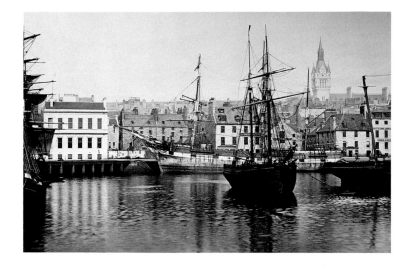

For ports such as Fraserburgh that had invested heavily in providing facilities for the herring fleet, but which lacked the mercantile base of major centres like Aberdeen (above), the collapse of the fishery as a consequence of the First World War brought long-term economic decline.

At the peak of the herring boom between *c.* 1880 and 1914, northeast Scottish harbours were crowded with boats in season (left) and in some cases the local populations were quadrupled by the influx of migrant workers. This seasonal trade brought both economic prosperity and social problems more usually associated with industrial centres in equal measure.

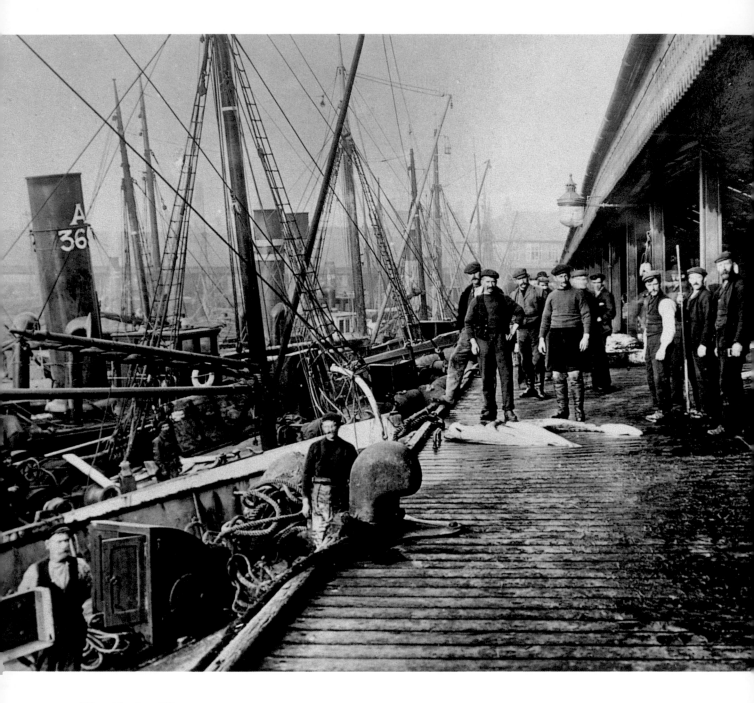

128 coastal and rural life

The shore-based side of the herring boom employed more people than worked on the boats. The fishery supported an ever-expanding complex of harbourmen, fish-market workers, buyers, curers, gutters and packers, coopers and shippers. The major ports attempted to secure ever bigger shares of the fishery by providing better facilities, such as quayside markets (left, at Aberdeen *c.* 1910) and railheads.

Thousands of young unmarried women provided the muscle for the herring gutting and packing operations (right). While many were drawn from the local fishing communities of the main ports, the majority were seasonal migrants, often from the West Highlands and Islands, who followed the fleets around the coasts. Their earnings helped to support their families in the crofting districts.

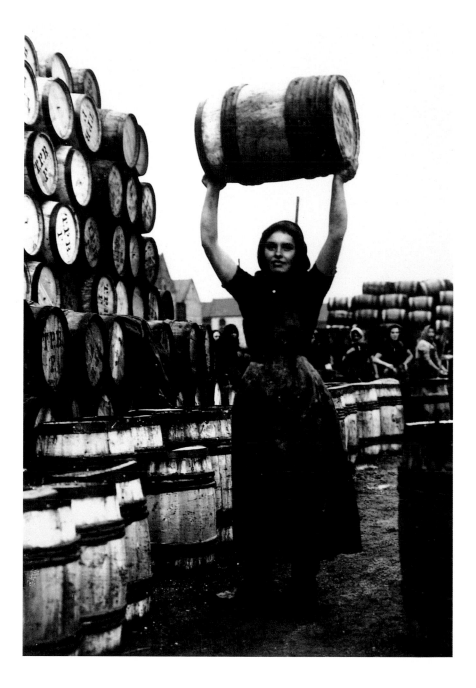

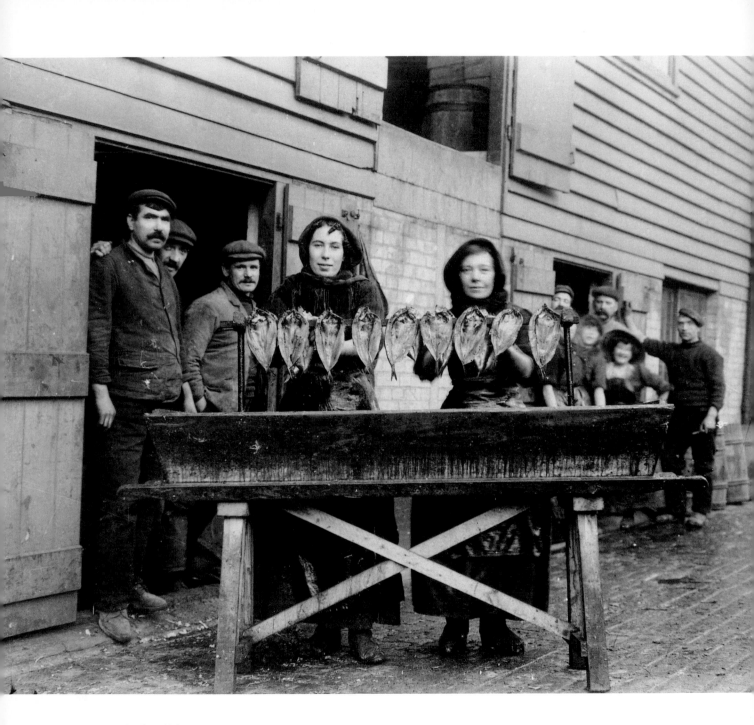

While most of the fish caught was gutted, packed in barrels and pickled for export, mainly to eastern Europe and the Baltic countries, much also went to meet domestic demands. Dried or smoked fish (left) had been popular in parts of Scotland for centuries, but the development of the rail network introduced these delicacies to a wider market. The kipper became a regular feature of middle-class breakfast tables.

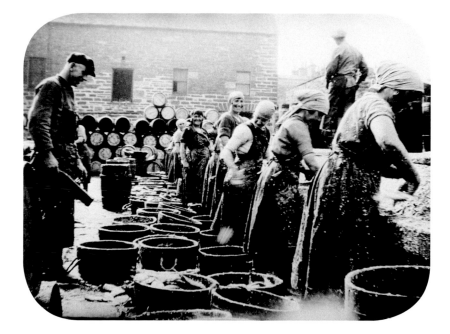

Despite the smiles on the faces of these women and their overseer (above right), relations between employers and workers in the fishing industry were often strained. The curers, who controlled the buying, processing and on-sale of the fish, often used their power to drive down prices offered for the catch and wages paid to gutters and packers. For those involved in the lower ends of the industry, hours were long and the rewards low. Fishwives, who carried their fish to the doors of customers, left home before dawn to bring the fresh catch to town (below right).

132 coastal and rural life

Scotland's nineteenth-century fishing booms had a high human cost and wrecks and sinkings of all classes of vessel were common in the unpredictable and dangerous waters around the coast. Unseasonal storms in August 1848, for example, sank and damaged 124 fishing boats off the Caithness coast and drowned over 100 men. A similar event in October 1881 devastated the fishing community at Eyemouth in Berwickshire, drowning 129 fishermen.

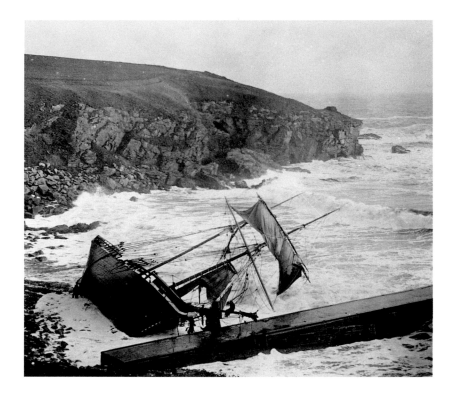

chapter 4

work and industry

Scots' ingenuity in diving technology (above) provided marine engineering skills that were honed to perfection by Sir William Arrol's workforce in the building of the Forth Bridge (right). The bridge's span and need for seabed foundations tested the technology of the day to its maximum.

The dawn of the photographic era broke on a country standing both at the cusp of transformation into an industrialized society and also on the brink of an economic recession that marked the end of the first phase of industrial development. Early industrialization had been driven forward by water-powered textile manufacturing, but in the 1840s Scotland climbed out of the economic slough on the back of new, 'heavy' industries. It was the era of coal, iron and steel. By the early 1860s, an integrated economy had been created in the western central belt, where the mining of coal fuelled iron and steel production, which in turn fed the development of heavy engineering, especially boiler-making and shipbuilding. Employment in these booming industries acted as a magnet that sucked in population from the rural fringes of Scotland and from overseas, leading to the rapid growth of sprawling working-class communities focused on Glasgow. The industrialized society that emerged in the course of the century after 1840 was one of stark and shocking contrasts, where images of Scotland as the powerhouse of the Empire, bubbling with enterprise and innovation, are juxtaposed with a darker record of exploitation, human and environmental degradation and social struggle. Out of the birth-pangs of this new age was born the radical working-class Scotland of the early twentieth century.

Coal provided the fuel that drove forward this revolutionary era. Mining is on record in Scotland since the later twelfth century, and had been developed on a commercial scale in

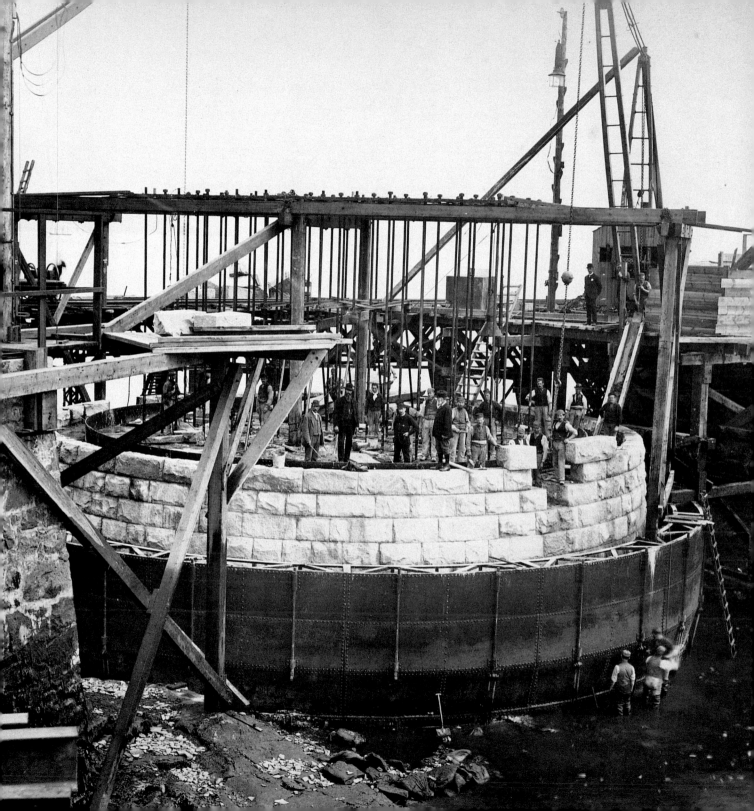

Lothian and south Fife from the later 1500s. Fewer than 10,000 people had been employed in coal-mining around 1800, but by 1870 that number had swollen to around 47,000 men working in 400 pits and in 1901 to nearly 128,000. Until the 1842 Factory Act, women and children had also worked underground, boys and girls as young as seven working 14-hour shifts hauling coal from the face to the surface. The prohibition on female labour in this and other heavy industries, whilst driven by welfare considerations, resulted in the establishment of mining as a bastion of masculine dominance in the workplace, through which the notion of 'separate spheres' of male and female employment was reinforced. The benefits brought by the Factory Act to female and child labour were slow to filter through to the men, who still worked 60-hour weeks in appalling conditions. By the 1870s, however, negotiations had shortened the working week to between 39 and 50 hours, depending on the coalfield, but it was not until 1909 that underground work was limited to 8 hours by law.

Limitations on working hours did not extend to all employment. Railway workers in 1892 were still averaging 80-hour weeks, a shocking statistic that explains in part the industry's horrifying reputation for accidents and death. Chemical workers could spend up to 84 hours in a 7-day working week in their plants, adding fatigue to the industrial hazards of their work, which included phosphoric, lead and mercuric poisoning, whilst 60-hour weeks were

common in the iron and steel trades. But extended hours were not restricted exclusively to industry and transport, for some of the longest working days were served by shop- and office-workers, two sectors that employed a high proportion of cheap female labour.

The notion of 'separate spheres' was not as universal or entrenched as some casual observations might indicate. Even before 1914, female labour dominated in certain trades, especially in textiles and clothing manufacture. Here, however, it was costs that drove the trend, for in a traditionally cut-throat sector lower female wages offered the prospect of a substantial saving to owners. Female employment was most pronounced in the Dundee jute mills, where by 1900 women between the ages of 20 and 45 outnumbered men by a ratio of three to two. In 1921, 24 per cent of married women in Dundee were in employment, some four times the average of Edinburgh or Glasgow. This situation started young, despite contrary legislation, for before 1914 some 5000 girls of 12 to 14 years of age were given dispensation to leave school (or attend evening schools) to go to work in the mills. It was a situation deplored by both social reformers and Socialists, who considered it corrosive of 'proper' family life and evidence of the malignancy of capitalism.

Much of the resistance to the spread of female labour into other sectors came from within the male dominated industries, where skilled

(below) **Unloading jute, Dundee docks**, *c*. 1930. Scottish involvement in the Imperial trade brought a flow of raw and semi-processed goods into Scottish ports. Dundee dominated the world jute trade, importing the raw fibres direct from what is now Bangladesh. (right) Tea auctioning and sampling at the Co-op, Aberdeen, *c*. 1920. Firms such as Melrose & Co. in Edinburgh and Lipton's Ltd in Glasgow controlled much of the tea trade, owning their own plantations in India, Ceylon (Sri Lanka) and Kenya.

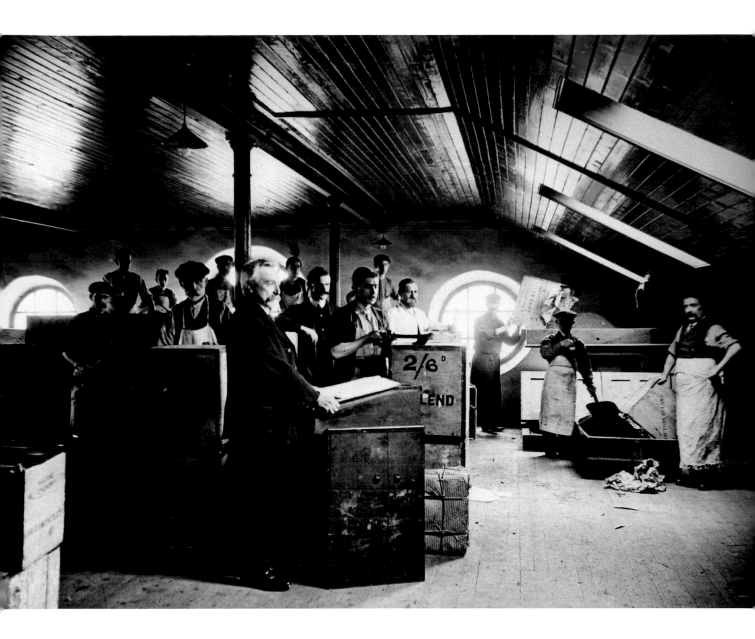

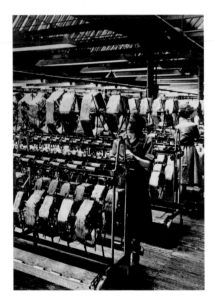

Interior of textiles factory, *c.* 1930. As well as coarse materials, such as jute sacking, Scottish textile companies secured a world-class reputation for finer cloths. East coast linen, centred on towns like Arbroath, and the Borders' woollen industry in particular, dominated the British market.

employees feared 'dilution' through the introduction of semi-skilled or unskilled workers. Skilled craftsmen, who had served long apprenticeships before achieving their well-paid position at the apex of the labour hierarchy, fought a long and ultimately unsuccessful rearguard action to preserve their status. Training itself was a source of friction, for the skilled men also feared, with justification, that employers would take on a high ratio of low paid apprentices to qualified (and expensive) journeymen to keep wage costs down. More disturbing was the poor quality of much of the training. While formerly most youths entering an apprenticeship at 16 had spent five years learning different aspects of their chosen trade, there was a growing trend towards over-specialization where boys were trained rapidly in one area then employed, in effect, as cheap, semi-skilled labour. Coupled with a movement towards increased mechanization, this trend threatened to erode the skilled labour base upon which the industries had been built. The reaction was entrenchment on the part of workers, who adopted increasingly inflexible positions in respect of demarcation between trades in defence of their status. The consequence was a social and economic straitjacket that eventually crippled Scottish industry.

Shifting trends in patterns of training and employment overlay a deeper malaise within the industrial sector. Heavy engineering, which had come to encapsulate the ideals and

aspirations of Victorian Scotland, typified the position. In the 1870s and 1880s, there seemed to be no technical problem that Scottish engineers could not overcome. Ambitious building projects, such as the rail bridges over the rivers Tay and Forth, symbolized the confidence of the age. Yet a peak of achievement was reached in the 1880s and, thereafter, Scottish heavy industry stagnated and was overtaken in terms of innovation and growth by foreign developments. Although buoyed up by the naval arms race in the lead up to the First World War, and by a switch to war-time production in 1914–18, by the mid-1920s engineering and shipbuilding were in crisis. A combination of complacency before 1914, where under-investment in research and development and increasingly inflexible working practices and traditional techniques had allowed more innovative and responsive foreign competitors to gain a commercial edge, and financial exhaustion post-1918, which limited investment in modernization, contributed to the decline of a once world-leading sector. It was only a series of government-aided or funded projects in the 1930s that provided a lifeline for these former flagship industries, permitting them to struggle on into the post-1945 era until shipbuilding's eventual collapse in the 1970s and the virtual demise of heavy engineering in the 1980s.

It was not just heavy industry and the traditional industrial heartlands that faced this roller-coaster existence. Distilling, for example,

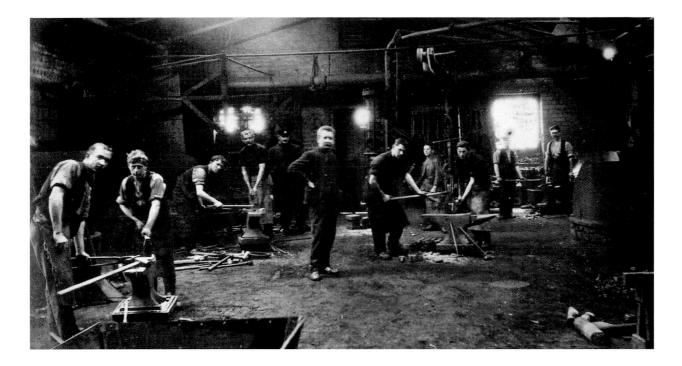

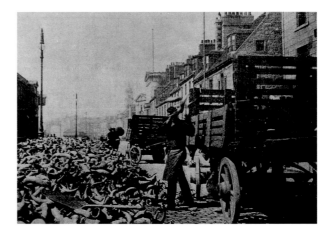

(above) **The forge at Summerlee Ironworks**, Coatbridge *c.* 1910. Heavy industry, especially coal, steel and ship building, were exclusively male preserves from the early nineteenth century. The maintenance of a 'separate spheres' segregation of the sexes at work survived the use of women in traditionally male jobs during the First World War. (right) Male labourers loading horn for the comb works at Regent Quay, Aberdeen, *c.* 1920. Men held all jobs involving what was considered to be physical effort beyond the capabilities of women.

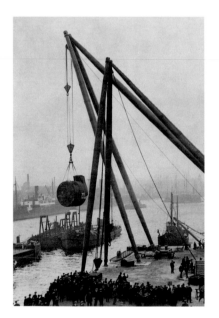

experienced rapid growth through the second half of the nineteenth century. A booming export market and rising domestic consumption of whisky brought investment in buildings and machinery. Confidence, however, crashed in 1914 and the contraction of the market through war was followed in quick succession by Prohibition in the USA and by the Depression of the 1930s. A brief recovery at the end of the decade was brought to a shuddering halt in 1939, and the post-War era produced no new dawn but rather further contraction and rationalization as small businesses went to the wall or were swallowed by growing corporate ventures.

In retrospect it can be seen that the catalyst that brought together the various strands of industrial decline in Scotland was the First World War. The easy conversion of much of Scotland's industrial base into an integrated and interdependent munitions industry reveals how narrow the country's economic foundation was. It was expected that the gearing for wartime production would stand Scottish heavy industry in good stead, as demand was expected to soar in a scramble to replace war losses once hostilities had ended. Unfortunately, foreign competitors were equally poised to seize that market and Scotland failed to re-establish its pre-War position in sectors, such as shipbuilding, where overcapacity was a global problem. The collapse of shipbuilding in the 1920s had ramifications throughout Scotland, for much

of the rest of Scottish heavy industry was tied to the needs of the shipyards. As demand for iron and steel slumped, so too did demand for coal, and between 1920 and 1933 mining contracted by almost 50 per cent. Unemployment, especially amongst men, climbed steadily and to a higher level than the British national average. By 1932, over 25 per cent of the labour force of west central Scotland was unemployed, and the figure would have stood at an even higher level had the preceding decade not seen an unprecedented level of emigration.

Drastic remedies were needed to relieve the crisis, principally re-organization, relocation, reduction in the scale of the traditional industries and diversification into new sectors, but few companies had the will or the resources to make the necessary investments. Government intervention in the mid-1930s, in the form of the Special Areas scheme, provided cash for the development of new 'industrial estates' founded on light industry, but these emerging businesses were founded mainly on cheap female labour and made no significant impact on male unemployment. Temporary redemption came with the rearmament programme of the late 1930s, which saw a rapid recovery in the traditional heavy industrial sector focused on shipbuilding but, as in 1914–18, the outward vibrancy of the sector merely masked the internal symptoms of continued decay that would be revealed to devastating effect in the post-1945 era.

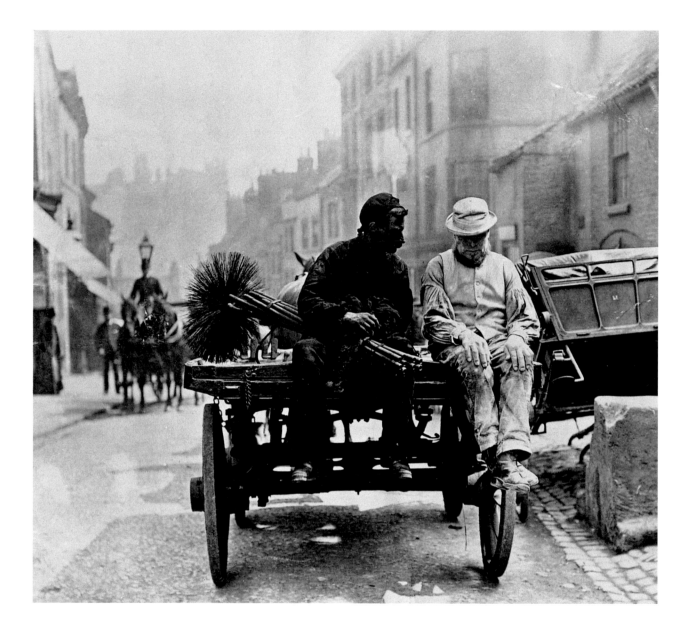

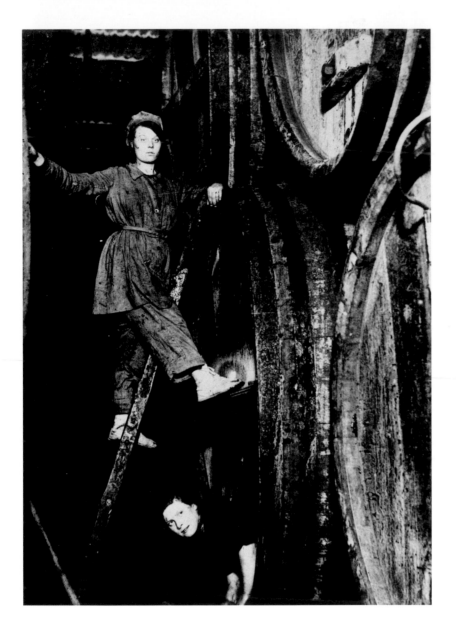

In the brewing and bottling industry, the female role had been limited before 1914 to activities such as bottle-washing and labelling (right), but by 1916–18 women had taken up the heavier jobs in the brewhouses (left). With the exception of fish-processing and textiles, the workforces in most Scottish industries until 1914 were overwhelmingly or exclusively male. By 1916, the shortage of male workers in all but reserved industries – such as coal-mining – had forced a switch to female labour.

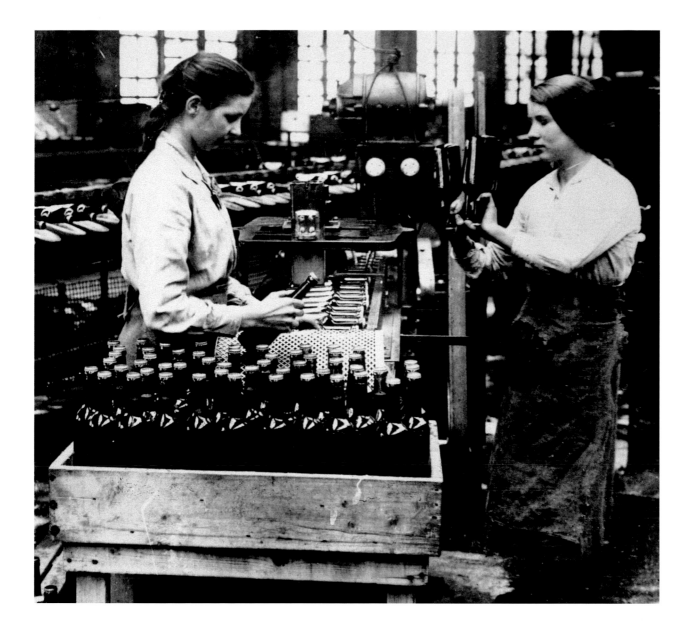

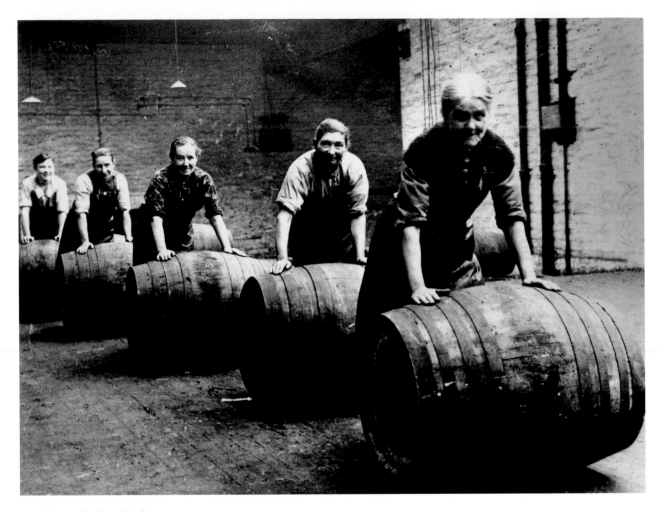

Women rolling barrels in the
Tennent's Brewery in Glasgow
c. 1918–20. A common scene during
wartime, by the 1920s these jobs
had been resumed by men returning
from military service.

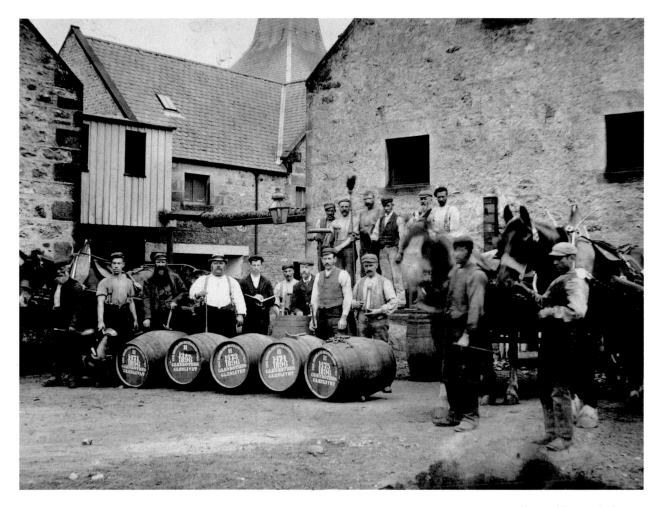

Distilling workforce at Glenlivet, *c.* 1870. Glenlivet's agent, Andrew Usher and Co., developed 'blended' whisky in 1853 and triggered the dramatic expansion of the distilling industry.

Until the 1950s, most of the smaller distilleries still malted their own barley. Work in the maltbarns (left, at Lagavulin Distillery, Islay, *c.* 1910) was the first stage in a young man's progression through the craft. Only a chosen few would move up to the mash-room, where the malt liquor was produced (below left, mash tun at Dalwhinnie Distillery, 1904).

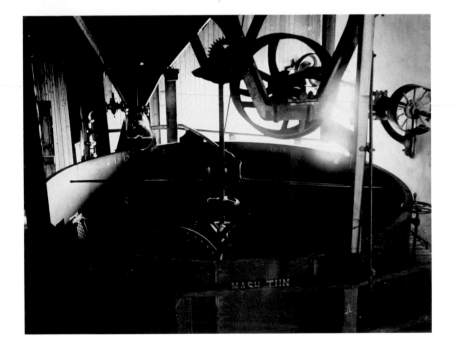

(right) Stills at Glenlivet's Glen Rothes Distillery, Rothes, Moray, *c.* 1880. The distinctive form of the copper whisky stills finally emerged in the mid-nineteenth century after the freeing up of the licensing of distilling earlier in the 1800s.

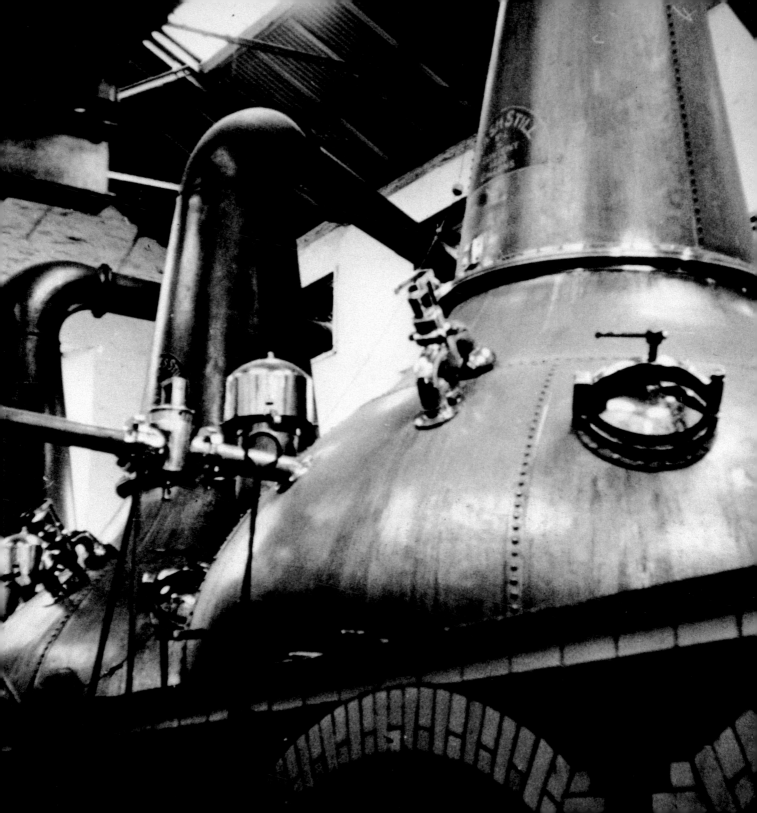

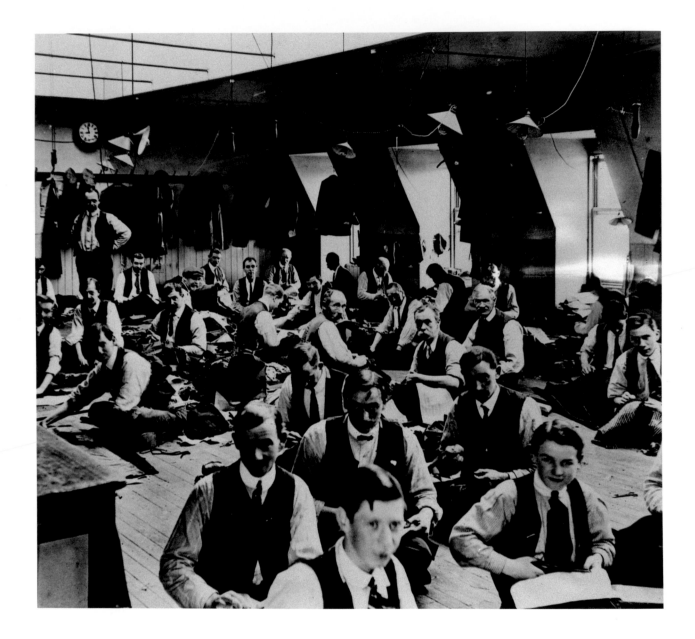

148 work and industry

The clothing industry was still dominated by small workshops until the emergence of 'off-the-peg' fashions post-1945. In an industry notorious for its sweat-shops, tailors' rooms such as that at the North Co-op, Gallowgate, Aberdeen (left), *c.* 1930, were models of good practice.

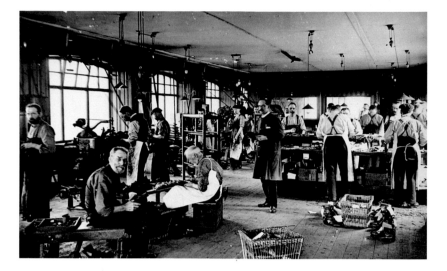

(above right) The shoe-making workshop at Loch Street Co-op, Aberdeen, *c.* 1920, was light and airy, and used modern power tools as well as traditional methods. Co-operatives provided both cheap and good quality products for their members, but also offered good employment conditions for their staff.

(right) The Scottish printing and publishing industry occupied a powerful and influential place within British society. Modern plants, such as William Blackie and Co.'s book bindery at Glasgow in 1932, helped to establish Scottish dominance in the home market.

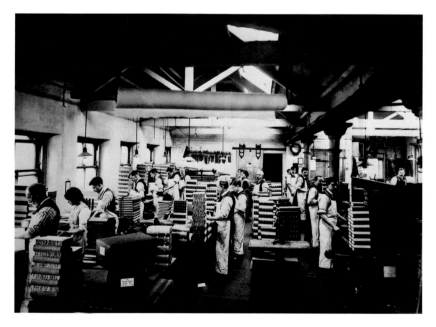

A nurse at Edinburgh Royal Infirmary, 1913 (right). Throughout the nineteenth century, Scottish medical research and Scottish medical practitioners were at the forefront of developments in medical and nursing treatment. Indeed, the Scottish doctor is one of many 'archetypal' Scots in literary and film tradition.

(below) Hospital ward in Leith, 1917. The later 1800s had seen significant advances in treatment facilities, with new hospital buildings such as Edinburgh Royal Infirmary, opened in 1880, incorporating the latest ideas.

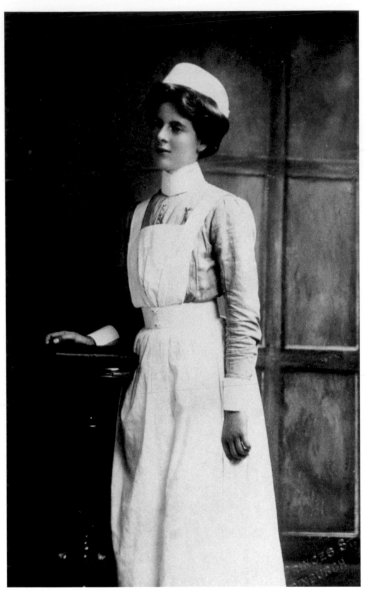

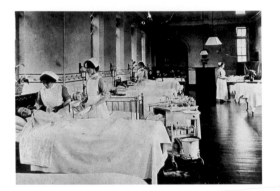

(opposite) An operation being carried out using a carbolic spray to disinfect the operating area in Aberdeen in 1889.

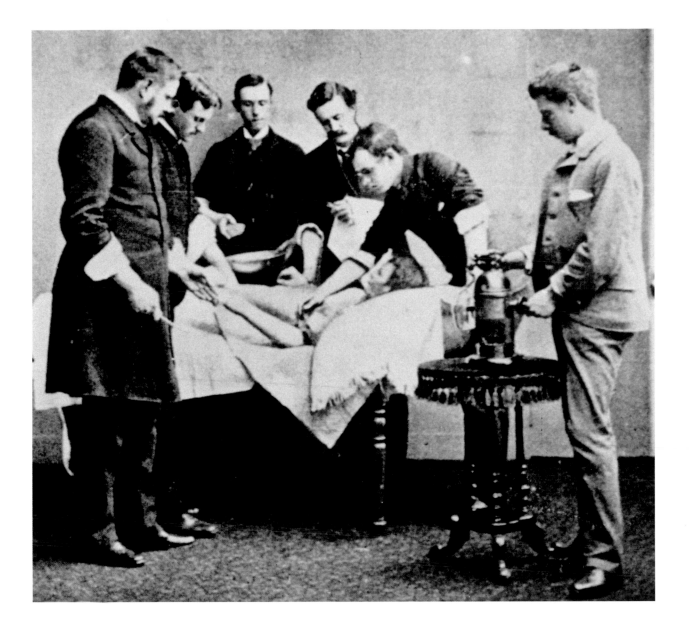

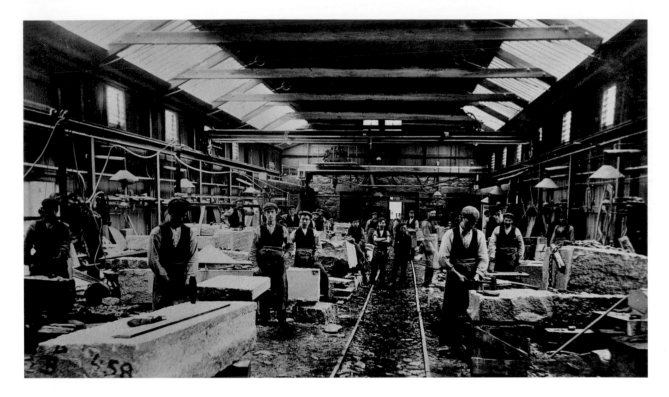

The great Rubislaw Quarry in
Aberdeen (opposite), the source of most
of the distinctive grey granite used in the
building of the city until the second half
of the twentieth century. The excavated
area was vast and extraction of the
stone tested the ingenuity of the quarry
engineers. The scale can be gauged by
looking at the figure standing above the
roof of the buildings in the centre left
of the photograph. The rapid physical
expansion of Aberdeen and its satellites
c. 1875–1900 required a tremendous
volume of cut stone, prepared in
specialist workshops (above).

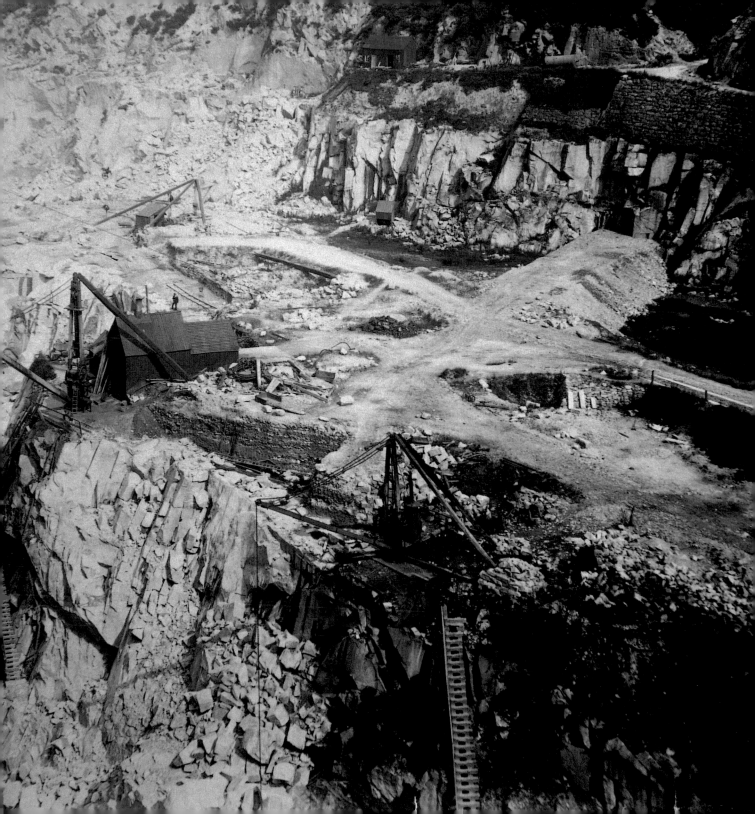

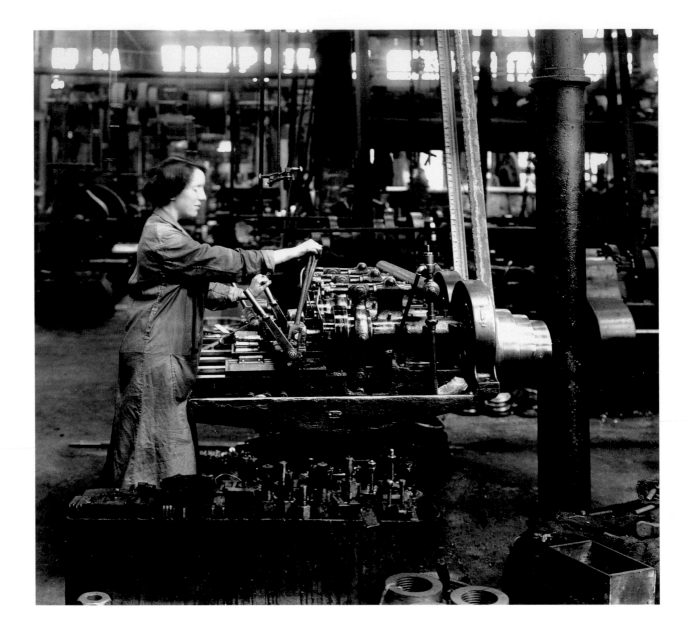

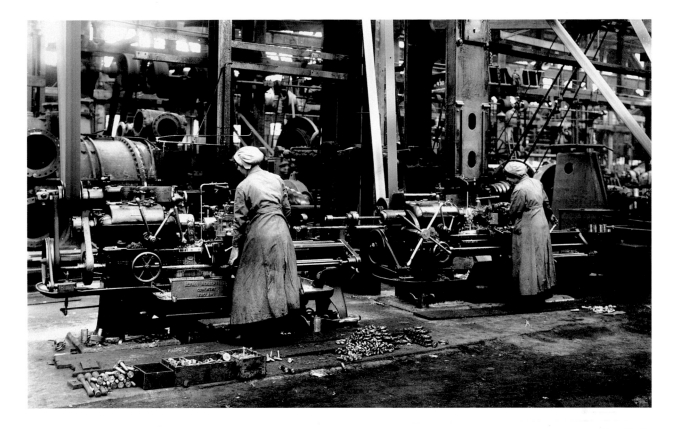

In the Stephen's Engineering Workshop
in Glasgow by 1916 (left and above), more
women than men were employed in the
machine-shop. Male-dominated unions
resisted 'dilution' of labour through the
introduction of young, semi-skilled men
and women. With increasing numbers of
skilled men leaving to serve in the Army
after 1914, those barriers were broken down.
After 1918, the men were guaranteed a
return to their old jobs and women again
disappeared from this sector of industry.

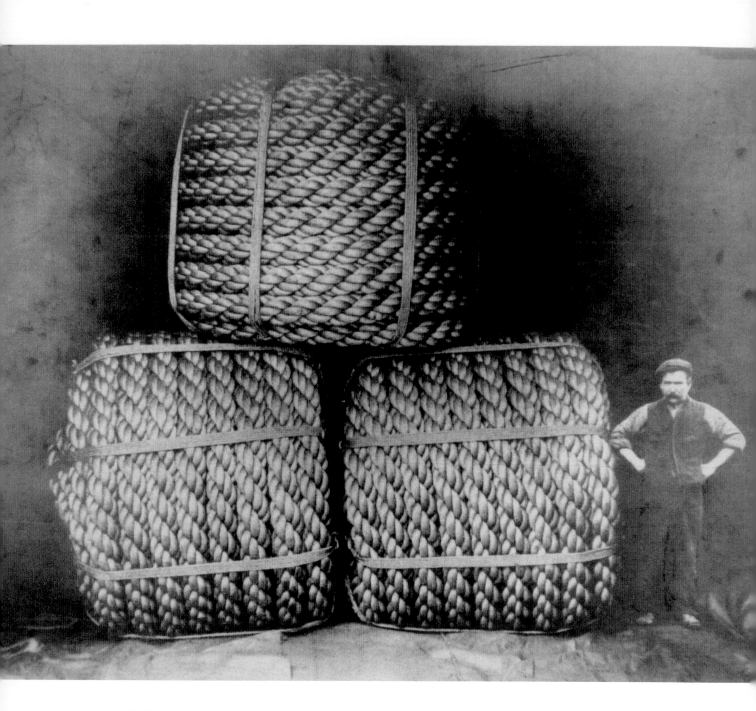

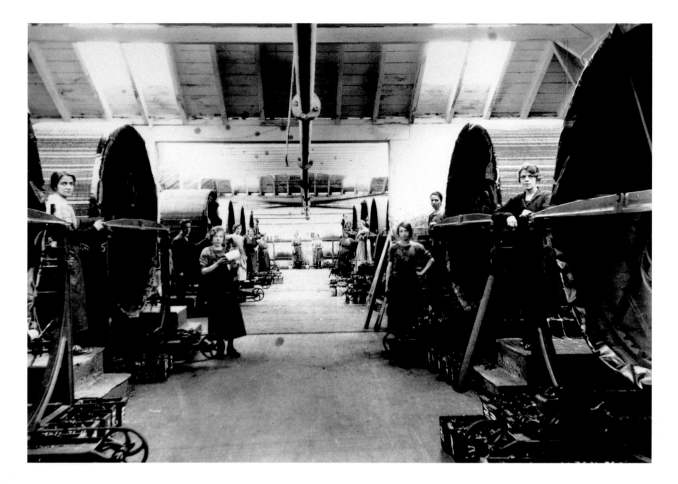

Until the second half of the twentieth century, Dundee dominated the world's jute-processing industry. Much was spun, then woven into sacks for everything from coal to potatoes. Jute fibre was also coiled for ropes, like these huge coils at the Tay Rope Works, Thomson Street, Dundee, *c.* 1910 (left). Loose woven jute was also used as backing for linoleum, manufactured in Dundee but mainly in Kirkcaldy, and for carpets, here in the dyeing room (above) at Templeton's Carpet Works, Glasgow *c.* 1910.

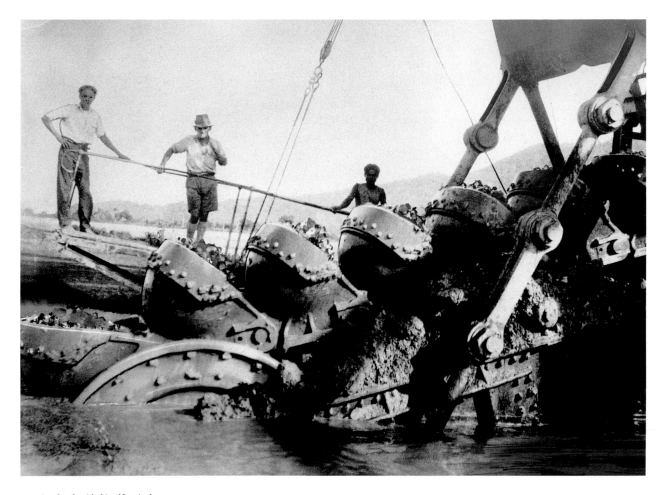

Scotland prided itself on its heavy engineering industry, pioneering many technological developments. Companies such as Lobnitz of Renfrew, makers of specialist marine engines and equipment such as dredger buckets (left), maintained a strong presence in the export market (above, a Lobnitz dredger in operation), but by 1900 they had lost their world-leading role to German and American companies.

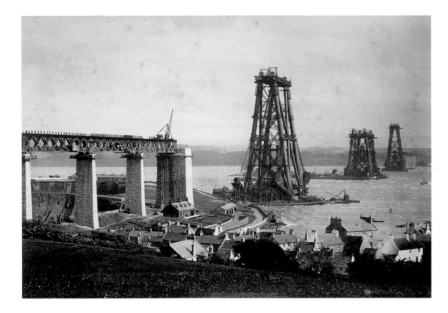

**Forth Bridge under construction,
c. 1888** Photographed as an
engineering marvel throughout its
construction, the bridge is *the* icon
of Victorian Scotland. With a total
span over water of 6,156 feet (1876
metres), it was considered a triumph
of Scottish technical skill, spanning
a river-crossing long considered
unbridgeable. Its engineer typified
another Scots conceit. Sir William
Arrol (1839–1913) was an archetype
of the self-educated and self-made
man, who started work aged nine in a
thread factory, then was apprenticed
to a blacksmith. Moving into boiler-
making, he progressed to large-scale
iron-working and engineering before
being appointed contracting engineer
for the second Tay Rail Bridge and
the Forth Bridge.

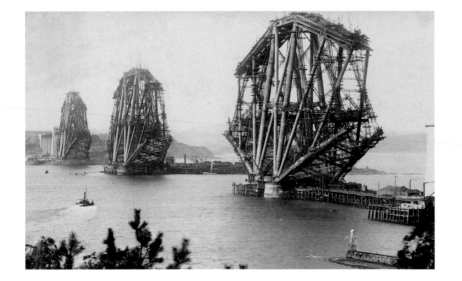

**(opposite and following pages)
Construction of the bridge** marked
the pinnacle of nineteenth-century
Scottish engineering skills. New
technology was stretched to the limit
by the largest single engineering
project of the century, assuring
the public of Scotland's place at
the cutting edge of innovation.
Unfortunately, lack of continued
investment saw Scottish engineering
slip into a backward conservatism
that doomed it to contraction and
failure in the twentieth century.

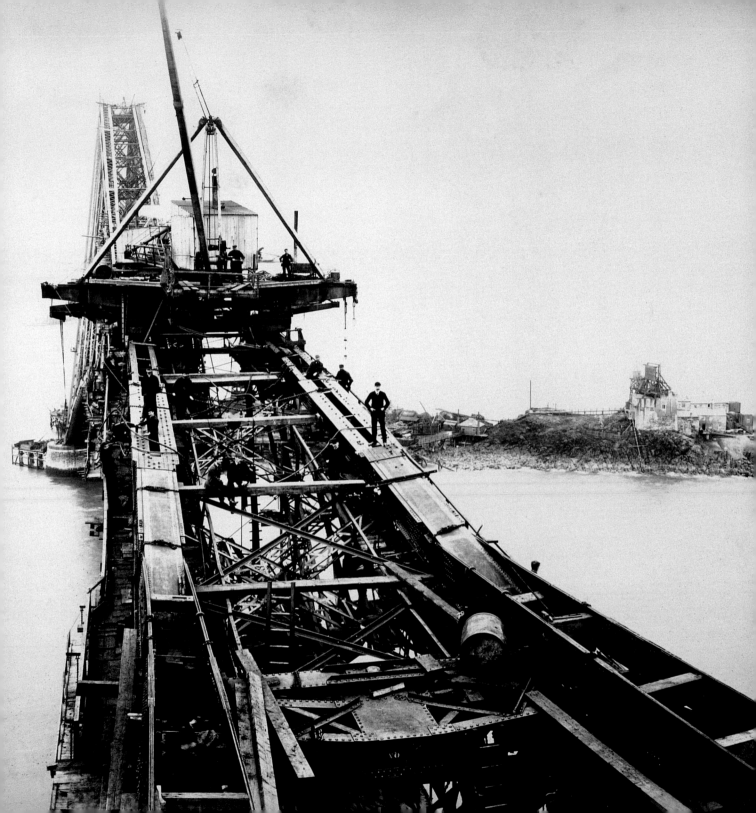

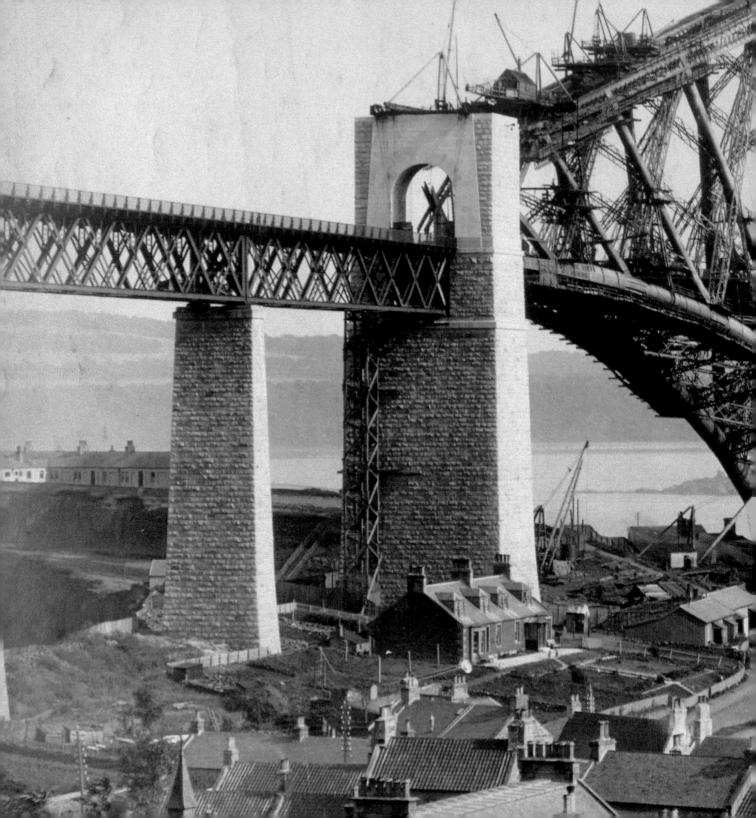

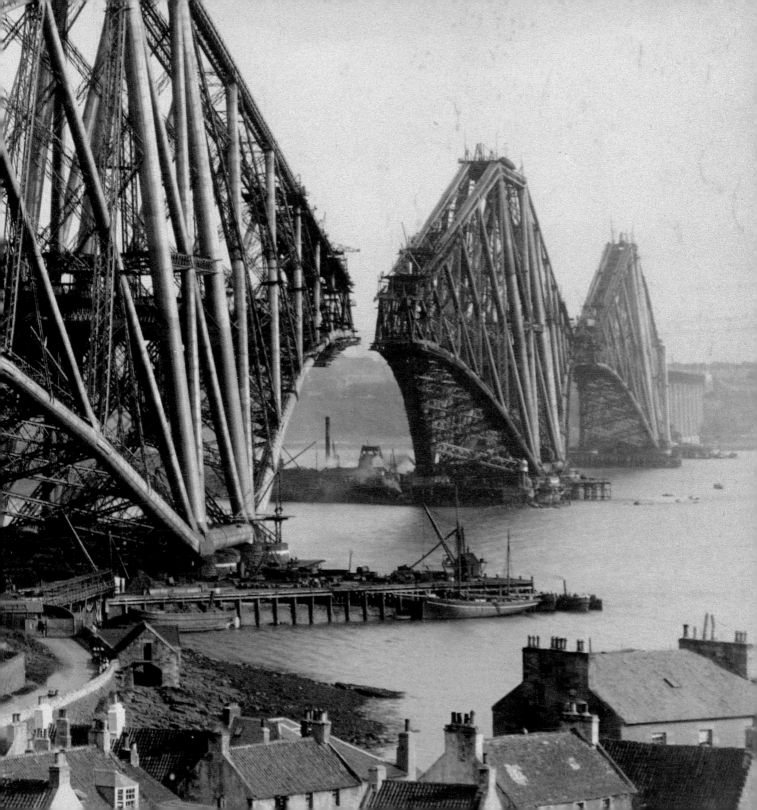

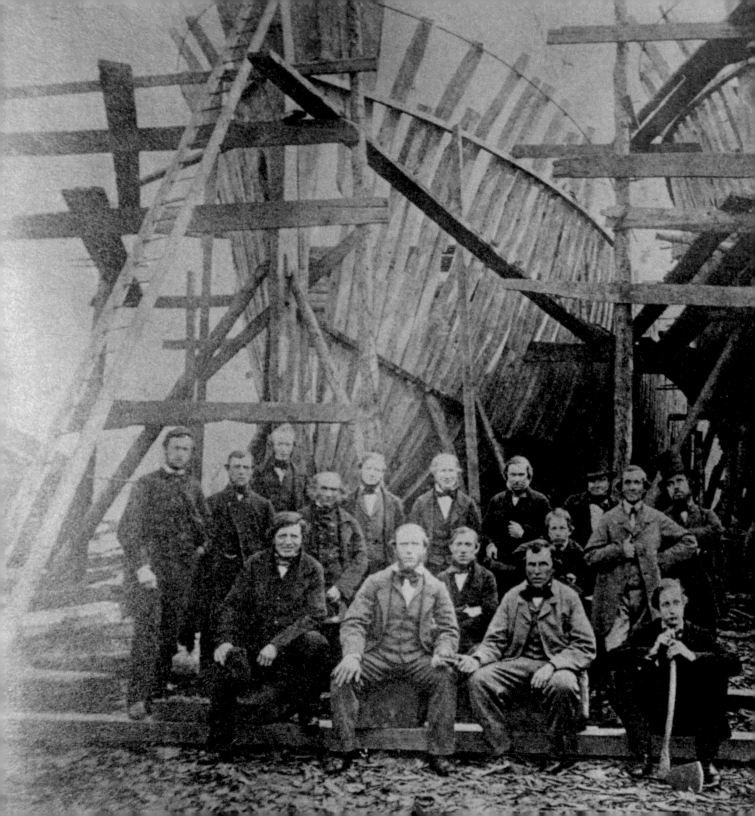

Shipbuilding, Hall Russell Shipyard, Aberdeen, *c.* 1870. Capturing the period of transition between wood and iron as the main material in shipbuilding this rare photograph shows the wooden ribbing of two vessels under construction at Hall Russell's Aberdeen yard. By the later nineteenth century, few yards outside the major centres of Clydeside, Aberdeen, Dundee and Leith still produced ships, concentrating instead on boatbuilding for the expanding fishing fleet. Management, staff and apprentices have turned out in their 'Sunday best' to be photographed.

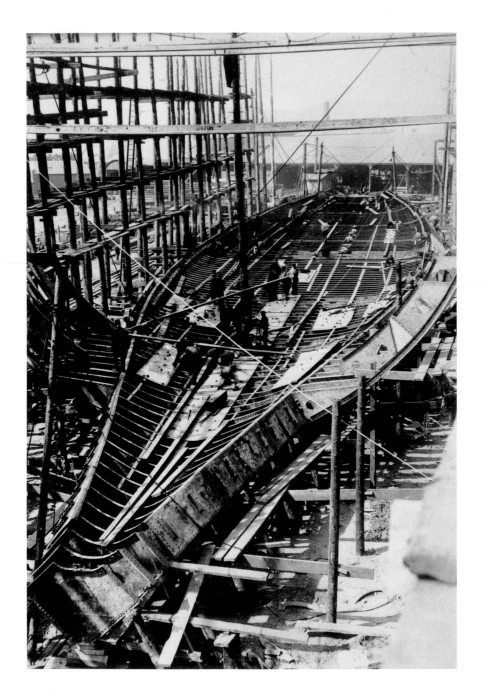

(left) **The new liner** *City of New York* takes shape at Clydebank, 1886. Scottish shipbuilding technology still led the world in the late nineteenth century, although foreign competitors were already threatening to overtake in terms of ship design and the increasing lack of competitiveness of the sector was eroding its market share.

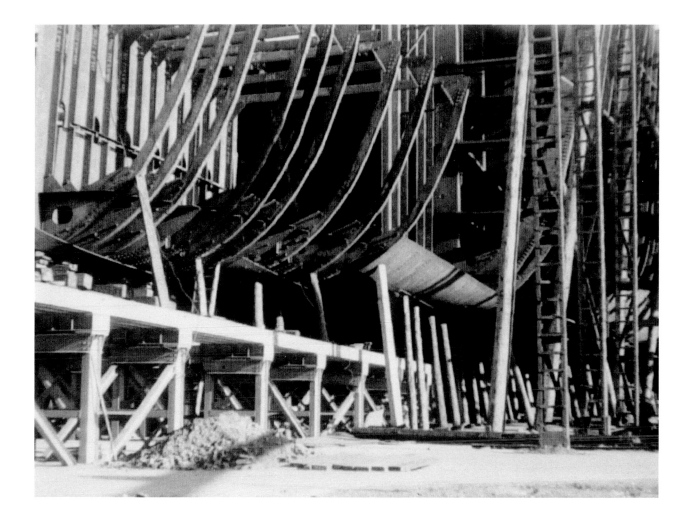

**Although the Clyde had come to
dominate** the Scottish shipbuilding
industry through its proximity to
the coal- and iron-producing centres
around Glasgow, there was also a
strong East Coast-based industry. The
Caledon Yard at Dundee (above), one
of the major builders, maintained a
precarious existence into the 1970s.

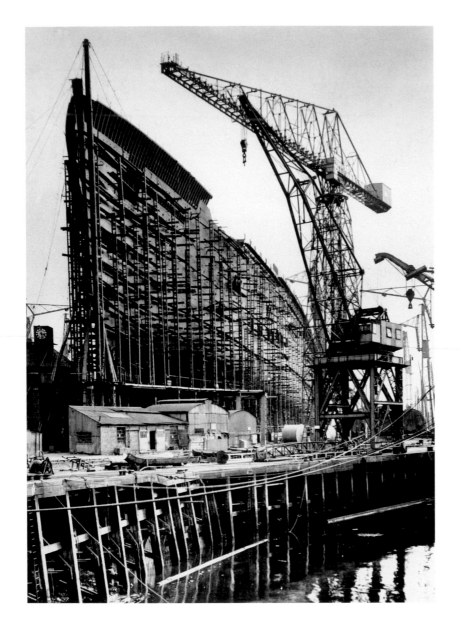

The Wall Street Crash of 1929
and the ensuing global Depression
almost proved fatal to the Scottish
shipbuilding industry. On 10
December 1931, work on the giant
Cunarder ship No. 536 at John
Brown's yard on the Clyde was
suspended as the slump took grip
(left). After the amalgamation of
Cunard and the White Star Line,
work resumed in April 1934,
signalling the end of the slump. No.
534 was launched as the *Queen Mary*.

(right) The morning of the launch
of *City of New York* in 1887 (see also
p. 166). At the time of its launch,
the liner was the largest vessel of its
type with twin propellers, and was
a symbol of Scottish shipbuilding's
continuing technical strength.

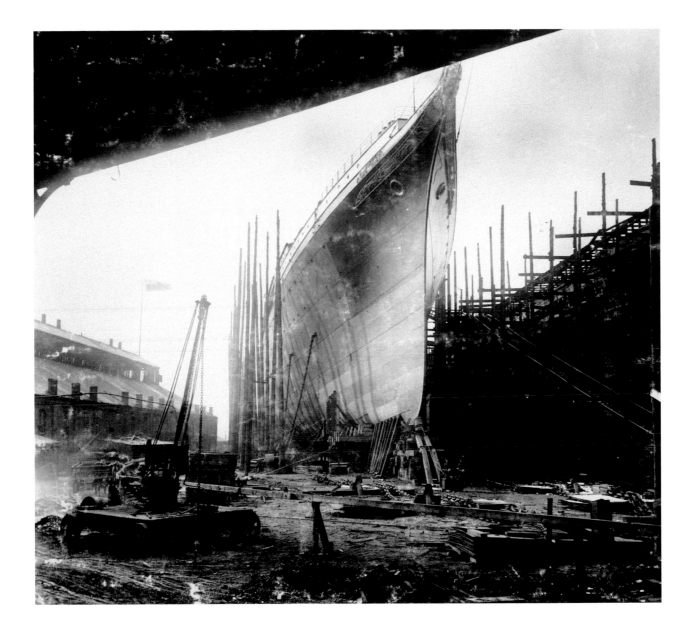

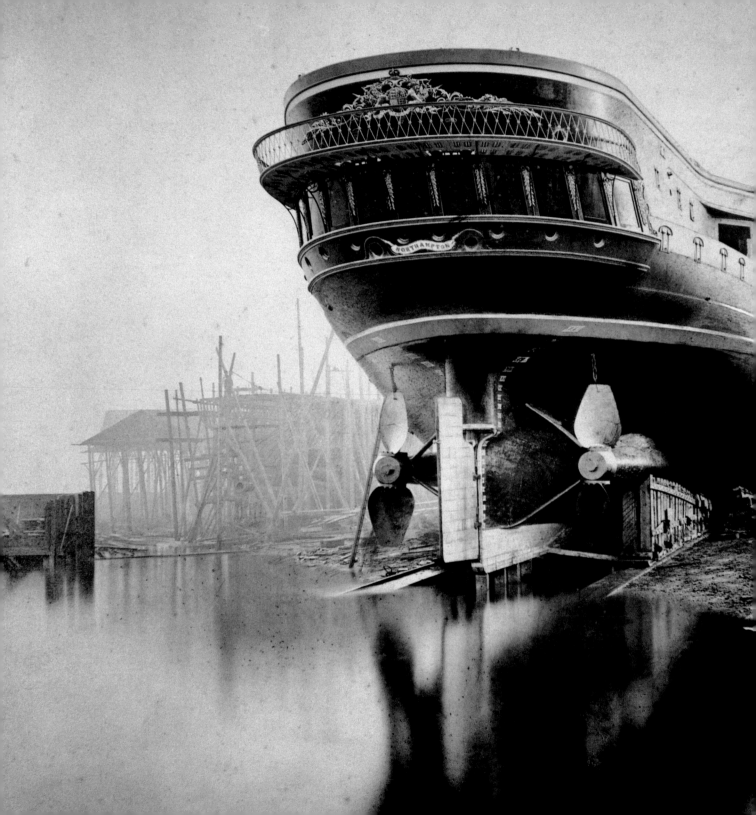

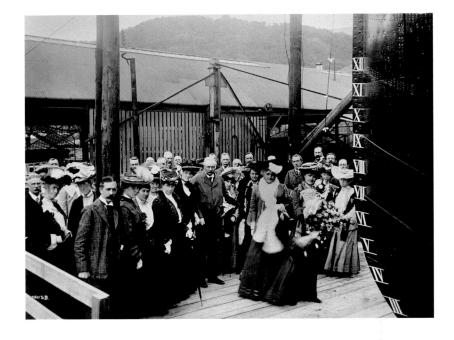

The Clyde was – and is – a centre of naval shipbuilding as well as commercial construction. (left) The cruiser HMS *Northampton* nears completion at Robert Napier and Son's Govan Yard in 1876. Although constructed in iron, the ship's design and decoration shows the Royal Navy's continuing attachment to the trad-itions of the 'wooden walls' of Nelson's day.

(above) Launch of Paton and Hendry steamer *Foyers* at the Scotts of Bowling yard, 1904. Launch day brought celebration for management and workforce alike, and by the late 1800s had developed into something of a festival with leading dignitaries forming a launch party.

chapter 5

transport

The development of the petrol combustion engine and the progressive improvement of road communications from the late 1890s (above) signalled the end of the railways' domination of the Scottish transport system. (opposite) Engine 4447 leaves Aberdeen Railway Station, c. 1925.

Scotland's transport revolution had begun in 1790 with the opening of the Forth and Clyde and Monkland canals, which permitted the bulk shipment of coal and other raw materials from the collieries and quarries of Lanarkshire to the emerging industrial complexes and swelling population centres across central Scotland. The linking of the two canals with a railway between Kirkintilloch and Monkland in 1826 marked the dawn of a new era, for the economic potential of this new transport medium for the rapid carriage of bulk goods and passengers was quickly realized. The first steam railway in Scotland, between Glasgow and Garnkirk, opened only five years later and within a quarter century all of the main cities and towns were joined in a network that was itself linked into the rapidly developing British rail system. By the eve of the First World War, the Scottish railway network stretch from Thurso and Wick in the far north to Portpatrick in the south west, and from Kyle of Lochalsh and Mallaig in the west to Berwick or Peterhead and Fraserburgh in the east. Rail lines had penetrated the central Highlands and Southern Uplands, serving to open up those regions to both commercial development and tourism. The construction of the network was one of the triumphs of Victorian engineering, but it had not been achieved without its share of tragedies.

Scotland's deeply indented coast-line and mountainous interior long posed problems for railway developers. The easy and commercially most attractive routes had, naturally, been

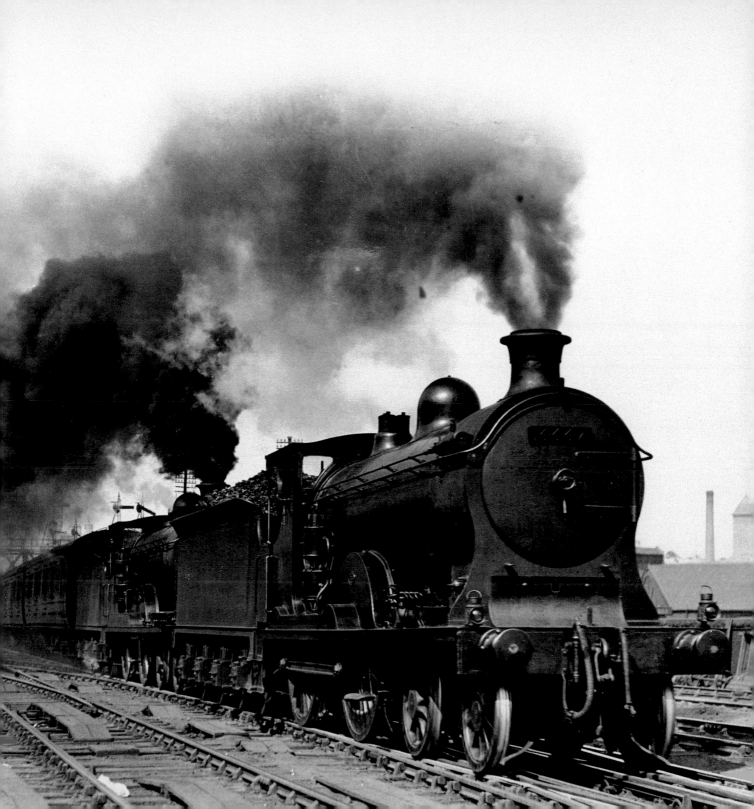

Electric trams revolutionized public transport in Scottish towns and cities, signalling the death-knell for horses as the main power for passenger vehicles. At Aberdeen (below) trams carried day-trippers at the start of the Trades' Holiday across the Dee to Torry and the seaside at Nigg. Motor vehicles also quickly displaced draught horses on commercial vehicles. By *c.* 1920 (bottom), the Dundee jam and marmalade manufacturer James Keiller and Son was running a fleet of lorries.

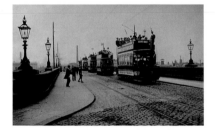

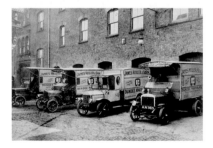

constructed first. A rail link between Scotland and England via Carlisle was opened in 1847, and in 1850 the east coast line between Edinburgh and London was completed. Within Scotland, however, the railway system remained disjointed and various constraints – economic, political and geographical – often forced builders to take less direct routes. On the east coast, for example, the wide estuaries of the Forth and the Tay formed formidable barriers that forced travellers either to take the long, circuitous route via Stirling or Perth, or break their journey to take ferries across the rivers. The first step in completing a direct east coast route was taken in 1871 when the North British Railway Company started construction of a bridge over the Tay designed by Sir Thomas Bouch. At 10,700 feet (3,261 metres) long, it was regarded as a wonder of modern engineering at the time of its opening in 1878, but its collapse in December 1879, taking with it a laden passenger train, sent shockwaves through a society that had grown convinced of its technical infallibility. The North British had just commissioned Bouch to build a bridge over the Forth also, but this project was halted following the Tay Bridge disaster. Eventually, in 1882 the leading Glasgow-based engineer, Sir William Arrol, started work on bridges over both rivers, completing that over the Tay in 1887 and the Forth in 1890. Although the rail network continued to expand into the early 1900s, most notably with Sir Robert McAlpine's line from Fort William to Mallaig, the completion of the Forth Bridge marked the apogee of Scotland's railway Golden Age.

Opening the Lowlands to rail had been comparatively straightforward, but in the Highlands it was a different story. In 1839, the transport system within the Highlands and Islands was still based on the road network laid out by the British military between 1725 and 1767, supplemented by Thomas Telford's road- and bridge-building programme after 1803. By the mid-1840s, plans were in place for a series of railways through the central Highlands, including a line from Perth to Inverness, first opened in 1863. There were numerous other plans that never got beyond the drawing board, or which were built only in part. The Marquis of Breadalbane, for example, whose estates stretched from the Tay in the east to Loch Etive in the west, devised schemes that would open up his property for commercial exploitation. Only parts of his plan were built, including short links between the main rail lines and steamers on Loch Tay and Loch Lomond, which ferried passengers and goods the length of the lochs to rail terminals at their opposite ends. In many parts of the Highlands, this integration of rail and water transport remained in place into the interwar years, the chief example being the train and ferry connections along the Great Glen between Inverness and Spean Bridge.

For the Northern and Western Isles, water-borne transport remained the only medium for

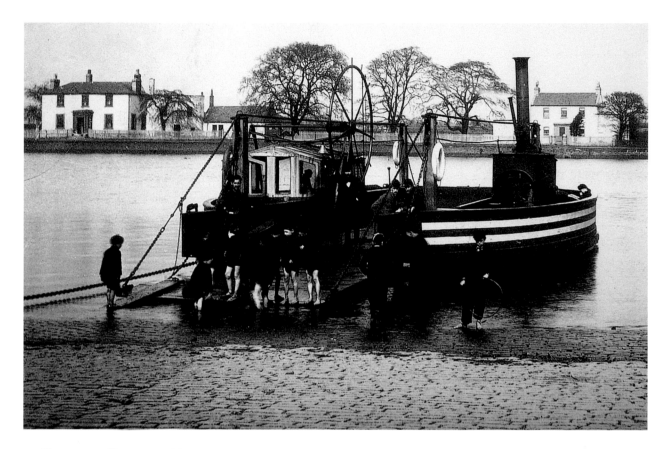

The movement of large commercial traffic on the River Clyde as far as the Broomielaw at Glasgow prevented the building of any bridges over the river downstream from the city. Instead, fixed chain-pulled ferries, the best known of which was at Renfrew (above), carried foot passengers and small vehicles between residential suburbs and industrial areas north and south of the river.

long-distance or bulk transport. A network of scheduled ferry links and commercial carriers had begun to emerge before the end of the eighteenth century, but the nineteenth century saw the development of a more complex network that linked a host of small ports around the western estuaries, sea-lochs and islands. Whereas nowadays water is often considered as a barrier to effective

communication, in the late 1800s and early 1900s it formed a vital linkage between geographically remote communities. By the 1870s, regular steamer services operated across the Solway to Cumbria, the Isle of Man and Liverpool, from the Clyde ports to destinations in Argyll and the Islands, whilst Orkney and Shetland were linked to Aberdeen, Leith and ports further south. Eastern ports, too, were

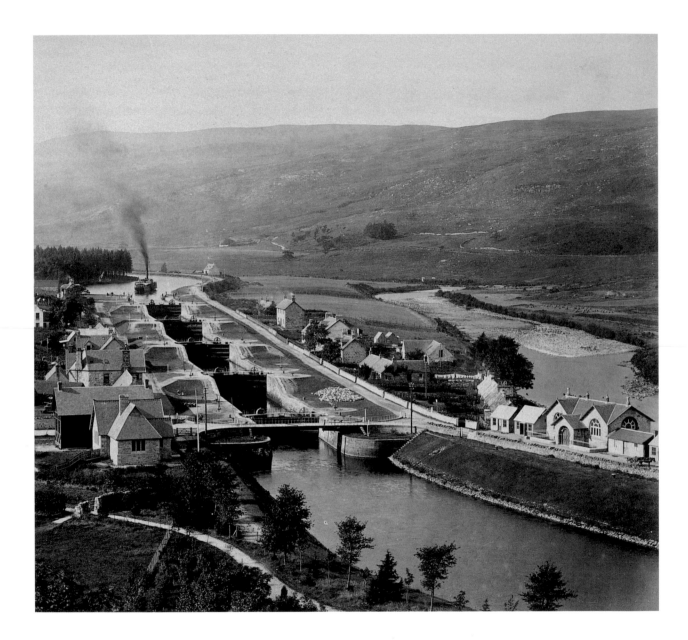

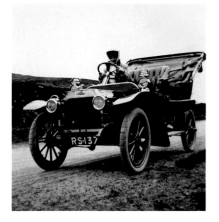

The Caledonian Canal, with its magnificent flights of locks at Fort Augustus (left) and Banavie, was started in 1803 but completed only in 1847. While canals in central Scotland quickly lost much of their traffic to the railways, the Caledonian Canal's use by fishing boats moving from northeastern ports to the West Coast fishing grounds ensured its survival.

Private motor vehicles were, until the post-1945 era, the preserve of businessmen and the rich, such as this wealthy woman driver (above), *c*. 1910.

linked by carrier services that moved bulk goods, such as grain, timber or coal, more efficiently than the railways. Aberdeen, for example, still received most of its coal supply by sea until the middle of the twentieth century, and at Glenmorangie distillery on the Dornoch Firth, which had its own railway siding, barley was still shipped in by water in the late 1940s. On the west coast, by the 1890s, the steamers plying regular routes had been joined by a host of small vessels, characterized by the Clyde 'puffers', that moved goods between the main ports and outlying coastal settlements. Capable of being beached for unloading at low tide, these vessels did not require the deep-water quays and piers needed by the larger steamers, and they thus provided a vital lifeline for communities that otherwise lacked access to the main transport links. As road transport improved in the 1930s and post-Second World War era, and Government became involved increasingly in the nationalization and subsidizing of the transport infrastructure of the country, the role of the puffers declined sharply and they had all but disappeared as a feature of Scotland's maritime communications by the 1950s.

The nineteenth-century development of the Scottish transport system has traditionally been linked closely to the rapid industrialization of the central Lowlands. Transportation of raw materials to and finished goods from the factories was always key to the process, but bulk movement of

agricultural produce and other foodstuffs from country areas to the urban centres was equally important. It was, for example, demand for fish that led to the building of rail lines to the northeastern and west coast ports, while Orkney's grain harvest found a ready market on the mainland, leading to the provision of regular shipping services. Alongside the carriage of goods, however, from the first the new transport systems – which offered cheap fares – were carrying people. Railways and steamers opened up Scotland as never before, permitting a two-way movement of people and produce. Scottish tourism received a major boost through the new services and, after the introduction of statutory Saturday half-days and annual holidays for the working class, trains and ferries, with their cheap fares, opened up to them a previously unreachable world and stimulated the further development of seaside resorts and day-trip destinations, such as Largs, Rothesay or Dunoon. Together with the development of the Royal Mail service, which used both rail and water to carry the post around the country, the new transport services revolutionized Scottish life. New phenomena, such as mail-order catalogues, gave the inhabitants of remote areas access to the same quality and types of goods as the occupants of the main centres. In many ways, this contributed to the erosion of the regional cultural distinctiveness that had been a characteristic of pre-Industrial Scotland, as

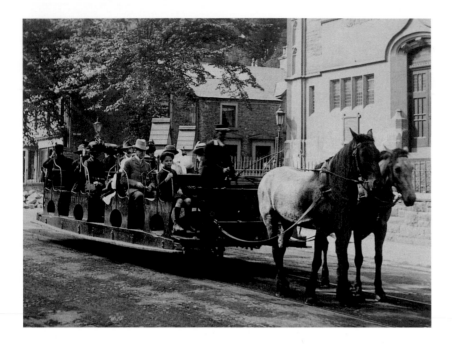

Horse-power had dominated on Scotland's roads since the Middle Ages. Horse-drawn trams for mass transport had been introduced into even provincial towns like Stirling (left) by the 1880s. For the middle and upper classes, the private hansom cab (below) was the preferred form of transport around town. Before the railways penetrated rural Scotland in the late 1850s and 1860s, long distance travel was carried out by stagecoach. (opposite) Coach in the Pass of Melfort, Argyll, *c.* 1880.

local producers found it difficult to compete with the mass manufactured commodities on offer, but in other ways it served to reinforce new identities as individuals became more aware of the wider world beyond their local horizons.

After 1918, rail and ferry's domination of Scottish transport began to fall apart. Although the greatest contraction of Scotland's rail network came with the Beeching Cuts of the 1960s, many of the less commercially viable local lines had begun to close – at least to passenger traffic – in the economically austere 1920s. Advances in motor vehicle technology, moreover, were serving to make road transport more attractive and, with more investment in road- and bridge-building in the 1930s, the Age of Steam gave way to that of the petrol combustion engine. Greater car-ownership and provision of motor-bus services, too, was removing one of the mainstays of the railways, for passenger numbers declined sharply, especially in rural areas. Holiday traffic, too, declined as the middle classes discovered the delights of motor touring. Access to the countryside was now no longer dictated by the routes of the railways.

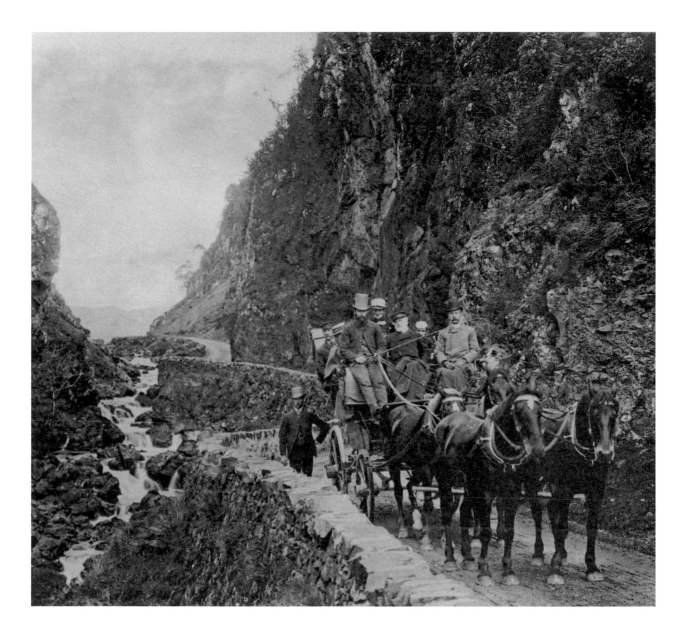

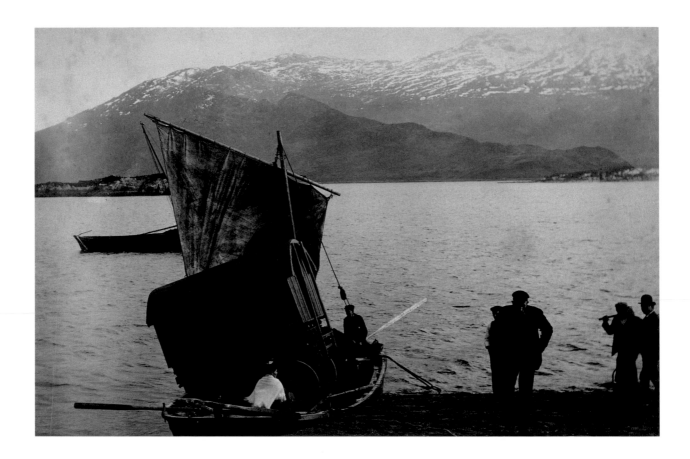

Within the Highlands and Islands,
with their deeply indented coastlines,
water proved a barrier to road
transport. There were few bridges
and ferries were often inadequate to
the demands placed upon them. This
wagon is having a precarious trip
over the sea to Skye, *c.* 1870.

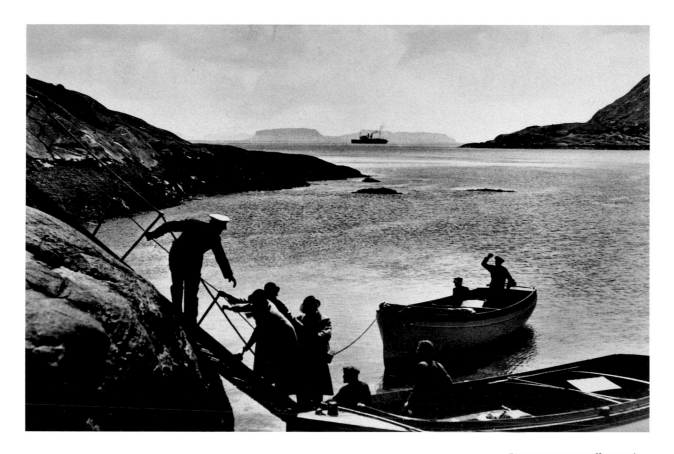

Passenger steamer traffic around the Western Isles increased steadily through the nineteenth century as tourist numbers rose. Harbours and quays with the capability of receiving these vessels were very scarce and arrangements for landing visitors could be precarious, as for these tourists coming ashore from a steamer in Loch Scavaig to see Loch Coruisk in Skye, *c.* 1920.

Elite transport. (left) The smartly turned out carriage and pair, *c.* 1880, was soon threatened by their owners' indulgence in new fashions. (right) A wealthy businessman shows off his new Daimler in Glasgow, 1887.

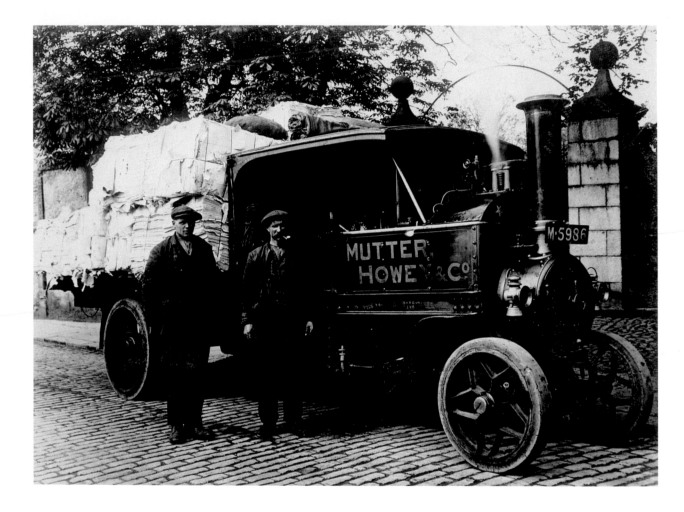

Mutter, Howey and Co. steam lorry, Aberdeen, *c.* 1880. Steam-powered road vehicles, used for carrying heavy or bulky loads, became more common on Scottish roads in the 1880s.

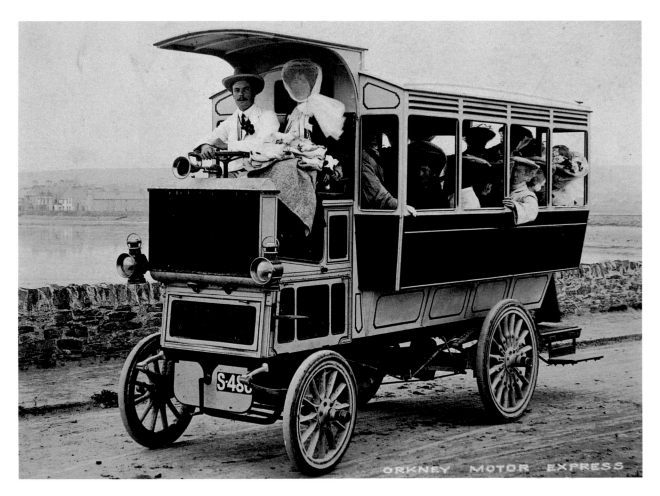

ORKNEY MOTOR EXPRESS

The Orkney Motor Express, *c*. **1910**.
By the early 1900s, petrol-powered
vehicles were registering a presence
outside the main towns and cities.
Motor buses made a quick impact, with
companies offering them for hire for
day-trips to the seaside or scenic areas.

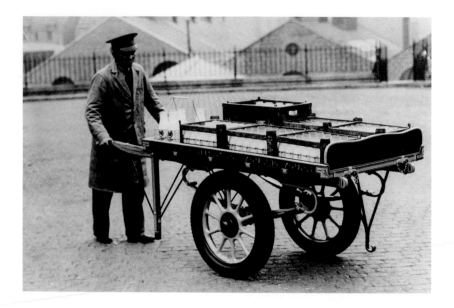

Hand-barrows (left) had been a common feature and obstacle of Scottish streets since the eighteenth century and continued in regular use for carrying small loads until late in the twentieth century. Carriers, private carters who took mixed loads, operated at the level above the barrow-men. 'Parcel Sandy' (below left) operated between Aberdeen and Cults. This form of commercial transport disappeared with the development of motor lorries.

Down to the later nineteenth century, fishwives had walked with their creels all the way from their villages to the towns. Railway and tram companies offered concessionary fares to the women, allowing them to carry one creel free of charge (right).

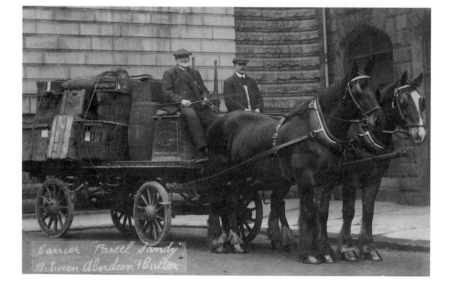

Carrier 'Parcel Sandy' Between Aberdeen & Cults

(**following pages**) One icon crossing another. The Aberdonian Express, from Aberdeen to London, crossing the Forth Bridge, *c.* 1930. This was the golden age of competition between railway companies for the fastest journeys between Scotland and England.

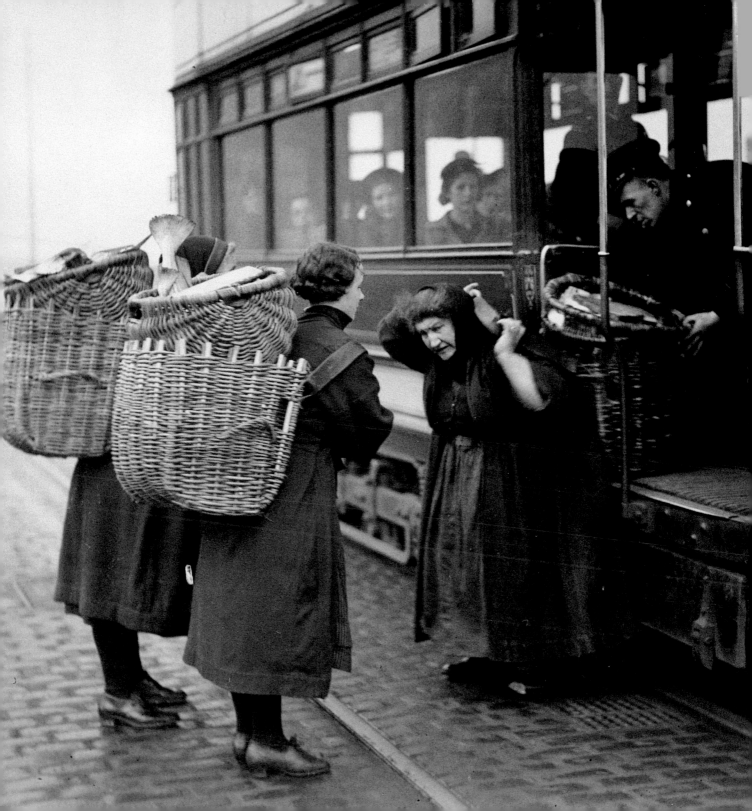

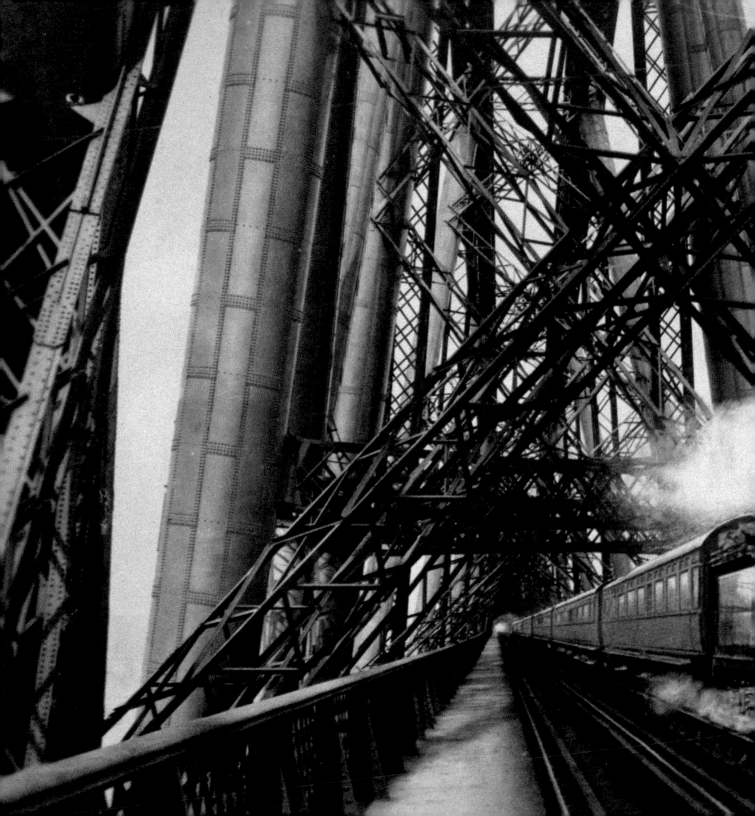

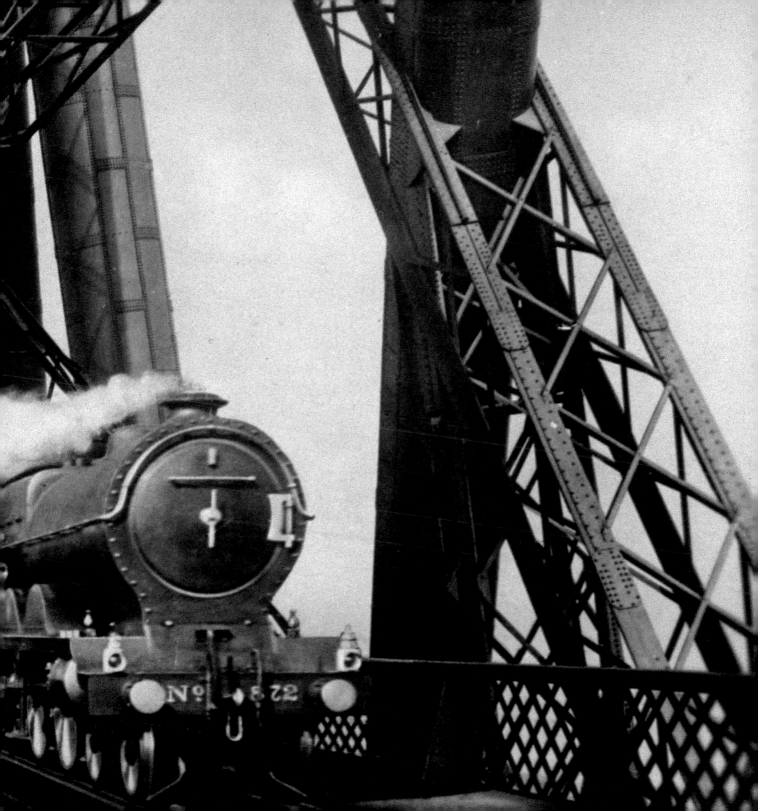

The Scottish-built Kinnaird, c. 1850
(left). The railways in Scotland
expanded rapidly during the 1850s,
with Scottish engineering companies
putting their boiler-making skills
to good use and moving into
locomotive manufacture. The new
technology, however, sometimes
failed spectacularly and the railways
had an appalling safety record
in their early years: (below left)
the results of an exploding steam
compression system, c. 1855.

The arrival of the railways changed
forever the face of most of Scotland's
towns, but perhaps none more so
than Edinburgh (right), where the
main line from England and the
lines running west and north met
in the heart of the city between the
Old and New Towns. The building
of Waverley Station from 1848
onwards required the demolition
of the fifteenth-century Trinity
College, and created a chasm which
helped to separate the slum areas of
the Old Town from the smart and
prosperous new town to the north.

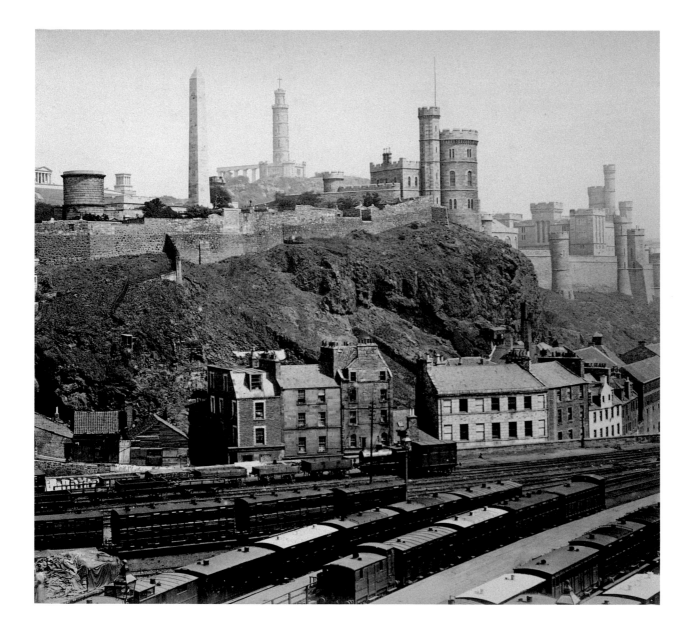

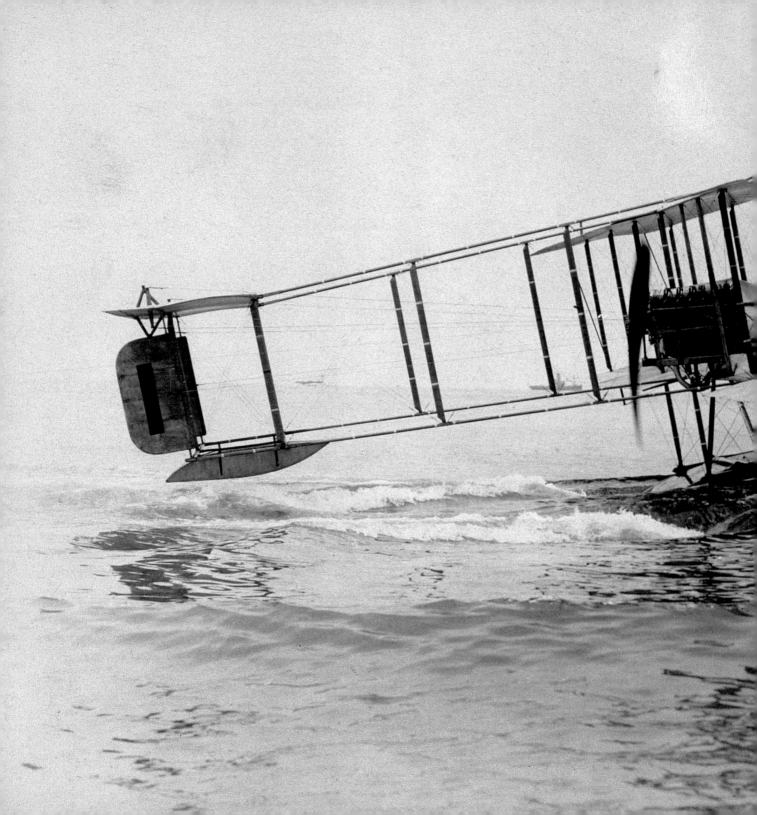

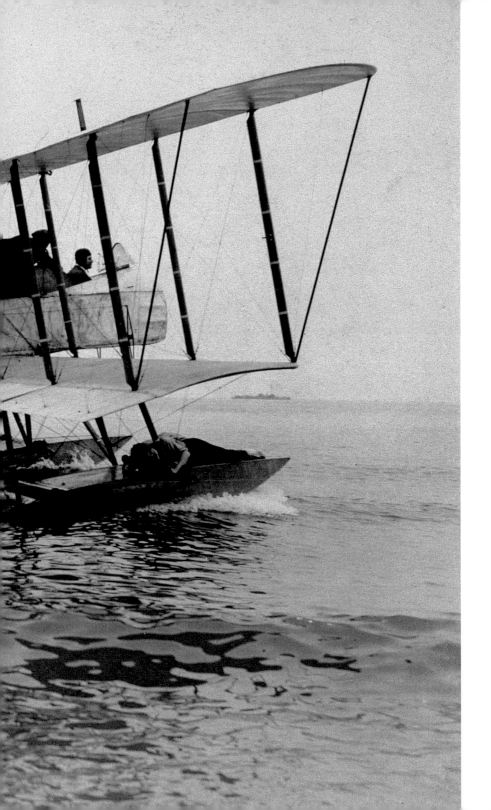

While Scots may have been slow to embrace new industrial technology in the early twentieth century, they were always quick to acquire the new products which that technology brought. In the decades after the Wright Brothers' pioneering flight in the USA, Scottish airmen were amongst the leading figures in aeronautical development.

chapter 6

sport and leisure

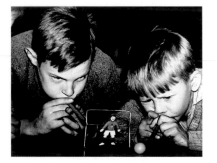

Boys playing blow football, *c*. 1935 (above). Football was a Scottish working-class male passion whose appeal almost outstripped even sex and alcohol as leisure pursuits.

(opposite) Bell-boys carrying guests' golf clubs at Gleneagles Hotel, *c*. 1930. Golf, by *c*. 1875, had joined shooting and fishing amongst the 'accomplishments' of upper-class society. Gleneagles catered for a clientele far removed from the players at the country's public courses.

Until the second half of the nineteenth century, leisure time, other than the hours spent by male workers in the pub, was not a concept that meant anything to the average Scot. Long working hours, a six-day working week and limited finances ensured that leisure time was an ill-affordable luxury for ordinary people. Fairs and the annual Trades' Holidays offered the main recreational activities outwith the licensed trade, but social reformers considered them as little more than occasions for fornication, drunkenness and crude entertainments. Generally, there was also little by way of sporting activity involved, other than as spectators at the horse-racing that was a feature of some local fairs. What could be termed as 'leisure activities' were largely the preserve of the rich.

'Sport', in the sense of hunting, was, *par excellence*, the pleasure of the landowning class. Hunting acquired a new cachet from the 1850s as Queen Victoria's family embraced the outdoor, sporting life and used it to project an image of health, dynamism and individual prowess. Coupled with the Queen's own Romantic attachment to the Highlands, pub-lication of images of her extended family indulging their passion for the hunt on Scottish mountains and moors secured the country a reputation for sporting excellence. The hunting offered by Scottish estates was a jealously guarded prerogative of their owners, enjoyed by only a favoured few and their guests. Game rights had gained increased significance when plummeting incomes from wool as a result of cheap bulk imports from

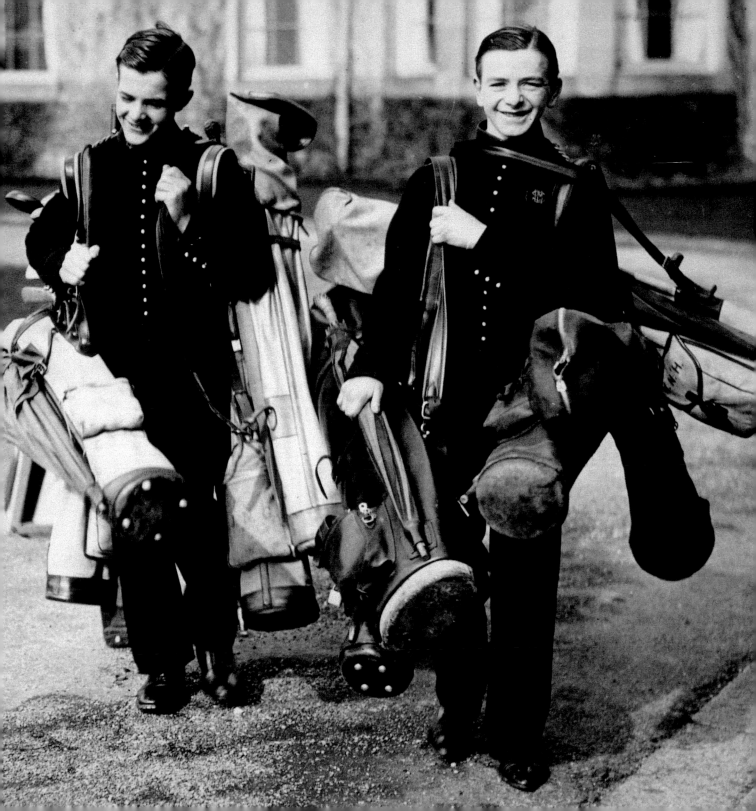

The 1920s and 1930s saw the emergence of many strange 'sporting' fads for those with the leisure time and money to indulge themselves, but perhaps none was as bizarre as ski-ballooning. Above, an enterprising young female exponent of the sport, *c.* 1925.

Australia forced estate-owners to maximize the potential of other assets, especially shooting and fishing on their properties. In some parts of the Highlands and Borders this move brought a new wave of Clearance as sheep-walks were replaced by deer-parks and grouse moors. Shooting rights were rented out, often to high-society aspirants, for whom entry to the hunting, shooting and fishing fraternity marked social arrival. The new class of industrialist-aristocrats, such as the Bulloughs, Langs and Carnegies, acquired Highland estates as part of their personal portfolios, where they could retreat for private holidays and entertain peers, politicians and clients. The country house shooting-party became one of the great social events of late Victorian and Edwardian Scotland, where sport combined social interaction and public displays of personal skill. Game books were kept as records of individual achievement on the moors. One day on the Fasque estate in Kincardineshire in 1905 saw the laird and seven guests bag over 3000 pheasants.

Shooting on this scale entailed careful management of resources and estate-owners and shooting-tenants took pains to safeguard the value of their investments. One consequence was an attempt by landowners to control access onto and through their estates. Such policies caused friction with other groups, who were starting to view the mountains and moors as recreational facilities – in particular from the 1880s the growing number of

hill-walkers and climbers, and amateur and professional botanists and ornithologists. By the closing decades of the nineteenth century, there was a developing conflict between the shooting interests and these other groups, rooted partly in the political wrangles of the day surrounding Highland land-reform and partly in the entrenched stances taken by both sides. The Scottish Rights of Way Society negotiated a number of access agreements, especially in the Cairngorms, but in the 1920s and 1930s, as increasing numbers of working-class people became involved in hill-walking and mountaineering, the old conflicts re-emerged as politically radical 'right-to-roam' activists confronted landowners' attempts to regulate access. It is an issue that still raises strong passions today.

One sport that originally bridged the social divide was golf, but its nineteenth-century re-organization also secured for it an elitist tag. The old Society of St Andrews Golfers had been re-established in 1834 as The Royal and Ancient Golf Club under the patronage of the future King William IV, and swiftly secured for itself a pivotal role in the formalization and development of the game. From that date, while golf remained popular with a broad social range, its structure was controlled increasingly by the middle and upper classes – who had the leisure time to play – and equipment costs moved it beyond the reach of most workers. For ordinary people, their closest contact with the sport was as caddies

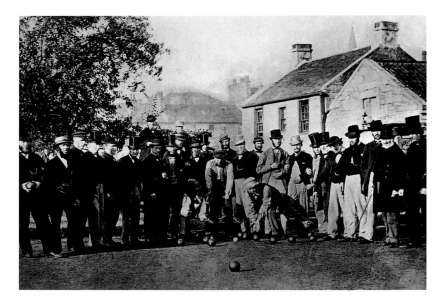

The introduction of half-day holidays for the working classes in the 1860s saw the development of sport and recreational facilities designed to ensure that workers expended their energies in moral and healthful activities rather than drink, illicit sex and radical politics. It is perhaps difficult to see bowls (right) or draughts (below) as alternatives for any of these pursuits, but they enjoyed tremendous popularity amongst men.

for the wealthy who took up golf in increasing numbers. As with most sports of this period, its formal club structure made it an almost wholly male preserve, and the social composition of the clubs entrenched an atmosphere of exclusivity. An explosion of popularity in the game from the middle of the nineteenth century, which saw the organization of the Open Golf Championship and the making of sporting legends in the person of Tom Morris (green-keeper at St Andrews 1863–1908 and Open Champion in 1861, 1862, 1864 and 1866), encouraged the formation of new clubs and new courses around the country. It was, however, only after 1918 that public courses began to be developed in numbers, opening the game to a growing working-class following.

Leisure time for the working class had arrived in the 1860s with the statutory introduction of a Saturday half-day holiday. It is no coincidence that organized sporting activities for the workers burst into being at the same time. In an age saturated with the ethos of health, fitness and godliness, sports clubs offered a medium through which physical – and moral – fitness could be provided alongside fellowship that was Christian and exclusively male. Clubs took many forms and offered a range of sports, from quoits and bowls through to shinty and football. Mass games of football were (and still are) played in various parts of the country since the Middle Ages, but what we would recognize as modern association football was first played in

Scotland in 1815 at Callander in an unofficial 'Scottish Championship' between teams from the Highlands and Lowlands. Amateur clubs, however, were slow to develop and it was another fifty years before a club network began to form. Many modern Scottish football clubs had their origins in amateur sports groups, from Queen's Park (founded 1867) with its early links to the YMCA, through to Celtic (founded 1888), organized by the Marist priest, Brother Walfrid, to raise money to provide free school meals for poor Catholic children. Brother Walfrid, however, was not the first man to see the money-making potential in the game and by the 1870s many clubs were charging spectators who came to watch their matches. Professionalism was a short step away, and a formalized club structure was established in 1872 with the founding of the Scottish Football Association. By the 1890s, there were between 130 and 190 clubs in Scotland, and Celtic could build a stadium capable of holding 70,000 spectators. In 1906, 121,000 supporters watched the Scotland–England International and in 1937 the national stadium at Hampden Park hosted a world record 149,515 for the same event. Football could claim to hold a greater significance than organized religion for many working-class Scotsmen, who attended games in greater numbers than they attended church.

The numbers of men watching the Internationals reveals other aspects of Scottish football. Reinforced by its wholly separate league structure and the emergence of a national team, by the early 1900s football had become a potent symbol of national identity. It also served as a vehicle for the expression of other, more local identities, as clubs drew on and absorbed the traditions and prejudices of the communities in which they were rooted. By the mid-1890s, the sectarianism that blighted Scottish football throughout the twentieth century had already established its presence in the rivalry between Celtic and Rangers in Glasgow. The rioting that followed the Celtic–Rangers Cup Final of 1909, which saw around one hundred fans injured, set a pattern of inter-community sectarian violence on and off the pitch, to which additional bitterness was given by the teams' identification with Irish Nationalist and Unionist politics. The problem could be dismissed glibly as a manifestation of working-class tribalism, for the middle classes had deserted football largely in favour of golf and rugby, but the rivalry was manipulated by the businessmen and political figures who formed the boards of the professional clubs, and intensified by the partisan reporting of the Press. If football was a national game, the violence and sectarianism endemic within it was surely a reflection of the inner disorders of Scottish society.

Unlike football, rugby's presence was more tenuous. The game was imported to Scotland in the mid-nineteenth century, coming as part of the 'off-the-shelf' introduction of English-style private schools in Edinburgh

and Glasgow. As a result, until the second half of the twentieth century many Scots viewed it as a 'toff's game', played by the sons of the privileged. The exceptions were to be found in the Borders towns, where it served as an alternative to the anarchic mayhem of the traditional games of mass street-football, such as Jedburgh 'Hand Ba' '. Despite its limited appeal, the game developed fast in Scotland and, in 1871, a Scottish team was able to take on and defeat an English side at Edinburgh. Two years later, the Scottish Rugby Union was set up as the official governing body for the game in Scotland.

At their peak in the mid-twentieth century, field sports clubs in some parts of Scotland drew on a membership of around 25 per cent of the young adult male population. There

had also been active female involvement, with women's teams associated with some of the big men's clubs in the Central Belt, but in a society that still considered the woman's place to be in the home, few survived beyond the late 1920s. In such an environment, few women outwith the leisured classes had the opportunity to become involved in regular, active sport, and were steered instead towards Church groups which placed great emphasis on domestic and mothering skills. It was only in the second half of the twentieth century that women succeeded in breaking into the world of male-dominated sport.

Leisure, of course, was not solely sports-oriented. In a society that traditionally placed great emphasis on self-improvement, and where healthy activity was seen as a

Rugby, which long struggled in most of Scotland with an image of being an 'English' game for middle- and upper-class boys, was introduced in the mid-nineteenth century as part of the development of English style boarding schools. Its popularity, however, burgeoned, and in 1871 a Scotland team (right) was able to take on and defeat England.

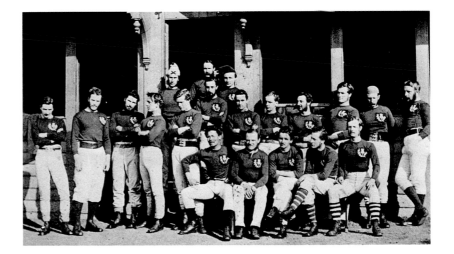

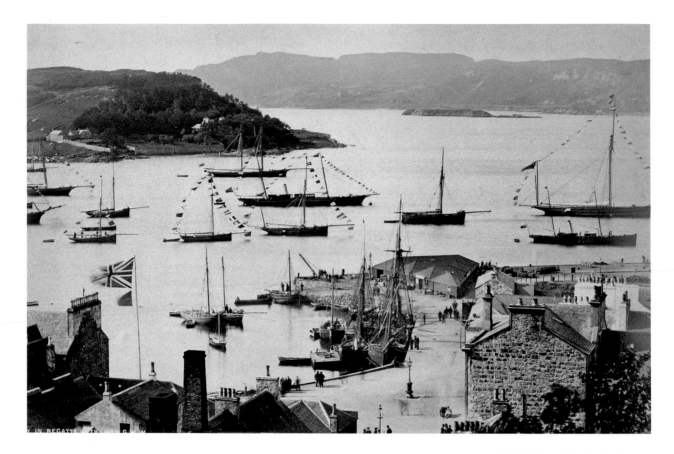

moral and spiritual good, educational and
intellectual developments were considered
equally important by social reformers as
healthful leisure pursuits for the workers.
Throughout the later nineteenth century, there
was a proliferation of Mutual Improvement
Associations, where workers were encouraged
to share their skills and knowledge with others,
and where they could hear guest lecturers. But

such activities failed to engage with the mass
of the urban poor, many of who were under-
educated and too overworked to sacrifice their
limited free time to pursuits that brought little
perceptible reward. Indoor leisure instead
revolved around the pub and the music hall,
and, from the 1920s, the cinema and dance
halls. Leisure for the masses meant pleasure
and relaxation.

Until the later 1800s, Scotland's coasts
and beaches were considered mainly as
productive working areas rather than
places of leisure, other than for the idle
rich. Yachting developed as a passion
of the rich in the period 1880–1911,
largely through its association with
the Prince of Wales (later King
Edward VII). Regattas, such as at
Oban (above), *c.* 1890, were key events
in the high society calendar.

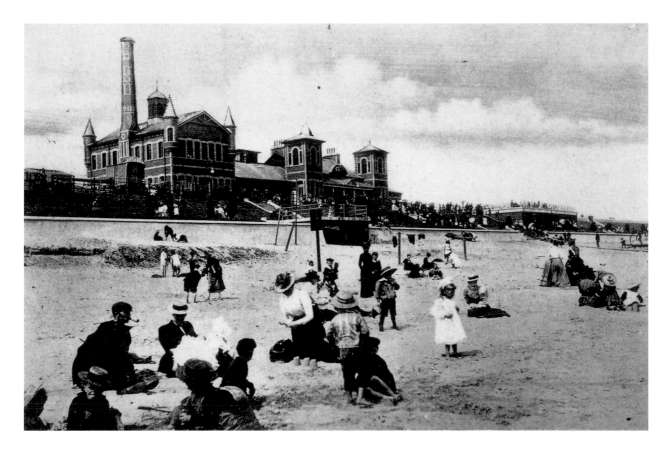

As the idea of the traditional English seaside resort spread northwards, Scots began to discover the pleasures of their own coastal areas. Aberdeen (above) constructed a promenade, beach pavilions and other facilities for the middle- and working-class families to spend their half-day holidays. By 1900, Scotland had acquired the whole paraphernalia of the seaside, from punch-and-judy shows (right) to ice-cream parlours, donkey rides and winter gardens.

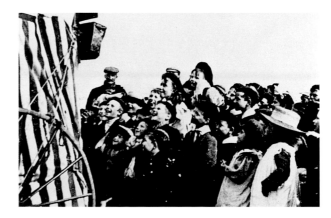

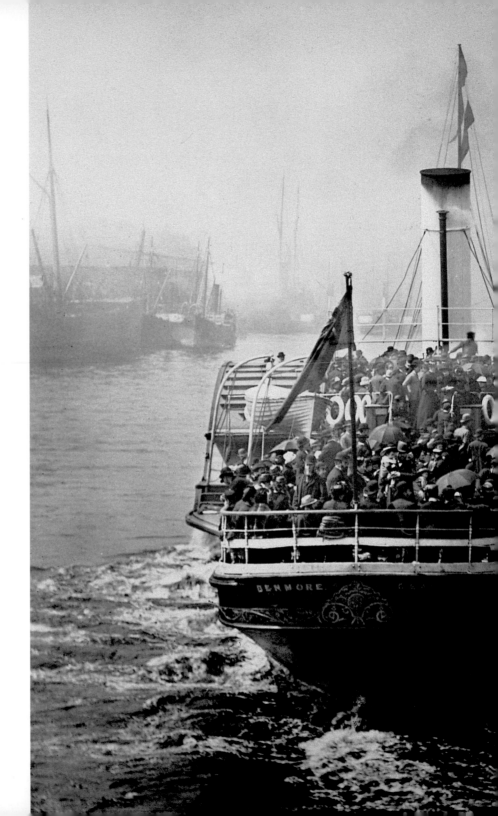

Paddle steamers leaving the Broomielaw, Glasgow, early 1900s. No city embraced the idea of the working-class holiday or pleasure trip quite like Glasgow. Its location, within easy reach of Loch Lomond by road and rail, or the Clyde estuary by steamer, saw the development of a distinctive style of day-trip. 'Doon the watter' – trips by water to Dunoon, Hunter's Quay, Largs, Rothesay and Brodick – became an annual highlight of Glasgow workers' holidays.

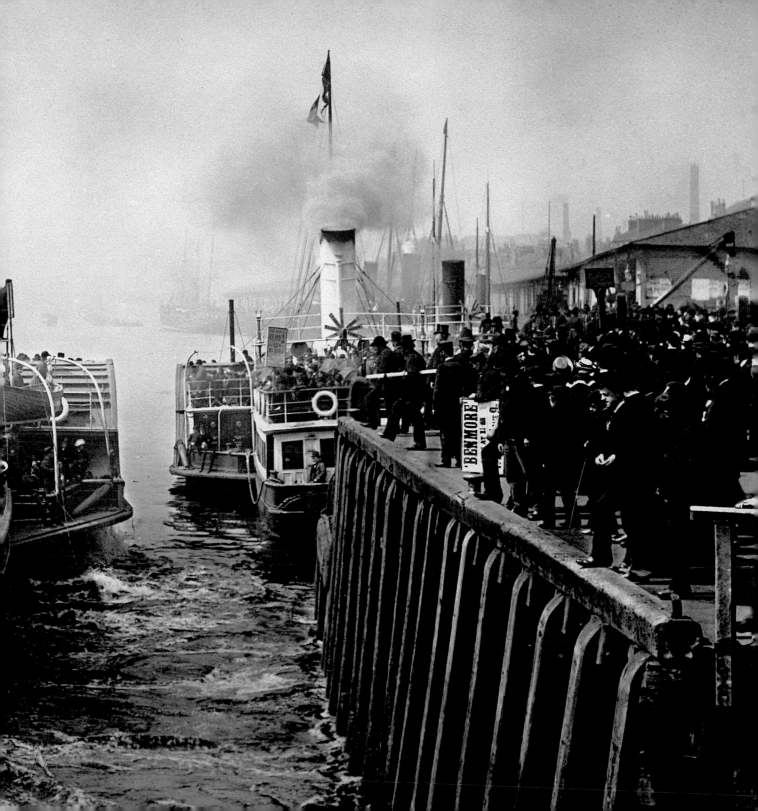

204 sport and leisure

Since the late eighteenth century, Scotland had been acquiring a reputation as one of the finest 'sporting' areas in Europe, especially for the quality of the shooting available for wildfowl (left) and deer (below right). As estate incomes from traditional sources declined in the later nineteenth century, increasing numbers began to be given over to game and the shooting rights let out. The development of sports shooting also stimulated the growth of competition target-shooting, with the Scottish team captained by Horatio Ross (above right) performing well in several international competitions in the 1870s.

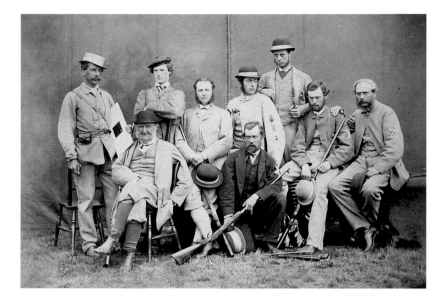

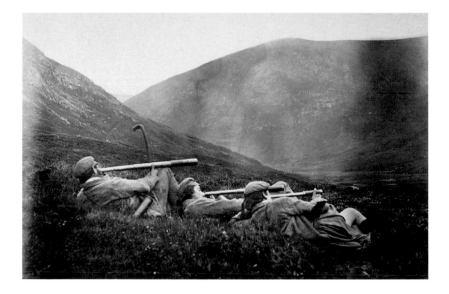

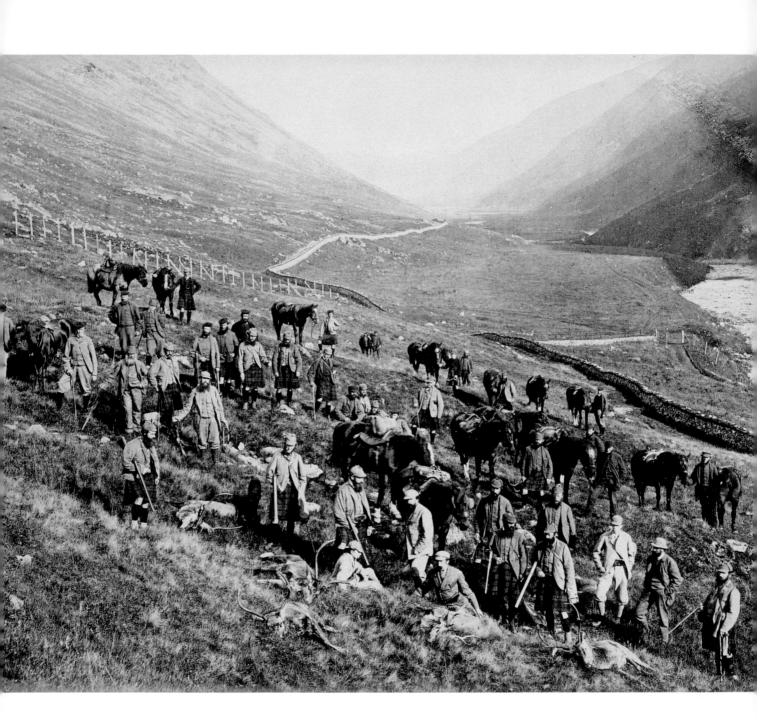

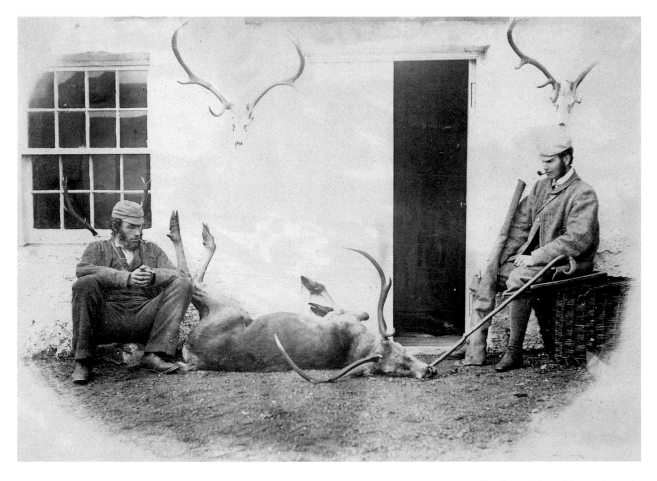

Shooting rents brought economic security to some of the bigger Highland estates in the late 1800s. Teams of ghillies saw to the ponies, gave advice and carried equipment for paying guests. Less than a quarter of the party opposite were the tenant and his guests. Highland red deer (above) was seen as providing the best sport in Britain.

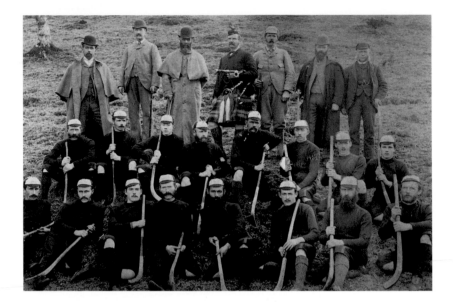

Two distinctively Scottish contributions to sport: shinty and golf. Shinty (left) was played all through Scotland in the seventeenth century, but by the nineteenth century was limited to the Highlands and Islands, where it was organized by the Camanachd Association.

(below left) Sir Hugh Playfair and golfers at Scotscraig Golf Club, *c.* 1849. Playfair (1786–1861), a son of a former principal of St Andrews University, returned from India in 1834 and devoted his energies to restoring the fortunes of his home town and university. He was instrumental in the revival of the 'Society of St Andrews Golfers', which was re-established as the Royal and Ancient Golf Club under the patronage of the future King William IV. Playfair (centre left) also founded the Scotscraig club; he is shown here with the ground's owner, John Dalgleish (centre right), club members and caddies.

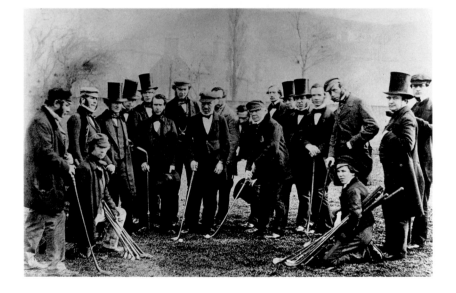

By the late 1800s, St Andrews (right) had established its place as a golfing metropolis and centre of the sport's premier regulatory authority. Like most sports, it was a largely male preserve, although middle- and upper-class women began to make their presence felt in the early 1900s. Around 1900, when this scene at St Andrews was photographed, women did not have regular access to the formal courses.

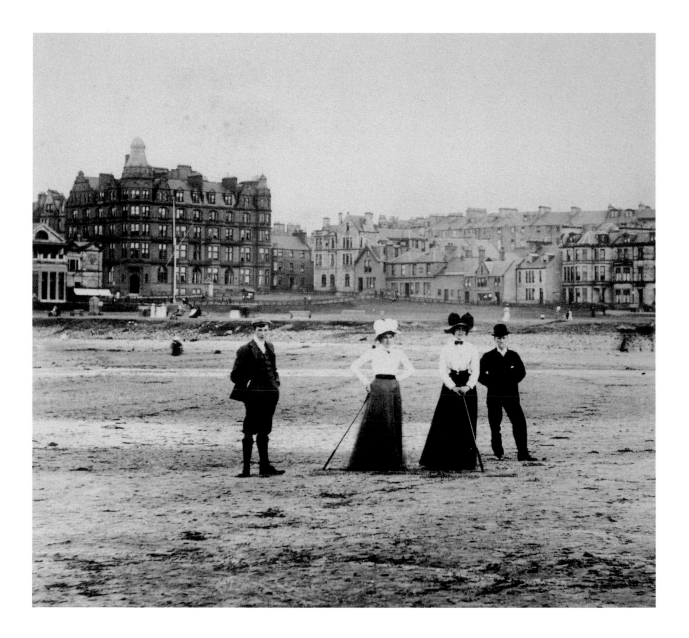

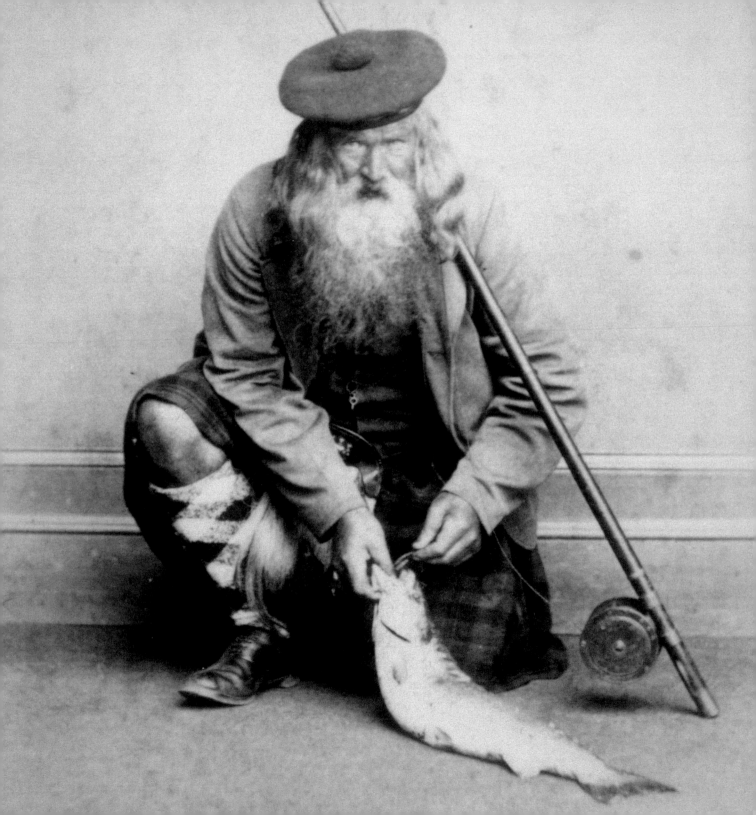

Game fishing, like shooting, became increasingly popular with the upper and middle classes in the later nineteenth century. Skilled ghillies and anglers like Will Duff (left), a master of the Spey salmon fishing, were feted like modern sport-stars.

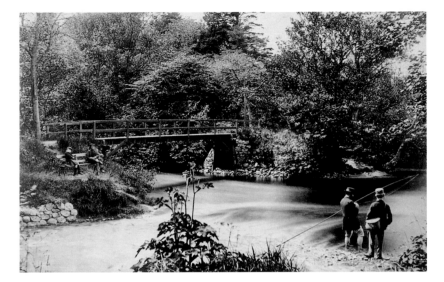

Anglers, Ness Islands, Inverness, *c.* 1870 (above right). As the upper reaches of most of Scotland's salmon rivers became the exclusive preserve of the sporting estates, the opportunities for ordinary anglers to enjoy their sport became limited. 'Town beats', the sections of the river where fishing rights were part of a burgh's privileges, became among the few areas where access was affordable for ordinary individuals. Estate beats were jealously guarded economic assets rented out to tenants, whose money provided employment to water bailiffs, ghillies and boatmen (below right).

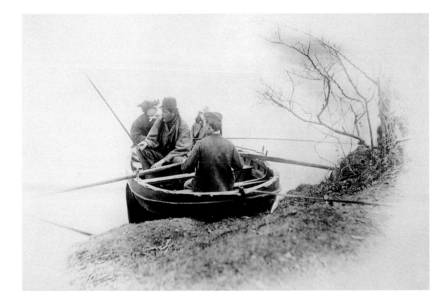

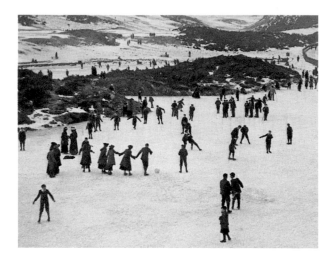

Curling, Berwickshire, *c.* 1880–90 (right). Scotland's unique contribution to winter sports dates from at least the early sixteenth century and achieved formal recognized status in 1838 with the founding of the Royal Caledonian Curling Club. Until the 1920s, curling was a popular outdoor winter activity for all social classes throughout Scotland, with most estates, rural communities and urban parks having a pond. Any harsh winter provided the opportunity for curling bonspiels on frozen ponds and lochans, but any frozen water was seized upon by all classes to indulge a Scottish passion for ice-skating, as at Dyce on the River Don in 1904 (above). Indoor ice-rinks were an innovation imported from the USA in the twentieth century.

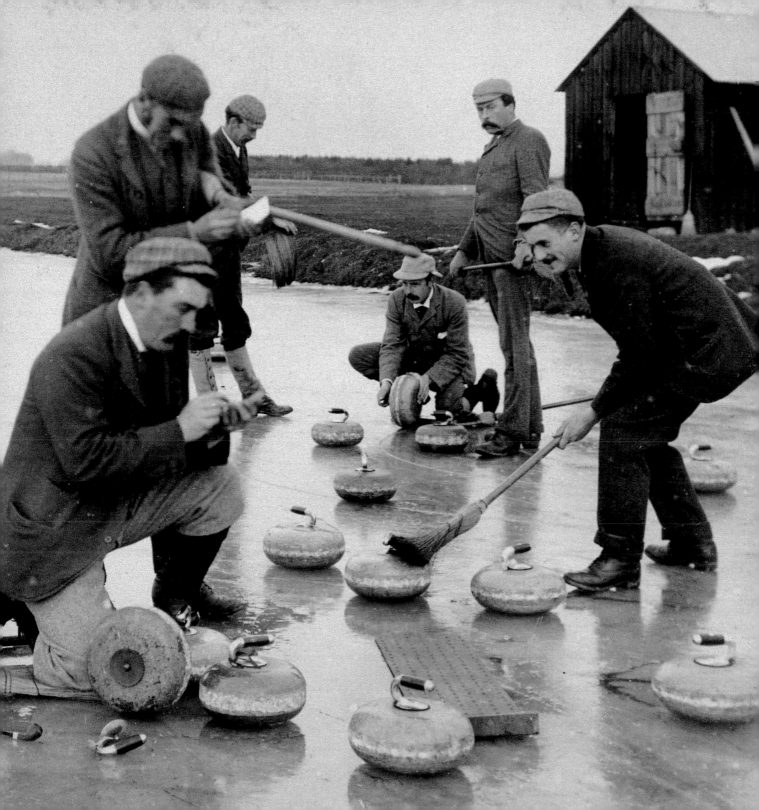

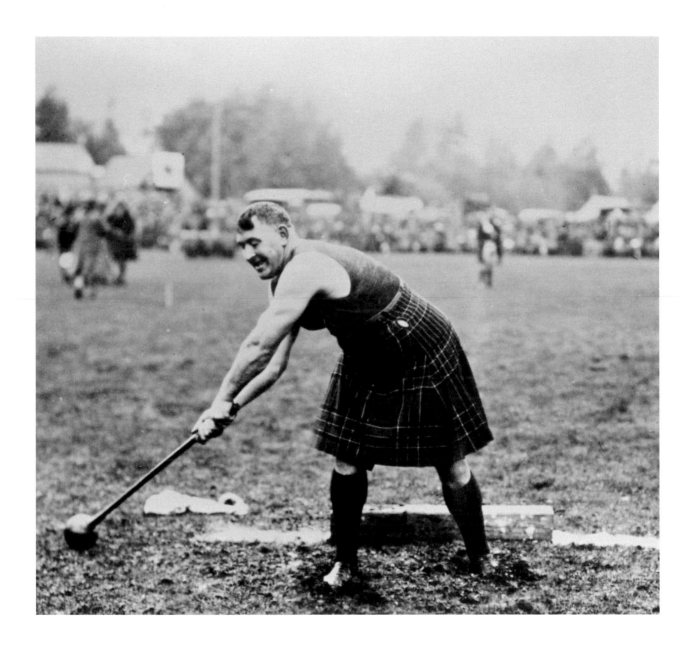

Amongst the many elements of the Victorian ideal of the Highlands, the Highland games, which combined traditional sports with dancing and piping competitions, have been among the most enduring. (left) Hammer-throwing at the Braemar Gathering. (right) Sword-dancer and piper *c.* 1890.

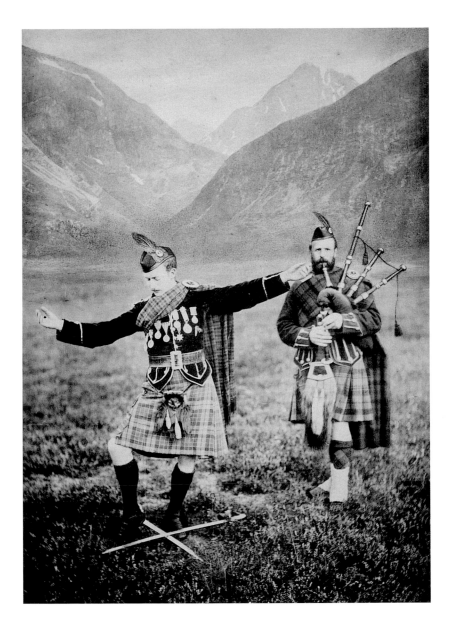

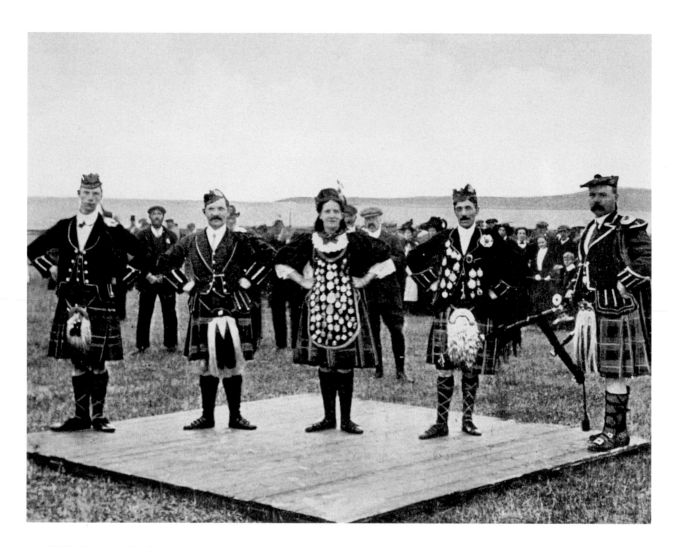

**Highland dancing and traditional
music** enjoyed a renaissance in the late
1800s. The foundation of An Comunn
Gaidhealach at Oban in 1891 provided a
formal organiz-ation for these activities;
in 1892 it held its first festival, or Mod,
which offered competitive performances
and sought to improve standards. Medal-
winners (above) were held in high regard.

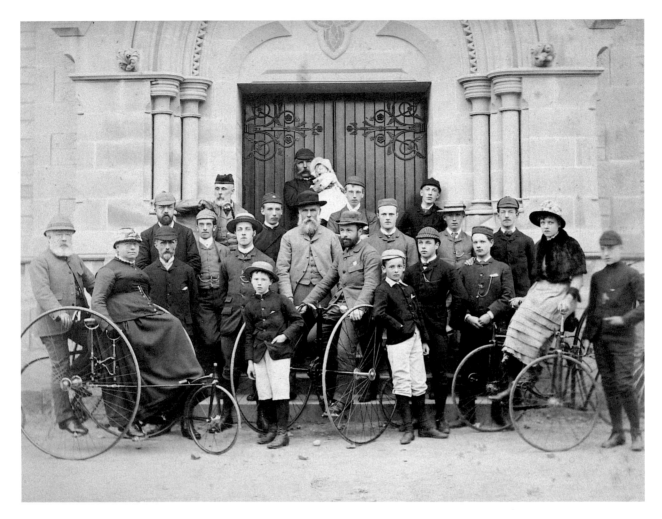

Club organizations of all kinds flourished in later nineteenth-century Scotland, often as an offshoot of church activity. Good companionship, physical health and clean morals were viewed as vital components of a strong Christian society. The members of this cycling club, *c.* 1880, glow with physical and moral health.

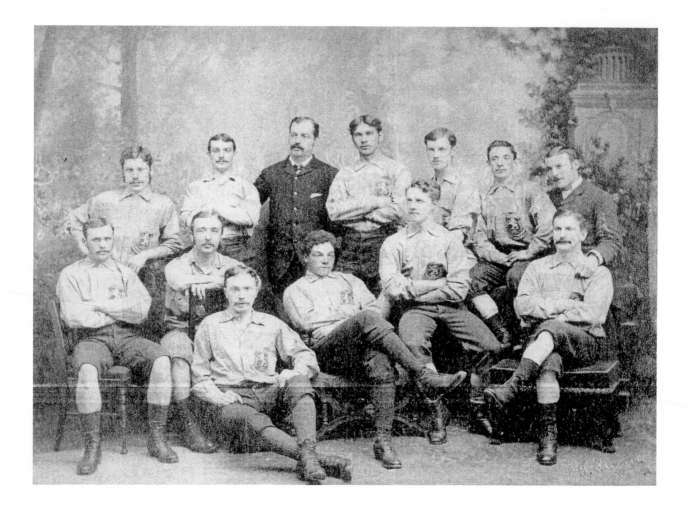

Scotland Football team 1882. Seated in the centre is full back Andrew Watson, who captained the team to victory over England. Watson, who was of Guyanan background, was the world's first coloured team captain. An outstanding all-round sportsman – he was also a skilled high-jumper – he captained Corinthians FC.

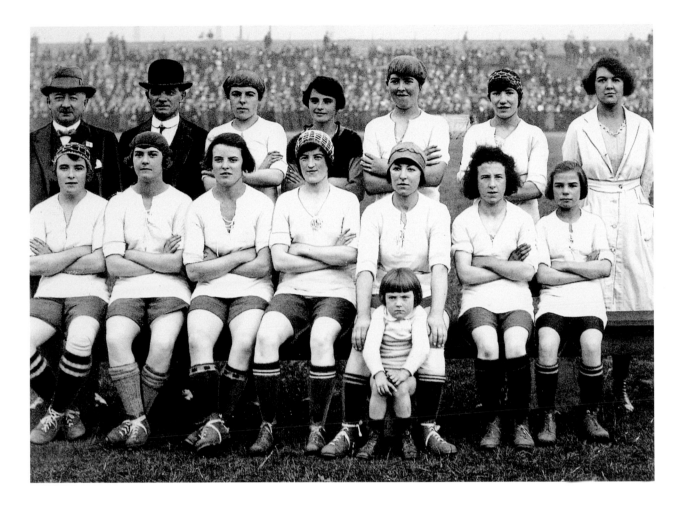

Football in Scotland was not, contrary to popular tradition, an exclusively male passion, watched and played only by working-class men. Women's teams flourished in the early 1900s, many often associated with male professional clubs. Above, *c.* 1920, Kilmarnock FC's women's football team, who represented Scotland in international competitions.

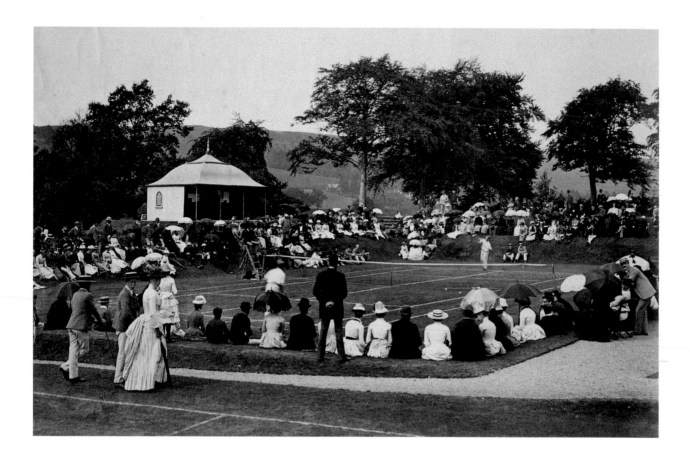

While football was viewed generally as a working-class sport, games such as tennis enjoyed a more genteel reputation. The social complexion of players and spectators at this tennis tournament at Moffat *c.* 1900 would have been wholly middle class.

Tennis's popularity began to grow rapidly in the inter-war years with the emergence of skilled and attractive competitive players who caught the public's imagination.

(right) Donald MacPhail was four times winner of the Men's Singles at the Scottish Tennis Championships between 1933 and 1946, and was a member of Britain's Davis Cup team in 1946.

(following page)
An early glider, *c.* 1910. Scots were prominent in the pioneering days of flying and involvement in the development of powered flight was matched by the early emergence of gliding as a leisure pursuit.

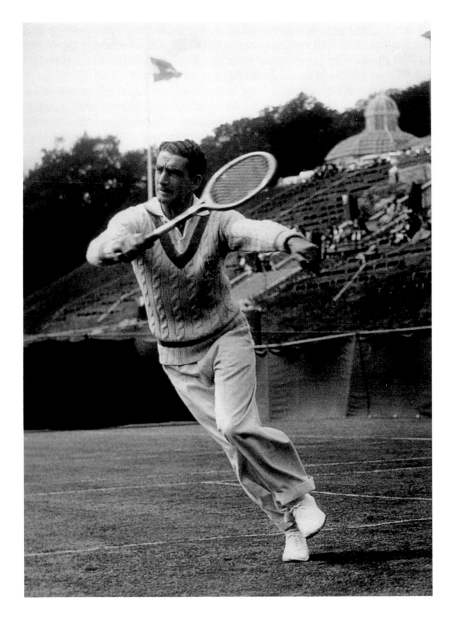